Spencer Drate & Judith Salavetz

VFX ARTISTRY

A VISUAL TOUR OF HOW THE STUDIOS CREATE THEIR MAGIC

ELSEVIER

AMSTERDAM • BOSTON • HEIDELBERG • LONDON
NEW YORK • OXFORD • PARIS • SAN DIEGO
SAN FRANCISCO • SINGAPORE • SYDNEY • TOKYO

Focal Press is an imprint of Elsevier

Focal Press

Focal Press is an imprint of Elsevier
30 Corporate Drive, Suite 400, Burlington, MA 01803,
USA
Linacre House, Jordan Hill, Oxford OX2 8DP, UK

Notices
Knowledge and best practice in this field are constantly
changing. As new research and experience broaden our
understanding, changes in research methods, professional
practices, or medical treatment may become necessary.

Practitioners and researchers must always rely on their own
experience and knowledge in evaluating and using any infor-
mation, methods, compounds, or experiments described
herein. In using such information or methods they should
be mindful of their own safety and the safety of others,
including parties for whom they have a professional
responsibility.

To the fullest extent of the law, neither the Publisher nor
the authors, contributors, or editors, assume any liability for
any injury and/or damage to persons or property as a matter
of product liability, negligence, or otherwise, or from any
use or operation of any methods, products, instructions, or
ideas contained in the material herein.

Library of Congress Cataloging-in-Publication Data
Drate, Spencer.
 VFX artistry : a visual tour of how the studios create their
magic / Spencer Drate, Judith Salavetz.
 p. cm.
 ISBN 978-0-240-81162-8 (pbk. : alk. paper)
1. Cinematography—Special effects. 2. Computer drawing—
Special effects. 3. Digital video. I. Salavetz, Jütka.
II. Title.
 TR858.D73 2009
 778.5′3—dc22
 2009027186

British Library Cataloguing-in-Publication Data
A catalogue record for this book is available from the British
Library.

ISBN: 978-0-240-81162-8

For information on all Focal Press publications visit our
website at www.elsevierdirect.com

09 10 11 12 13 5 4 3 2 1

Printed in China

Working together to grow
libraries in developing countries

www.elsevier.com | www.bookaid.org | www.sabre.org

ELSEVIER BOOK AID International Sabre Foundation

CONTENTS

INTRODUCTION

David Robbins

In a darkened room … there is only flickering imagery on the screen … and you, the viewer, in rapt attention.

If the director, actors, photographer, and editor have done their jobs, you have become one with the movie. Then something surreal may happen, something so fantastic or absurd by real-world standards, that you have no doubt of its validity in the seamless context of the movie, because it could only happen there. Your inner psyche whispers something like: "AWEsome!" When this happens, the visual effects people have done their job. This book is about paying homage to them.

Over the last hundred years and counting, special effects has played a significant role in the emotional way we view movies, and there is a reciprocal arrangement between the psychology of the audience and the purpose of the movie. Because visual effects are so woven into films to the point that movies are in themselves special effects, it would be shortchanging the history of the art of special effects by not regarding their context in shaping the overall history and the business of film.

THE FIRST EXPERIMENTERS

Nowadays the competition among special effects artists has become steeper with the abundance and convenience of digital technology. There is hardly a movie put out there without some sort of visual digital effect. Anyone with a desktop computer and knowledge of Photoshop can accomplish wonders only dreamed of by early special effects pioneers like Georges Méliès (*A Trip to the Moon*, 1902), Fritz Lang and Eugen Schüfftan (*Metropolis*, 1927), along with Merian C. Cooper and Willis O'Brien (*King Kong*, 1933), all of whom relied on tactile physical or mechanical special effects, and a lot of costly trial and error in order to achieve their masterful results.

Photo manipulation was nothing new even before the invention of film. Photographers such as Oscar Gustave Rejlander (1813–1875) and Henry Peach Robinson (1830–1901) used print manipulation and some in-camera techniques to create their allegorical works.[1] Naturally, these effects could be achieved in paintings, but photography was "authentic" and motion pictures even more so. As photography was a feast for the eye, movies were a jolt to the id. Motion pictures evolved during a time when the telegraph, motorcars, and airplanes served to speed up the world from agrarian to industrial, and the pace of culture began to exceed that of man's ability to grow into it.

The first of these motion picture experiences happened in 1895, when Englishman Alfred Clarke released his film of the beheading of Mary, Queen of Scots. Using stop-action photography, the actress on her way to the henchman was replaced with a dummy with a detachable head, history was recreated as it shocked the audience.[2]

However, it took an illusionist to perfect the method of early special effects. French magician Georges Méliès (1861–1938) had bought a theater and needed to attract his audience. He chose the new medium of motion pictures, and had a camera with special lenses made for him by British inventor/filmmaker R. W. Paul.[3] The camera's operation was erratic and frequently jammed while he was filming. During one of these malfunctions in 1896 he had an epiphany. While reviewing his

footage of a street scene the camera jam was apparent, but when the camera started working again and the scene switched, people that were once walking one way were now walking the other, men had morphed into women, an omnibus had morphed into a hearse. Méliès not only had his magic act, he perfected the malfunction in many different ways to become the father of in-camera trickery and special effects. He turned to humor, and is most fondly remembered for *Indian Rubber Head* and his film adaptation of Jules Verne's *A Trip to the Moon* (*A Voyage dans la Lune*), both released in 1902.

The outbreak of World War I bankrupted him and he had to close his theater. Also, his style of filmmaking had by then become stale, and his efforts could not compete with the epochs that were gracing the screens. He ended up in obscurity, amazing children by demonstrating toys from a kiosk in the park on the Gare Montparnasse.

Through his cinematic innovations, Méliès inspired other filmmakers not only to develop new special effects, but also to consciously think out of the box. Such technicians and filmmakers were Britishers Robert W. Paul (*The Motorist*, 1906), G.A. Smith (*The Corsican Brothers*, 1909), and Cecil Hepworth (*The Explosion of a Motorcar*, 1900, and *Alice in Wonderland*, 1903).

There are other techniques that have been attributed to Paul and Smith. Paul was the first to use the dolly shot, whereby the camera was dragged along rails. Smith is attributed with perfecting a matting technique by filming a subject against a black background, then double-exposing another image in juxtaposition with the first. He also attempted experiments with depth-of-field cuts and extreme close-ups. Most importantly, Smith was the first to use parallel editing, showing simultaneous events to enhance the rudimentary plots of his movies.[3]

In 1903, American filmmaker Edwin S. Porter produced *The Great Train Robbery*. Often overlooked among the editorial innovations in the film was Porter's use of the traveling matte (a continuously wound loop of scenery), where he trapped a scene of moving countryside within the open doors of the train to achieve a sense of motion. The most famous scene in *The Great Train Robbery* occurred at its end, when one of the robbers, shown in head and shoulders close-up on the screen, aimed his gun at the audience and fired it. This sent some viewers running for their lives from the theater. This type of viewer reaction remains the bedrock of the achievement of special effects—hopefully without sending the audience scampering from the theater.

THE EARLY STUDIOS

In 1905–1910 there were a number of technical and psychological forces at work that would subtly change the outlook of man toward the world and toward himself. The first of these innovations was the X-ray, which, first invented in the 1870's, was by this time period commonly used as a means to look inside a person's body. Peripherally, this introduced cubism as an art style to accomplish the same sort of in-depth look abstractly on canvas. Sigmund Freud was also at work with his discoveries of the workings of the mind through psychoanalysis. Finally, by 1910, Albert Einstein had published his *Theory of Relativity*, extolling an infinite universe and its relation to the speed of light and, by extension, its relation to the passage of time.[4]

These futuristic techniques and discoveries made the public more accepting to cinema's sleight of hand, playing an emotional role in attracting more people to the movies, which became a form of escape for the audience. This getaway from the routine provided a rudimentary definition for a business model. Growing numbers of people paying to see more movies turned movie production into a competitive business.

In America, artists A. E. Smith and J. S. Blackton formed the Vitagraph Company in 1898, which became the first major film company. From their studios in Brooklyn, NY, they produced a number of commercial short films, along with the creation of some "news" shorts, such as *The Battle of Santiago Bay* (1898), complete with painted backdrops and firecracker explosions around cut-out ships pulled along by underwater strings. This way of reproducing news events through special effects set Vitgraph off as a propaganda shop and led to it being respected as a production studio. Biograph Studios, Vitagraph's rival from the Bronx, used the same techniques in their news films, such as when they recreated the San Francisco earthquake intermixed with actual footage in 1906.

The traditional "one-reeler" was 12 minutes long, and producers and promoters were not convinced that an audience's attention could be held much longer than that. But during the early years of the new century, motion pictures were establishing their niche in the market as pointed, well-scripted 9–12 reelers exceeding two hours. By 1910, the average feature film was 90 minutes long.

Something had to sew the events of these 90-minute attractions together, not the least of which was a plot, but other factors were needed to weave the action together. Generally, a fixed camera filmed the customary one-reeler as a stage production, constrained under the proscenium arch. Camera position, purposeful lighting, and editing delivered cinema from this restriction. Porter, in his *Life of an American Fireman* (1903), began this transition with continuity editing: cutting between related events happening concurrently in nearby locations to heighten the suspense of the plot.[5] In *The Great Train Robbery*, he used parallel editing, where disparate events are happening in different locations. Parallel editing serves the visual flow, while the purpose of continuity editing is to serve the plot, to give it emotional meaning.

Biograph Studio's D. W. Griffith mastered the balance of parallel and continuity editing in his three-hour-long spectacles *Birth of a Nation*

(1915) and *Intolerance* (1916). He introduced a number of other editorial techniques, such as the iris-in, iris-out cuts and the fade, which he accomplished by chemically bleaching the film by degrees. Griffith's editing served as a bed for purposeful optical effects, which served the film's editorial tempo. He worked with legendary cameraman Billy Bitzer, and his films, though controversial, were also marked by a sense of sentimentality and humanity. President Woodrow Wilson stated of *Birth of a Nation*: "It's like writing history with lightning."[6]

New York, with its less than hospitable weather, was not exactly the best venue for making movies. Feature films such as Griffith's became the production standard and required a more forgiving outdoor shooting environment. There was time to consider this inconvenience, however, for when World War I broke out, motion picture production waned.

Once the war ended, the industry moved out to Hollywood, California, where the weather was temperate and the sun always seemed to shine, in spite of the Santa Ana winds and occasional earthquakes. Mega studios, such as MGM, Paramount, Fox, Universal, and Warner Bros., were established as filmmaking became a bigger, more profit-motivated business. These studios were modeled after those, such as UFA in Germany, where films of real artistic substance were being produced by the likes of F.W. Murneau and Fritz Lang.

D. W. Griffith introduced more than editorial techniques to the industry. He also introduced stars, Lillian Gish, Blanche Sweet, and Donald Crisp, to the already developing "star system" featuring standards such as Theda Bara, Charlie Chaplin, and Mary Pickford. The stars emerged through close-ups as another force to draw audiences into the theaters—the viewer could project into a dream life through the screen stars to whom he or she vicariously related. This marriage of human instinct to what was on the screen gave movies a crucial psychological focus. Over time

this mental link would also generate the desire for thrills through the visual effect.

As the American movie industry grew in Hollywood, which became its icon, so even more did the star system. Names of such movie idols as Clara Bow, Douglas Fairbanks, Lon Chaney, and Buster Keaton, among many others, became the draw. Filtering through the star system were also genres of the film. Charlie Chaplin, Buster Keaton, Harold Lloyd, and the Keystone Kops epitomized comedy, while Theda Bara, Clara Bow, and Rudolph Valentino claimed the sex genre. Lon Chaney and Béla Lugosi were horror, and it was in this genre, and that of science fiction, where special effects found its true niche.

THE GERMAN CONNECTION

During the 1920s the German film industry developed quickly into huge movie factories, such as Berlin's UFA, which employed the key film directors and actors. Some of the first German science fiction efforts were directed by actor/director Paul Wegener, who prophesized that a "synthetic camera" would be developed and completely "artificial scenes" would be created through its abilities. Other directors such as F.W. Murneu, Fritz Lang, and Eric Von Stroheim achieved much fame through their movies at UFA.

Murnau directed a number of horror films, particularly his famous *Nosferatu* (1922),[7] an intensely evocative horror film. The makeup was chilling, and his direction was more like choreography. Along with its expressionist sets, the real feature of *Nosferatu*, along with Murnau's other equally famous conventional films, such as *Sunrise* (1927), was the interplay of light and shadows. Like an editing device in its own right, light and subjective viewpoints filtering through his films (such as *The Last Laugh*, 1925) provided the basis for cinéma vérité[8] and film noire. In *Nosferatu*, the light and shadow build the tension as an editing tool, further mastered by Orson Welles and Alfred Hitchcock.

The most deservedly well-known German director of science fiction films and special effects was Fritz Lang, who also produced his masterpieces from within UFA's huge studios. Among his films was an ambitious two-parter of the massive Wagner production *Die Nibelungen* (1924), wherein he had a 60-foot mechanical flying dragon constructed. Here he also utilized the Shuftan process, which used mirrors to combine miniatures with full-sized sets.[9] This process was used extensively in his true masterpiece, *Metropolis* (1926). Though originally critically dismissed, *Metropolis* has held up as a testament to the art of science fiction, German Expressionism, and social metaphor. In a later classic, *M* (1931), a controversial film in which a child murderer (Peter Lorre) is brought to justice by an even more brutal Berlin underworld, he would give definition to film noire, which he would later master in the American films he would direct in the late '50s.[10]

The roots of Lang's methods extended back to 1919, when he worked with Erich Pommer, the producer of *The Cabinet of Dr. Caligari* (1920), to introduce expressionist sets in the movie to convey the mind of the tormented killer.[11] In spite of Lang's unique suggestion, it is Pommer who is remembered as the "father of German Expressionism in film," for *The Cabinet of Dr. Caligari*. Since then, German expressionism has been effectively used (and ineffectively overused) as a psychological tool in a few mainstream and genre films.

Along with their developing artistic merit, many German films conveyed a critical social message. Even *Nosferatu* was no exception, with its veiled message of the plight of the post-WWI demoralization of the German people. Later, the emerging Nazi German nationalist political attitude, offended by the editorial license of such films, would drive Murnau and many great German directors and actors like Greta Garbo and Marlene Dietrich to move to America. Germany's loss would prove to be Hollywood's gain.

THE '20s: ANIMATION AND DEVELOPMENT OF AMERICAN HORROR

In America, a growing number of production studios were establishing special effects departments as the technique developed into more of an art … literally. Animation had been an American cinema hallmark since before the 1920s with Max and Dave Fleischer's rotoscoping technique featuring Koko the Clown in the "Out of the Inkwell" series (1914). Rotoscoping was a means to facilitate the ponderous frame-by-frame freehand animation rendering process through tracing of cells from live film footage.[12] The digital process of "tweening" has only recently replaced rotoscoping.

Throughout the mid-twenties, the process of combining live footage with animation was refined through the serialized "Alice Comedies" (1923–1926), produced by a young Hollywood newcomer, Walt Disney. The process was to be revisited a number of times in the Disney films to follow, most notably 60 years later in *The Adventures of Roger Rabbit* (1988). *Roger Rabbit* was a direct descendant of the "Alice" shorts, in which a live action character becomes involved with the dangers of a cartoon world. The principle of live animation provided a recipe for future possibilities in special effects, becoming a basis for phenomenal cinematic results.

Horror films became a standout American genre, as represented by the works of former circus performer-turned-film-director Tod Browning (*The Unknown,* 1927, *London After Midnight,* 1927, *Dracula,* 1931, and *Freaks,* 1932).[13] Perhaps due to Browning's carnival roots, makeup was the special effect, along with the featuring of deformed people, in many of his films. He also introduced Lon Chaney, Sr., one of the first real superstars of horror. Browning would make about 10 films with Chaney before the star's untimely death in 1930. In 1931, he cast Béla Lugosi as Dracula, and created another Hollywood horror icon with both the film and the actor.

In several of his films he collaborated with my grandfather, Clarence Aaron "Tod" Robbins, who wrote *The Unholy Three* (1925) and *Freaks* (1932). Because *Freaks* was so controversial and poorly reviewed even after edited, it was to be Tod Browning's undoing. Paradoxically, today *Freaks,* which is still considered notorious, has surfaced as a cult classic.

A NEW EFFECTS STAR IS BORN

The most significant development in film history started with a gamble from down-and-out Warner Brothers Studios in 1927. On the verge of bankruptcy, they produced a film, *The Jazz Singer,* featuring a new technique that was still in research and development among its competitor studios: the Vitaphone sound-on-disc method. The "talkies" were here. Fox Studios soon introduced the Movietone sound on film technique, which would become the standard. Despite its promise, many studios were slow to come around to integrated sound right away, thinking it too much of a gamble for a passing whim. But by the mid-'30s, though, most of the major studios produced sound films and they were, well … talkative.

Once movies found a voice, there seemed to be a competition as to who could pour more words into a minute of film. As if the technique were ready to burst from bulging film cans, there were a slew of talkies from Fox and Warner Brothers. And they were vociferous beyond the pale. Within a few years, "All Talking, All Singing!" became an MGM and RKO tagline for seemingly hundreds of movie follies.

But sound came at a price. Its first casualty was the current star system. More than a few stars who might have been masters of the emotive face in silent films had voices too weak or tinny for the rigorous demands of early sound recording. By recruiting from theater performers who could project their voices, a new sort of film actor emerged. By the mid-'30s, the new star system would be well on its way through the likes of Clark Gable, Douglas Fairbanks (also a silent star), James Cagney, Jean Harlow, and Carole Lombard, to name a mere few. Paradoxically, Charlie Chaplin wouldn't speak on film until *The Great Dictator* (1940).

THE '30s: A HIGHER PURPOSE FOR SPECIAL EFFECTS

Because the devices used to record sound were so overwhelmingly noisy, they needed to be shielded from the voices of the actors. This brought filming indoors, into the sound studio where the producers and directors could better control the creative elements of the craft. Filming in the studio required more transparent realism in traveling mattes and rear projection along with the construction of sets and detailed miniatures. The features presented new challenges and opportunities in the art of special effects. In the studio environment, studio moguls and some directors found a means to cut production costs through more creative effects. Many of these effects found purchase in the lavish MGM Busby Berkley musicals of the mid-'30s. The optical printer allowed for otherwise impossible visuals and sophisticated techniques by combining traveling mattes on film in the editing process, thus creating the "cast of thousands" effect, along with innovative wipes, also overused in many of the musicals.

The same optical techniques used for Fox's Astaire/Rogers dance scenes to make them appear flawless were also applied to what is arguably the most poignantly masterful science fiction/ horror film to come out of the decade: Merian C. Cooper's *King Kong* (1933). Using a range of optical techniques, complicated miniatures, and stop action photography, the effects wove together a story of greed's inhumanity toward the natural world and rendered a movie that raised the bar for special effects.

Director James Whale picked up Tod Browning's gauntlet as master of the horror film with *Frankenstein* (1931). With some of his succeeding films, *The Invisible Man* (1933), *The Bride of Frankenstein* (1935), and *The Man in the Iron Mask* (1939), he pushed the limit of technique by majestically electrifying Frankenstein's monster, along with his wife, and by making the invisible man appear (or disappear) invisible once the bandages were removed. The characters in the horror films of the '30s also brought us the pathos of emotional threads, which characteristically weave together many successful dramas. One prime example of this (along with King Kong) was Boris Karloff's portrayal of Frankenstein's monster. Karloff was to emerge as a horror superstar for decades to follow, not because he was a "scary monster" like Nosferatu or Dracula, but because his characters, like Frankenstein's monster, were more human, with soul. It was this kind of character quality, along with the special effects, that pulled the audience in and worked to make the supernatural seem real.

THE GROWING HOLLYWOOD MYSTIQUE

During the '30s, the American movie business had more than survived the ongoing economic depression. "Hollywood" ceased to be merely a place on the map in southern California: it was a state of mind. Going to the movies had become necessary therapy, and the more escapist the movie, the better. Movies were a 10-cent escape from the national woes of the global depression. The economic situation helped to establish Hollywood as the cultural legend it has remained—and the gold standard of global film production.

The studios had their individual personalities: Warner Brothers was known for gangster and noir movies, along with poignant women's movies and Errol Flynn swashbucklers. RKO/Fox was represented by the comparatively low-budget panache of dance movies. Universal produced the

Tod Browning and James Whale horror pictures. Of all the studios, Paramount and MGM produced the most extravagant movies. MGM was mainly responsible for establishing the Hollywood legend throughout the world with epics such as the Busby Berkeley follies and huge productions such as the legendary *Gone with the Wind* (1939) and *The Wizard of Oz* (1939).

Generally, the stars under contract with the studios established the themes of the movies. Béla Lugosi and Boris Karloff, for instance, were under contract with Universal. Relatively lesser-known actors such as James Cagney, Pat O'Brian, Humphrey Bogart, Veronica Lake, Bette Davis, and Lauren Bacall were under contract with Warner's, while Astaire/Rogers worked for Fox. The stars with the biggest draw, such as Greta Garbo, Clarke Gable, Gary Cooper, and up-and-coming "kid" stars like Judy Garland and Mickey Rooney were with MGM. Star quality came at a price to the stars. Generally, and especially with MGM, the stars were under strict control of the studios, often to the detriment of their health and emotional well-being.

Films were also branded with their directors. As James Whale was associated with the horror genre, John Ford was known for his westerns, and Alfred Hitchcock for his suspense films. Walt Disney, a 33-year-old perfectionist director/producer, was the mainstay of animation. Disney studios, established in the late thirties, broke the animation mold in 1937 with *Snow White*, which was to win the Academy Award for that year. More of a work of art than the sketchy one-reeler animations shown before the feature that the public had come to expect, *Snow White* was the first feature-length color animated film. The cell animation technique would elevate the art of visual effects to a new level of precision.

The 1930s began with sound and ended with Technicolor, which was actually developed in 1925—before sound became popular. It was a costly process that required three times the light-

ing, and it wasn't until the end of the '30s, with high-budget MGM movies such as *The Wizard of Oz* and *Gone with the Wind*, that it proved more practical with high-resolution/higher speed film stock. However, color was still cumbersome for the special effects department, for instance, in the development of traveling mattes, where the three primary colors prepared for the film stock had to sync exactly to the live action they supported. Both Oz and GWTW used traveling mattes nearly flawlessly, but when it was done a little bit wrong, the result was awful. By 1939, the audience had become as sophisticated as it was demanding, and one out-of-sync color scene could destroy the emotional power of the whole movie.

ENTER THE FEDS—AND A NEW STANDARD IN FILM EDITING

One might argue that some movies of the late '20s and early '30s were over the top in the license they took in the name of entertainment. In an attempt at federal control to match the national "success" of prohibition, the Hays Code was established in 1934[14] to oversee and purify the content of the movies. The code was to be in effect until the late '60s, when it was replaced by the current ratings system, which liberated film content. Through mandating the curtailing of sex in many mainstream films and violence in gangster films, the Hays Code had a seemingly limited effect on the content of horror and suspense films, where the suggestion of violence became key to building the suspense. Mainstream films followed this idea through the use of natural devices such as shadows and chiaroscuro to build plot tension and waves crashing on the shore to suggest a sexual encounter. The use of metaphor as an editorial device became a foremost plot builder.

THE '40s: PROPAGANDA AND FILM NOUVEAU

Many films of the '40s were in increasingly refined black and white. One of the finest examples of

artistic filmmaking was gifted to us in 1941 with Orson Welles's *Citizen Kane*, arguably one of the greatest films ever, in plot and technique. Special effects using traveling mattes and rear projections were used profusely throughout the film, yet with such transparency that the film was not even nominated in the special effects category—an oblique testament to Welles's mastery over visual effects and film editing. It was nominated for best film in 1941, but was defeated by Fox's box office comedy *It Happened One Night*. However, with *Citizen Kane*, Orson Welles set the intellectual and technical quality standards for future films, not only in his subtle use of special effects, but also in establishing a model for auteur and independent films to follow.

Films and their special effects took on a new role with the outbreak of World War II. Though Hollywood produced 40 percent fewer films during wartime, the home front attendance in theaters was high. This time people went to the movies not only to forget their woes, as was the case during the depression, but also to remember the "boys": husbands and sons fighting for freedom overseas. Horror and science fiction films, the vehicles of the most obvious special effects, were pretty much shelved in favor of what sold: patriotism.

Actor John Wayne was a prime catalyst for the fighting spirit of the American soldier. Already having established himself as a film cowboy in John Ford's westerns, he now donned the uniform to do battle in the theater of Hollywood, and one could argue that he won the war in Peoria. "The Duke" starred in relatively few war films, but he emerged as the consummate American patriot, a box office draw and a propaganda success. The standard for the "fighting patriot" cast in celluloid defined the moviegoer as much as it did the star, and would become a pervasive box office draw—and a magnet for special effects—in the decades to follow.

Effective propaganda is spectacular, and here is where the special effect found its way into war films. Entire war scenes were recreated using traveling mattes, rear projections, and whole fleets of miniatures. MGM erected a 300-square-foot water tank flanked with a rear projection screen. Despite the size of the tank, miniatures could not be that small because they had to show enough detail to be convincing. A 50-foot-long miniature aircraft carrier can take up a lot of space in such a tank of water, especially when surrounded by a task force of miniature Hellcats suspended from wires taking off, landing, and occasionally crashing into it. Also, as fans blew on the tank water to make it look choppy, the waves had to appear in proportion to the miniatures, or the effect was lost.

Also, explosions had to look convincing, and this gave rise to a new special effects person: the pyrotechnic artist. These guys may have come from the foxholes as explosive experts, but they had an eye for the physics that made a battlefield explosion look realistically different from an exploding gas tank or the barrage bombing of a city. So now not only did special effects have to make things look convincingly real, but the effect had to be executed with moderation. This would be a daunting task for today's effects directors, who are conditioned to make things look outrageously fantastic.

Another genre finding its way into wartime cinema was the suspense film. Though the style had been popular in the past, it now achieved a new refinement through the achievements of director Alfred Hitchcock. Having garnered directorial success in his native England, he was hired in 1939 by David O. Selznick at MGM on a seven-year contract. Fresh from his Oscar-winning production of *Gone with the Wind*, Selznick's first collaboration with Hitchcock was *Rebecca* (1940), which won Best Picture and Best Director in 1940. From the beginning of their relationship, Selznick's demand for artistic control may have crimped Hitchcock's style, but not his genius.

Like Orson Welles's controlled use of special effects, Hitchcock also wove them transparently into his movies. In *Rebecca* he used extensive rear projection and miniatures to create the eerie atmosphere of Manderley, the English manor home featured in the film. In *Lifeboat* (1944), he used rear projection to convey the breadth of the ocean. Increasingly, he would rely on special effects treatments in his films, but like the underlying trademark of his gallows humor, the special effects would be subtle.

THE '50s: SUBURBIA AND MONSTERS IN RUBBER SUITS

The movie industry shifted gears at the end of the war and into the '50s with a surge in the economy and the resulting consumerism. The nature of movies was also retooled for another reason: they were competing against the new force brought on by television.

The movie industry took a number of hits during the '50s. The effect of TV was as pressing to Hollywood business as its growth was immediate with the growing suburban household consumer culture. The economics of advertising-supported free viewership of television significantly reduced turnout at the theaters to about half of what it had been. Adding to this was a 1948 ruling by the federal government that the Hollywood/movie theater alliance was monopolistic, and that the movie business had to relinquish its control of the theaters and the distribution of films. As a result, the cinema houses became independent and could choose what films to show.

All of this may have actually been a double-edged sword for both the film and theater industry in the sense that they could align their demographic to a growing number of kids and teenagers: the baby boomers. Without the burden of depression followed by war and more free time on their hands in a growing economy, parents would drop their kids off for an afternoon at the movies while they went to play golf. Also, teenagers would flock to the movies at night while their parents

stayed home to watch Uncle Miltie (Milton Berle) and Sid Caesar, as television revived vaudeville. In a sense, the local theater became a babysitter.

The '50s movies advanced a number of new technologies to compete with the tiny television screen. The technique and resulting quality of animation were improved, as evidenced in the Warner Brothers and Disney animations. The methods of optical printing and traveling mattes were further refined. But the two most significant '50s standouts were Technicolor and Cinema-Scope, two areas where television couldn't compete.

Color had been introduced in 1935 with RKO's *Becky Sharp*, but the seeming lack of audience interest coupled with the cost of the process and the war diminished its use during the '40s. The studios banked on its comeback in the '50s, and from early in the decade more and more films appeared in color. Oddly enough, audience numbers remained the same whether the movie was in color or black and white, so color became relegated to epic films and studios with bigger budgets.

CinemaScope, under any other name, seemed to produce a bigger draw. More ambitious theaters enlarged their screens to accommodate the widescreen format, while standard-sized screens projected a letterboxed version. Even on a standard screen, wide projections seemed to (at least psychologically) show more. CinemaScope also presented more challenges (thus opportunities) for the development of matte and rear projection special effects, while providing the screen real estate for more and detailed models.

Both CinemaScope and color served to revive the epic story, and there was no shortage of them in the '50s. From *The Robe* (1953) to *The Ten Commandments* (1956) to *Ben Hur* (1959), there were a slew of interpretations of biblical stories—in biblical proportions—all in widescreen color grandeur. These epics called upon a wealth of special effects that have by now become legendary. From the raining down of toads to the parting of the Red Sea, special effects recreated acts of God in *The Ten Commandments*. From the recreation of Roman war galley sea battles to chariot races in the Coliseum in *Ben Hur*, they recreated a Hollywood version of history.

The epic film drew in audiences of all ages, but the most consistent audience was that of teenagers. Most of the major studios saw little future in catering to such a narrow market, but more independent studios sprung up with a slew of low-budget horror films featuring actors in rubber monster suits, such as *The Creature from the Black Lagoon* (1954) and *The Beast from 20,000 Fathoms* (1953), and mutated, stop motioned, mechanical ants, such as *Them!* (1954). Many of these films centered around nuclear experiments and explosions gone bad, a comparatively light-hearted account centering around the very real fear of nuclear annihilation. The reality was a bigger horror story than anything on celluloid, but as these horror stories tapped into the fear, they also served to reduce the dread, at least for 90 minutes.

The '50s saw the resurgence of the science fiction genre, which had been subdued since the '30s. Many of the sci-fi special effects for which the '50s are remembered are enduringly cheesy. Most prominent among these was *Godzilla* (translated "gorilla-whale"), the Japanese import created by Tomoyuki Tamaka in 1954.[15] The kitschy, gigantic lizard who made his clumsy trek through a model Tokyo was to make his appearance through 12 iterations in nearly 30 films.[16] There were also the quirky, hastily produced movies from the studio basements of Roger Corman (*Swamp Women*, 1955; *Attack of the Crab Monsters*, 1957) and of transvestite Ed Wood (*Glen or Glenda?*, 1953; *Plan 9 From Outer Space*, 1959).[17] Wood's legacy is marked by the 1980 "Golden Turkey Award" for "The Worst Director of All Time."[18]

Throughout the '50s, though, there were a small number of quality science fiction productions. Many of these came through the efforts of George Pal, who worked with the high-budget Paramount Studios. Starting with his animated "Puppetoons" in the late '40s, Pal went on to make *Destination Moon* (1950) and *When Worlds Collide* (1951). Perhaps his best-remembered film was the CinemaScope epic *War of the Worlds* (1953), which engaged a fleet of sleek, insectine aliens and their craft, along with sophisticated blue-screening, optical effects, cells, and mattes.

Ray Harryhausen, one of Pal's assistants from the "Puppetoons" days, soon after went on to develop a name for himself with *Mighty Joe Young* (1949), another popular overgrown simian, like Kong, but with a lot more heart and a sensitive ear for music. Harryhausen went on to make other sci-fi films, such as *It Came from Beneath the Sea* (1955) and *Twenty Million Miles to Earth* (1957). But perhaps he is best remembered for the special effects he created in his mythological films such as *The Seventh Voyage of Sinbad* (1959) and *Jason and the Argonauts* (1963), in which the beleaguered Jason has a swordfight with a gaggle of skeletons.

Disney Studios solidified their place with kids during the '50s with their television shows (*The Mickey Mouse Club and Walt Disney Presents*) and live action films, where they forayed into special effects. The most notable of these was *20,000 Leagues Under the Sea* (1954), based on the Jules Verne novel. In the movie, the crew of the Nautilus submarine was tormented by a giant squid, with whom Kirk Douglas did battle at the end. The mechanical flaws of the squid were convincingly hidden by the turbid seawater it stirred up around it. The movie ushered in a discrete new niche for Disney, and the studio would eventually break significant ground in the art and technique of special effects, providing examples for others to follow.

THE '60s: COUNTERCULTURE, THE LONE PATRIOT, AND A SPACE ODYSSEY

The 1960s began with John Wayne and ended with Jane Fonda—a journey from conformity to counterculture. This could be applied to the cultural tempo of Hollywood as well. The attendance at theaters continued to drop, save for some of the costly epics, such as David Lean's *Lawrence of Arabia* (1962) and *Doctor Zhivago* (1966), Lewis Milestone's *Mutiny on the Bounty* (1963), John Sturges's *The Great Escape* (1963), and John Frankenheimer's *Grand Prix* (1966).

These signature epics were indeed impressive showcases of widescreen cinematography. There was less reliance on traditional use of miniatures and pyrotechnics, due to the directors wanting to keep things authentic. In the case of *Grand Prix*, for instance, real cars were shot from canons to capture the reality of car crashes. In *The Great Escape*, real airplanes were crashed during several takes. In the case of *Doctor Zhivago*, David Lean sprayed fake snow over great expanses of Spain to simulate the Ukraine.

Only the largest studios could afford to produce such films, which were directed and controlled by sometimes-desperate studio committees. As a result many of these films went over budget in an already-suffering industry economy. None went more over budget than Fox's *Cleopatra* (1963). Relying on the star attractions of Elizabeth Taylor and Richard Burton and spectacular sets, one of which floated a $250,000 barge on a 20-acre set, which also housed a reconstructed full-scale Roman Coliseum that was larger than the 2000-year-old original, the film was produced at a cost of 44 million dollars. In today's currency, that would amount to well over a quarter billion. Such expenses would be impossible to recoup even under the best of attendance, but Fox's gamble didn't nearly pay off, making *Cleopatra* a legendary and colossal flop.

The failure of *Cleopatra* sent shock waves through the entire industry, placing future film production under the control of accountants and lawyers. The first element to suffer was special effects. Considered as unnecessary fluff, entire effects departments were dissolved, and the now-seasoned effects people either went into semi-retirement or became freelancers.

Many of the features of the '60s were British imports as, in light of the Beatles, everything with a British accent was culturally golden and offered a possibility for a profit. This was certainly true with British films marked as highbrow classics, such as *Tom Jones* (1963, Tony Richardson) and *A Man for All Seasons* (1966, Fred Zinnemann). But one film import from the UK, introduced in 1962, was destined to be a cinema cult money-maker: Bond… James Bond.

There were some landmark mechanical effects, such as the James Bond trademark bullet-firing, oil-spitting Aston Martin DB5 sports car in *Goldfinger* (1964). The perception of the James Bond film has remained legendary and fresh with each new film. Conceptually, it gave rise to the serial cult hero—the lone patriot—to be reflected in other movies and their sequels such as *Rambo* and *Indiana Jones*. One could argue that Sean Connery was the quintessential Bond, but James Bond is James Bond, a concept not tied to a particular actor.

20th Century Fox's *Planet of the Apes* (1968, Franklin J. Schaffner) revived the use of visual effects. It starred former-Moses Charlton Heston, redefining the lone patriot role as he assimilated into the ape culture. The makeup and effects were an innovative, amazingly convincing version of the rubber suit monster of the '50s. In fact, the viewer might be hard-pressed to not believe that the apes populating the planet were really humans in disguise.

The one major success that single-handedly revived and redefined visual effects as a feature through the achievements of effects-man Douglas Trumbull was *2001: A Space Odyssey* (1969, Stanley Kubrick). One could argue that the movie saved the film business in general, but it certainly set the draw of pure special effects as vital to a movie's success. Based on the enigmatic sci-fi novel by Sir Arthur Clarke, with a plot that thoroughly confounds the viewer even to this day, it nevertheless remains an elegant effects masterpiece. The miniatures choreographed to Strauss, the blue screen techniques, and the introduction of the slit-screen "stargate" effect in the end set the caliber for the revolutionary science fiction movies to come in the seventies.

The '60s also saw the establishment of the movie code, which classified movies based on the nature of their content. This finally broke through the pervasive shadow of the ubiquitous (though now all but forgotten) Hays Code of the '30s and opened the possibility for studios to script more natural, coarser dialog and to show more sex and violence. Generally, big-name studios who wanted to keep larger audiences stuck to tamer, more family-oriented films, such as musicals like 20th Century Fox's *The Sound of Music* (1965, Robert Wise). The ratings system gave rise to the independent studio: film freelancers with enough production money to make their film the way they wanted. These movies were more "realistic," and often called for subtle, yet convincing, special effects. Many of these independent auteur studios became associated with the larger (funding) studios, along the lines of Orson Welles's association with RKO in the making of *Citizen Kane*.

THE '70s: THE DRAW OF DISASTER IN THE DISCO AGE

The success of *2001*, though a tremendous boost to the art of the special effect, was something of an anomaly in the movie business. The television networks competed with theaters by bringing more studio films to the home screen, causing the studios to continue to lose money. There had to

be some real "blockbusters" on the big screen to draw the audience away from their homes.

Universal's *Airport* (1970, George Seaton) centered around the problems of an all-star cast running a Chicago airport and dealing with a 707 in flight with a bomb on it. The suspense-laden plot was a huge box office draw, and *Airport* spawned three sequels during the decade as "disaster films" became a formula for success, and Hollywood wanted more of them.

Irwin Allen, the director of the hit TV series *Voyage to the Bottom of the Sea, Lost in Space,* and *The Time Tunnel*, was hired to apply his magic to movies. After directing *The Poseidon Adventure* (1972), *The Towering Inferno* (1974), and *The Swarm* (1978), Allen was dubbed "The Master of Disaster." Other films such as *Earthquake* (1974, Mark Robson) and *The Hindenburg* (1975, Robert Wise) also drew huge audiences. Disaster films required innovative uses of rich audio techniques, mattes, miniatures, and pyrotechnics, putting special effects departments back in business.

The film *Westworld* (1973, Michael Crichton) was centered around a place where rich vacationers in search of true adventure could match wits with robots programmed to challenge them. The movie is notable for its pioneering use of two-dimensional computer-generated imagery (CGI) to illustrate the robot's point of view.[19] It was a painstaking process for a few minutes of footage but it paved the way for its sequel, the less critically acclaimed *Futureworld* (1976), which made use of 3D CGI.

Perhaps the most significant and lasting Hollywood phenomena of the '70s were three young directors nearly fresh out of film school: Francis Ford Coppola, George Lucas, and Steven Spielberg. They went on to direct immediate classics such as, respectively, *The Godfather* (1972), *American Graffiti* (1973), and *Jaws* (1975).

Spielberg's *Jaws* featured three sometimes-convincing mechanical sharks (all named "Bruce," as a tribute to Spielberg's lawyer) shown only in quick edits or murky underwater depths. The progenitor of the summer blockbuster, *Jaws* was highly promoted, over budget, and difficult to produce, as "Bruce" would not always cooperate.[20] But *Jaws*'s real strength lay in the Hitchcockian tradition of suspense, and it lived up to its hype.

It was Lucas's second major feature, *Star Wars* (1977), and Spielberg's next film, *Close Encounters of the Third Kind* (1977), that would raise the bar for the special effect, elevating it to a true art form.

THE STAR WARS PHENOMENA AND THE THREE NEW MASTERS OF THE UNIVERSE

The art and technique of special effects had come a long way since their 1930s adaptation in Buck Rogers movies and the spark-sputtering, string-drawn, bullet-shaped rocket ships with engines that sounded like a swarm of bees accented by broken fans. Drawing upon the visual elegance of *2001*, the phenomenal *Star Wars* elevated the special effect to the truly visual effect that it is today. Along with the stunning miniatures and sets that made an alien world seem entirely in synch with our own, the story line was drawn from events that happened "A long time ago in a galaxy far, far away …" This elevated the nature of the common science fiction story to high mythology with historical significance, based in its own reality.

Lucas drew from aesthetically simple sources for many of the special effects. The assortment of aliens, particularly in the famous bar scene, allegedly began as random cloud formations and shadows on the wall. The alien sound effects were also drawn from uniquely basic sources, recalling the innovative foundations of '30s radio sound effects. Lucas's concept was to serialize the story into nine parts, six of which have already been released to dedicated sellout crowds.

20th Century Fox gave Lucas the go-ahead for *Star Wars* in 1975 but then shut down their special effects department. Rather than search for another studio, Lucas established his own, Lucasfilm. The necessity for the studio to be based in special effects called for a special team of people, generally under the age of 30. Lucas approached Douglas Trumbull of *2001* fame for the job, but he turned it down and recommended computer programmer/artist John Dykstra. Hiring a team of recent film school graduates and animators, Lucas established a special effects studio, Industrial Light and Magic (ILM), to develop the film. Though ILM closed its doors after *Star Wars* was released, it was revived in 1980 to become the gold standard of special effects big business.[21]

Shortly after *Star Wars* made its theater run, Spielberg's *Close Encounters of the Third Kind* was released. Bringing the fantastic closer to our own planet, *Close Encounters of the Third Kind* injected believability into the subject of abduction and aliens returning some of their abductees to earth. Unlike the nasty aliens in *War of the Worlds* 20 years before, Spielberg's take was more benign. Many viewers were captivated by the subject and came out of the theater believing that alien abduction (especially away from a depressed economy and disco) may not be such a bad thing after all.

On top of it all, the film was visually stunning. More than the traditional icing on the cake, the special effects, sets, and the eerie beauty conveyed by the dramatic interplay of light in *Close Encounters of the Third Kind* were its core recipe. This kind of quality became the lasting trademark of Spielberg's films, through the broad range of his topics, from the kid's adventure *The Goonies* (1987) to the austere gravity and importance of *Schindler's List* (1994) and *Saving Private Ryan* (1997).

Francis Ford Coppola, the most seasoned of the filmmaker trinity, made his directorial mark early with *The Godfather* (1972), followed by *The*

Godfather II (1974). Both of these films had been critical and popular successes before *Star Wars* and *Close Encounters of the Third Kind* were released. A sullen density, with characters who existed more in shadow than light, recalling the German noir styles described earlier, pervaded many of Coppola's films. *Apocalypse Now* (1979) was drawn from several novels, most notably James Conrad's *Lord Jim* and *Heart of Darkness*, in the narrative style of Michael Herr's *Dispatches*.[22] *The Godfather* not withstanding, *Apocalypse Now* is arguably Coppola's masterpiece, and was as long in its production as it was reliant upon its special effects. In the case of *Apocalypse Now*, Coppola's use of effects seemed more restrained and woven into the plot than the sensational outlandishness required in the Spielberg and Lucas films to date. Coppola's controlled use of special and visual effects would find a way into the more mature films of the other two.

Naturally, films other than those produced by Spielberg, Lucas, and Coppola also rode into the late seventies inspired by the effects—and money-making—standards of *Star Wars* and *Close Encounters of the Third Kind*. *Superman* (1978, Richard Donner), *Star Trek: The Motion Picture* (1979, Robert Wise) and *Alien* (1979, Ridley Scott) were three such films typical of the new effects, and, like *Star Wars* and *Jaws*, they were all destined for sequels.

THE '80s: THE MOVIE AS THE SPECIAL EFFECT

Coppola, Spielberg, and Lucas raised the standard for moviemaking to come, as film had become something of a high culture. Audiences who had had enough of disco and the generally ordinary fare of network television shows demanded more for the rising cost of going to the movies. Like the orthodox established by Georges Méliès nearly 100 years before, amazing effects drew patronage into the theaters, and science fiction, along with thrillers featuring beefed up heroes, were their vehicles.

No longer were sci-fi films about alien invasions by clumsy, heartless creatures. Like the bittersweet portrayal of Frankenstein's monster by Karloff in the '30s, Spielberg's *ET* (1982) showed that aliens could also be believably sentient and even humorous beings. *ET* succeeded in touching the hearts of viewers of all ages, as the stunning effects were woven so efficiently into the film that there seemed nothing unnatural about them.

George Lucas turned away from science fiction in 1981, and reached into the vaults of the 1930s to produce *Indiana Jones and the Raiders of the Lost Ark*. Creating a quintessential privateer hero swashbuckling amid a swarm of special effects, he also created a new look for a second-hand plot formula. Indiana Jones as portrayed by Harrison Ford was to launch three equally successful movies in the series over the next 25 years. The genre once again pitted the lone patriot against insurmountable odds, but we all knew he would somehow survive all perils to live to fight again in the next sequel.

Following these lines, a near future sci-fi thriller featured not a man as the protagonist, but a questionably benevolent and impassive computerized machine (okay … a robot). *The Terminator* (1984) featured a pumped-up Arnold Schwarzenegger as the T-800 man/machine who would appear in two more highly anticipated films in the series. It would also serve to establish Schwarzenegger as a quintessential lone patriot, a beefy John Wayne, in roles where he was pitted against terrors of great proportions, where in the end he emerges as the slightly bloodied victor, in a world that is safe to carry on. The Terminator films were a riot of astounding special effects and pyrotechnics to the percussion of Taiko drums, under the directorial supervision of James Cameron.

In Ridley Scott's 1982 *Blade Runner*, traditional effects were applied as high art. Harrison Ford was cast as another 1930s-style character: this time a detective/cop in a dreary, noir setting of the mid-21st century. The undercurrent of the film anticipates environmental degradation and overpopulation. Visual effects using mattes, blue screens, and miniatures, along with soggy lighting, created a haunting and provocatively dreary feast for the eyes. This all served to accent the growing realization that the movie, in itself, is purely the special and visual effect.

THE NEW HOLLYWOOD ECONOMY

Unlike the disaster it had once been in the '50s and '60s, the sequel had now become a Hollywood preference. The front office realized that a blockbuster film in later iterations would assure a cult-driven blockbuster audience. Now that more studios were regaining control of theaters and film distribution, and that the *Star Wars* concept had bolstered the economy of the industry, Hollywood spent more production dollars on special effects. Whereas to produce and promote a typical film would cost around $2 million in the '70s, by the early '80s the cost would be up to $10 million, and by the end of the decade close to $25 million. Today, it's around $50 million. Though still a far cry from the (projected) $300 million 1962 catastrophe of *Cleopatra*, these costs, though substantial, were in line with blockbuster production costs. Hollywood would take such a gamble because every once and a while, there might be a chance to recoup $1 billion, as was the case with *Titanic* (1997, James Cameron).

During the '80s, the home video and cable television industries may have caused the same threat to the film industry as television did in the '50s. But Hollywood, having learned from its mistakes, was now savvy in finding ways to work in concert with home viewing through residuals. This could reach a point where costs could be recouped though video and cable sales alone. As part of this financial formula, releasing a mediocre film to video soon after its short run on the big screen could work to turn a profit on it. Naturally, though,

studios still focused on saving production costs, sometimes so the money could be put toward advancing the film. Case in point: Ridley Scott's 1979 Alien cost $10 million to produce and $15 million to promote. In the case of Alien, this strategy paid off, with much of the profits coming from residuals from video distribution. It also introduced the first major female lone patriot, Warrant Officer Ripley, played by Sigourney Weaver, who waged a solo battle against the nasty aliens.

The costs of model making and editing were heightening with demand and sophistication. One studio that was becoming painfully aware of this was Disney. Having produced a good number of modest films that were predictably Disney, such as The Shaggy D.A. (1974), the studio made its first science fiction film, The Black Hole in 1979, costing Disney the most it had spent on a film to date ($20 million to produce, plus $6 million to promote).[23] The film was uncharacteristic for the studio in a number of ways. A Disney first, the film contained light swearing, which earned it the studio's first PG rating.[24] Its relatively dense plot was religiously metaphoric and ended enigmatically, along the lines of 2001. But The Black Hole's most significant contribution was the most extensive use of CGI and digital audio to date. More importantly, their use had shown that fantastic effects could be generated in CGI, though a significant cost savings in their use was still 15 years away.

In 1982, Disney produced Tron, a story about a programmer (played by Jeff Bridges) who becomes part of a computer game, within the computer, in order to foil a greedy corporate scheme.[25] The film was roundly panned, but its true significance as to special effects was that there were large numbers of scenes that were computer enhanced, along with others that were purely CGI. Despite the kind of technical innovations only a programmer could love, the effects looked slapdash, even annoying at times, giving the movie a low-budget appearance. Audiences wanted Star Wars, Blade Runner, or even another Black Hole, and what they felt they got was chintzy Buck Rogers. The true value of Tron was in its role as an antecedent for the most significant advance in the history of special effects.

THE '90s: CGI—FROM ATOMS TO BITS

In his 1995 book, Being Digital, MIT computer guru Nicholas Negroponte commented that elements of our daily lives were undergoing a transformation from "atoms to bits."[26] Even the less skeptical among us could not foresee how that could happen, as it was beyond our imaginations. Now, 15 years later, we are routinely accepting this fact without question. Part of the path that led us to this point had its genesis in special effects in film, a transformation that had demonstrated to us the possibilities of technology.

Studios were turning to special effects houses, such as Lucas's ILM and James Cameron's newly formed Digital Domain, to efficiently create their films. Lucas and Spielberg in particular had mastered the art of working within budget and the tight, finished storyboard, which served to solidify the shoot without a lot of trial-and-error takes. Also, the films they made were based on action, rather than the temperament of actors: miniatures and static and animatronic models never complain. Finally, art worked in collusion with business, as Lucas and Spielberg were prominent creatives in their own right and knew the value of a shoot. They were the "producers' producers," and many mega studios (now themselves run by even bigger conglomerates) longed to work with them. Many of these special effects houses had staffs and departments easily larger than the whole studio crew it would have taken to produce a 1950s feature film.

Blockbuster movies such as James Cameron's Terminator 2: Judgment Day (1991) drew an even larger audience than the original and demonstrated the types of wonders that could be accomplished through special effects with the innovation of computer-generated characters. In the movie, the mercurial shape-shifting T-1000 robot, with the help of the geniuses at ILM, could morph into any form and kept audiences captivated. Movies such as the Terminator series and Die Hard (1988, John McTiernan), with Bruce Willis as the quintessential lone patriot, proliferated. Large numbers of viewers abandoned their TVs to flock to the movies to watch slo-mo action choreographed against a backdrop of pyrotechnics permeated with Dolby Digital surround sound. Many of these viewers would later rent the video or DVD to see what they might have missed the first time. This new classification of viewer was becoming involved.

The most stunning development in the art of digital graphics and animation was through something incredible made to look quite credible. Spielberg's Jurassic Park (1993), based on Michael Crichton's 1990 novel, required the adaptation of dinosaurs co-existing with humans. Meshing digital imagery into live action, Spielberg commissioned Stan Winston Studios and ILM to create an array of robotic animatronics dinosaurs and digital effects. The film's budget was $95 million ($65 million of that was for marketing and distribution), and it grossed about 10 times that, making it the 10th highest grossing film to current date.[27] Also, the computer imagery in Jurassic Park set the ideal for what would follow in the new millennium, notably Peter Jackson's Lord of the Rings trilogy (2001) and his version of King Kong (2005).

From Jurassic Park, Spielberg went on to direct the film he had intended to direct before it, Schindler's List. Sid Sheinberg, the president of Universal Pictures' parent company MCI, allowed Spielberg to go ahead on Schindler's List on the condition that he shoot Jurassic Park first. This directive was as wise as it was emotional. Sheinberg knew that Jurassic Park would not have had the "heart" and would not have been the blockbuster it was if Spielberg had first experienced the weight of Schindler's List. Spielberg later rea-

soned: "He knew that once I had directed *Schindler* I wouldn't be able to do *Jurassic Park*."[28]

In 1995, Disney Studios broke the digital effects mold again with the release of *Toy Story*, in partnership with Apple's Pixar Animation Studios for a three-film serial deal. *Toy Story* was the first fully digital film ever produced. With a budget of a mere $30 million, the film and peripherals pulled in nearly $370 million.[29] Inspired by the large profit that can be made with technology that was limited only by the creativity of the team, Disney/Pixar would produce seven more such high-grossing animations to date (2009), with five more to be released before 2012.[30] Many of these films have not been just cartoons for kids. Weaving 40-year-old pop culture references into the plot, they also appealed strongly to large numbers of former Mousketeers: the baby boomer market.

Success such as this does not go unchallenged. In 1994, ousted Disney corporate head Jeffrey Katzenberg (producer of such successes as *Who Framed Roger Rabbit?* [1988] and *The Lion King* [1994]) joined forces with Steven Spielberg and David Geffen to form DreamWorks Studios.[31] In the the 10-year span from *Antz* (1998) to *Madagascar II* (2008), DreamWorks produced 11 digital animation films, each a succession in refinement of the art. The most anticipated of these has been *Shrek*, whose initial $60 million budget produced $485 million (*Shrek 1*, 2001).[32] All of these immensely successful digital films are totally dependent upon the kind of special effects produced in computer graphics, and have created a solid golden age for special effects opportunities—and challenges.

One key groundbreaking special effects movie, *The Matrix* (1999, Andy and Larry Wachowski), won the Visual Effects Academy Award for the year, beating out the much-anticipated *Star Wars 1: The Phantom Menace*.[33] *The Matrix* was significant for its trademark visual effects using stop action photography morphed together as a clip, called "bullet-time." With a technique borrowed from the 1870s photographer Eadweard Muybridge, a battery of still cameras was set up to capture fluid movement.[34] *The Matrix* was also significant in that it raised the bar higher still for visual effects production, as it seemed to close out an era of optical, tactile effects to usher in yet a new digital revolution in film. The sequels *Matrix Reloaded* (May, 2003) and *Matrix Revolutions* (November, 2003) would use primarily digital techniques.

The astounding value of CGI did not progress from the rudiments of *Tron* to the perfection of *The Matrix* through a vacuum of ideas. Around 1986, five years after *Tron* was released, the home computer was a growing staple in many workplaces and households. Around the same time, computer gaming, which had been a growing phenomenon since the early '70s, was making its move from the arcade to the personal computer.

Computer games had vastly improved in their quality and depth of interaction. By the mid-'90s, games had incorporated many special effects devices in their production, such as character motion capture.[35] Three-dimensional role-playing games (RPGs) such as the first-person Doom (1993) and Myst (1993) would soon lead to more sophisticated third-person games, such as Lara Croft-Tomb Raider (1996) and Grand Theft Auto (1997). These employed user-controlled characters within an interactive—and debatably violent—story. In interactive computer games, corporate Hollywood found a new extremely lucrative option for extending the life of their blockbusters, assuring more sequels, such as *The Matrix*. Games were also (relatively cheaply) developed for some box office bombs in an attempt to recoup the lost costs.

The later '90s ushered in more sophisticated RPGs, but more importantly, gave definition to the "user"—a separate generation of audience who would command more action and more immersion into the film. This tactic has often sacrificed the depth of plot demanded by the more traditional, profitable, older generation of viewer. The making of today's movies is faced with striking this balance, which is continually changing, as each generation of filmgoer is influenced by new technical advances.

One in particular is arguably the most significant techno-cultural invention since the wheel—the Internet. It is here where virtual, interactive, real-time social environments are making new demands upon the role of special effects. In this sense, the user has become the media, as much as the media is the user. Marshall McLuhan's ubiquitous "Global Village"[36] has finally been realized.

THE NEW MILLENNIUM

From 2000 forward, visual and special effects has continued to be a work in progress, and these recent innovations are covered in the pages to follow. I suggest that conceptual formats for very real possibilities were presented in two badly reviewed movies early in the decade. The first was *Simone* (2002, Andrew Niccol), wherein a clandestinely digitized avatar replaces a real actress who has walked off the set. Believing she is real, the media make her a sensation. Real-world applications of digitized actors are not that far afield. Consider a real Brad Pitt playing a role with a virtual Clark Gable. Concepts like this were hinted at long ago in films such as Woody Allen's *Play It Again, Sam* (1972), where a Humphrey Bogart look-alike plays against Woody.[37] However, digitally created actors can be made to look and act flawlessly real, and they make no demands and work (relatively) cheap.

Another movie to consider is 2001's *Final Fantasy*. Though also badly received, the film cannot be slighted for its convincing animation. The viewer is hard-pressed at times to not accept the animated characters as real. Such real-world advances in digital animation make just about everything possible.

These developing ideals have created a whole new kind of audience. The viewer-turned-user eventually may wish to change the outcome of the film to their liking. This could change the traditional definition of "special effects." Once creating a purely audio/visual shared experience, these elements are now taken for granted. Special effects could now become much more about what isn't readily seen, but what is truly experienced through programming. The work is cut out for the special effects artists, as we are now only beginning to realize Georges Méliès's illusion through the magician that is special effects. All in all, though, the progress isn't bad for a century's worth of special effects.

REFERENCES
The Overall Resource for This Writing

Rickitt, R. (2007). *Special effects—The history and techniques*. Billboard Books, an imprint of Watson-Guptill.

Supplementary Resources

1. Handy, E. (2004). "Robinson, Henry Peach (1830–1901)," *Oxford Dictionary of National Biography*, Oxford University Press.
2. Special effect. (n.d.) Retrieved from http://en.wikipedia.org/wiki/Special_effects
3. Cousins, M. (2007). *The story of film, a worldwide history*. New York: Thunder's Mouth Press, an Avalon Publishing Group, Inc.
4. Miller, A. I. (2001). *Picasso, Einstein, Picasso: Space, time and the beauty that causes havoc*. Basic Books.
5. Cousins, M. (2007). *The story of film, a worldwide history*. New York: Thunder's Mouth Press, an Avalon Publishing Group, Inc.
6. Cousins, M. (2007). *The story of film, a worldwide history*. New York: Thunder's Mouth Press, an Avalon Publishing Group, Inc.
7. Nosferatu. (n.d.) Retrieved from http://en.wikipedia.org/wiki/Nosferatu
8. Murnau, F. W. (n.d.) Retrieved from http://en.wikipedia.org/wiki/F._W._Murnau
9. Shüfftan process. (n.d.) Retrieved from http://en.wikipedia.org/wiki/Shuftan_process; Pinteau, P., & Hirsch, L. (Translators) (2005). *Special effects: an oral history—interviews with 37 masters spanning 100 years*. Harry N. Abrams, Inc.
10. Fritz Lang. (n.d.) Retrieved from http://en.wikipedia.org/wiki/Fritz_Lang
11. Cousins, M. (2007). *The story of film, a worldwide history*. New York: Thunder's Mouth Press, an Avalon Publishing Group, Inc.
12. Max Fleischer. (n.d.) Retrieved from http://en.wikipedia.org/wiki/Max_Fleischer; Fleischer, R. (2005). *Out of the inkwell: Max Fleischer and the animation revolution*. University Press of Kentucky.
13. Tod Browning. (n.d.) Retrieved from http://en.wikipedia.org/wiki/Tod_Browning
14. Borden, D., Duijsens, F., Gilbert, T., & Smith, A. (2008). *Film: a world history*. New York: Abrams.
15. Godzilla. (n.d.) Retrieved from http://en.wikipedia.org/wiki/Godzilla_(1954_film)
16. Godzilla. (n.d.) Retrieved from http://en.wikipedia.org/wiki/Godzilla
17. Ed Wood. (n.d.) Retrieved from http://en.wikipedia.org/wiki/Ed_Wood
18. Medved, H., & Medved, M. (1980). *The Golden Turkey Awards*. Putnam.
19. Westworld. (n.d.) Retrieved from http://en.wikipedia.org/wiki/Westworld_(film)
20. Jaws. (n.d.) Retrieved from http://en.wikipedia.org/wiki/Jaws_(film); *Spotlight on Location: The Making of Jaws*. (2005). *Jaws* 30th Anniversary DVD documentary.
21. Industrial Light & Magic. (n.d.) Retrieved from http://en.wikipedia.org/wiki/Industrial_Light_and_Magic
22. Apocalypse Now. (n.d.) Retrieved from http://en.wikipedia.org/wiki/Apocalypse_now
23. The Black Hole. (n.d.) Retrieved from http://en.wikipedia.org/wiki/The_Black_Hole; Cinefantastique Magazine, "Black Hole Special Issue," Spring 1980.
24. The Black Hole. (n.d.) Retrieved from http://en.wikipedia.org/wiki/The_Black_Hole
25. Tron. (n.d.) Retrieved from http://en.wikipedia.org/wiki/Tron_(film)
26. Negroponte, N. (1996). *Being digital, Chapter 1*. Alfred A. Knopf, Inc.
27. Jurassic Park. (n.d.) Retrieved from http://en.wikipedia.org/wiki/Jurassic_Park_(film)
28. Jurassic Park. (n.d.) Retrieved from http://en.wikipedia.org/wiki/Jurassic_Park_(film); McBride, J. (1997). *Steven Spielberg*. Faber and Faber.
29. www.the-numbers.com/movies/1995/0TYST.php
30. List of Disney feature films: upcoming releases. (n.d.) Retrieved from http://en.wikipedia.org/wiki/Disney_films#Upcoming_releases
31. Jeffrey Katzenberg. (n.d.) Retrieved from http://en.wikipedia.org/wiki/Jeffrey_Katzenberg
32. DreamWorks Animation. (n.d.) Retrieved from http://en.wikipedia.org/wiki/DreamWorks_Animation
33. The Matrix (series). (n.d.) Retrieved from http://en.wikipedia.org/wiki/The_Matrix_(film_series)
34. The Matrix. (n.d.) Retrieved from http://en.wikipedia.org/wiki/The_Matrix
35. Motion capture. (n.d.) Retrieved from http://en.wikipedia.org/wiki/Motion_capture
36. McLuhen, M. (1964). *Understanding media*. Cambridge, MA: MIT Press.
37. Play It Again, Sam (1972 film). (n.d.) Retrieved from http://en.wikipedia.org/wiki/Play_It_Again,_Sam_(1972_film)

FOREWORD

Jakob Trollbäck

In the beginning, there was imagination. When we first gained consciousness, there must have been precious little knowledge around. We were basically guided by instincts, but besides that, we must have been pretty perplexed. Our brains must have compensated for the lack of understandable facts by making up stories. Those early stories attempted to explain what reason couldn't readily grasp. Occurrences in the outside world as well as our innermost, sometimes inexplicable, thoughts and dreams were ascribed mystical, imaginative meanings. The arch of those stories became part of our reality. Archetypes made our lives a little more understandable, and through mythology, we attempted to find a larger purpose for our lives.

As a kid in Sweden, I learned everything about the old Norse Gods. I was taught that in the past, people believed that whenever they heard the loud cracks of thunder, it was the mighty Thor riding the sky with his power girdle and iron gloves, throwing his mighty hammer to create striking bolts of lightning. I thought it was cool. Man, those Vikings were really loopy. Hadn't they ever heard about discharge of accumulated atmospheric electricity?

But imagined realities can sometimes help to anchor us. Like Einstein's famous fudge factor, the stories can be what make the equation work. From an existential point of view, it may be better to live in a fantastic, slightly made up but somewhat understandable reality than one that is totally opaque.

Besides the ability to fill in the blanks when reason grinds to a halt, imagination is essential when we try to figure out how things work. It allows us to experiment with different ideas and get a better perspective on life. In the game of imagination, it is much, much better to be original, weird, and passionate than to be right and true. The ability to inspire and project a different reality is essential for human progress. Imagination, and nothing else, makes us ask "what if?" and "why not?"

People with open minds full of creativity are vital if you want to initiate change. But before we go ahead and change things at random, it's important to first be able to conjure images of a better life, a more interesting future. If you can't imagine where you're going, why would you have an urge to go there at all? However unbelievable and far-fetched the stories of Jules Verne were, they surely inspired us to dream of an amazingly different tomorrow. I'm sure that after reading his stories, thousands of kids became explorers and scientists. The true genius of a visionary mind is the ability to project and inspire.

Still, our creative mind is not limited to finding explanations for what we can't comprehend and inspiring us to move on. Imagination—and its physical manifestation which we call magic—is essential for our well-being. To have the ability to stretch our thoughts and imagine a different life is a powerful antidote to hardship and suffering. We see it clearly in hard times, when we flock to the theatre and to the movies. There, we have a chance to take flight and trade our worries for a journey to magical places. Stories take us to other places where we can feel strong, righteous, and happy.

It is no wonder that magic, in whatever form, has fascinated people for thousands of years. In

the past, magic was conjured through primitive, but cleverly hidden, effects that depended on distractions to mask the fib that made the wonderful deception possible. Magicians were behind the first rudimentary special effects in the movies. Looking at them today, they seem pretty transparent and it's hard to believe that anyone actually bought the deceit. But back then, we were still very much in awe of the large screen, and not much was needed to make us believe. If the monster was scary enough—and the musical score made that abundantly clear—few people noticed, or cared, that it was clearly made out of papier-mâché and that a 2 × 4 was sticking out the bottom. To eyes not yet used to visual tricks, and minds that wanted to believe, that imaginary beast was real. The wish to believe in wonder is the best friend of all visual effects. Only cynics deny themselves the joy of being carried away.

Even the simplest of setups had the power to capture our imagination. Remember the infamous first screening of the Lumiere brothers' train film where the audience stampeded out of the theatre in panic as the train seemed to overtake them? Amusingly, in that case the only effect was a cleverly positioned camera. But to the virgin eye still not familiar to movement on a two-dimensional plane, it was all too real. As our eyes have become more used to filmic tricks, visual artists are working hard to find new ways to amaze us with their visions. The first goal has always been to make the effect look more real. Robotic monsters and matte paintings were largely retired when rapid developments in computer graphics made it possible to enhance and manipulate the visual experience in new ways. Though those early computer-generated visual effects may have my 10-year-old son in stitches, back then it worked wonders.

All too soon, all that over-the-top CGI started to wear off. Here lies the true challenge in visualizing fantastic images: as soon as you have seen the effect on a screen, you know that it was all made-up. It can still inspire our imagination the way a book does, but when the fantastic gets juxtaposed with the known world, it tends to lose some of its imaginative power. Could it be that the more you try to visualize the fantastic, the more common it becomes?

To counter this dulling effect, today's visual effects are carefully incorporating the physics of real life, and the best effects are carefully inserted into the world we live in. An enhanced reality is much more believable than one that is totally over the top. The movie *Blade Runner* set the stage by showing a future where levitating ships and video pay-phones were worn and riddled with graffiti. Twenty-five years later, computing power has increased about 30 thousand times and we have seen a hundred other futuristic visions, but the film still stands out as one of the most amazing trips into the future. The seamless integration of effects and reality is incredibly powerful.

But what makes the visual effects field so endlessly fascinating is that you can never stay still. Renewal is a must because the ultimate achievement lies in making us believe in imagination, something that can only happen if we see something that our minds haven't already processed and filed under Effects, comma, Visuals. Great storytellers and ingenious image-makers are well aware of this as they try to find new ways take us on fantastic expeditions. In the end, though, it's not about showing us things that we haven't seen before. We are only truly moved when the images tell a story that we haven't heard before.

In the end, the most important thing is to never lose the ability to believe. If we do, we'll quickly turn old and gray. Whenever you hear a child tell a story and sense the fantastic power of imagination, pray that she will always keep that spark. If she can hold onto that gift and stay afloat above the gravitational pull of life, her stories will be beautiful and true, and thus in the end, we will all be well.

Visual effects, circa 2008. Take a quick moment to stand up, stretch, and ask yourself, is it everything it promised you it would be?

Like a shimmering black Hummer with mud flaps reading "Back Off," the greater VFX industry still maneuvers astonishingly well, chasing down and often catching (in fleeting two-hour spells) an insatiable audience appetite for a faster, louder, deeper, more visceral experience. But as the challenge of fooling the eye becomes ubiquitous and expected, the overdue discourse between the science of what can be done and the art of what should be done will be forced to take place within the industry.

We only ask one thing of the realm of VFX: to transport us. Truly moving visual effects find their power by honoring the existing, diverse psychologies of the viewer. Effects work that opts for emotional connection and service to story retains significance well after the technique, science, and execution grow repeated, dated, or even obsolete. The distinction is as important as the difference between a homemade dinner and a plastic facsimile in the microwave. Spielberg accidentally–intentionally discovered this subtle, powerful difference with *Jaws*. A mechanical shark was not fully functional when shooting began. Most of the film shoot transpired shark-free, but audience fear is only magnified thanks to the glitch. Spielberg instead shot from the point of view of the shark. This serendipitous difficulty created a film that played not on our fear of sharks, but on our fear of being helpless in the water. We as an audience brought the most immensely powerful visual effect with us: our own psyche.

It seems that some work, several decades old, holds such strong relevance, while other pieces, shortly after their completion, are relegated to an uncanny valley floor of unwatchable, toy-like trivia. This valley is littered with artwork that banked on the effect as the story. VFX work that remains loyal, obedient, and conforming to the story maintains a remarkable level of transportive power, even if the execution itself runs past its expiration date.

Today's logistical, high-render workflows make it all but impossible for filmmakers to create, re-assess, and create again. Green motion-capture sets and actors crying to tennis ball tracking markers leave little room for the serendipity, failure, and flaw that filmmakers often cite as the saving grace of the finished work.

The idea that VFX as a craft can execute in a style that moves with and toward audiences with accessible flaws is more the exception than the rule. As filmmakers, we would do well to let our audiences in on our joke occasionally. The do-it-yourself VFX work of Michel Gondry connects to its audience by exposing and celebrating the hand of the filmmaker. Older, analog techniques, including stop motion animation, continue their resurgence. Nonetheless, much of the contemporary VFX industry seems content to expand the distance between maker and viewer, establishing bragging rights via a "you could never do this" philosophy.

Take, for instance, the notion of the "uncanny valley," the idea that human characteristics are perceived in forms that are very non-human, generating great empathy. Meanwhile, "almost human" forms stand out. Viewers' negative reactions range from distanced to repulsed. Belea-

guered audience reactions to the *Beowulf* and *The Polar Express* characters are cited as being caused by the uncanny valley. Surely there are countless other as-yet-undiscovered valleys in the vast VFX mountain range.

It sounds like Jungian gibberish, but consider audience psyche as part of the equation for success—or even most of the equation for success. A truly "affective effect" does not assume that all viewers are transported to the same place in the same way. Working away from spoon-feeding FX imagery to audiences goes a long way in allowing audience participation in the story (*Alien, Cloverfield, Jaws*). The heart of the viewer, the history that viewers bring to the table, should take a higher priority in the art of visual storytelling.

The moment Jar Jar uttered his first line, so began the desecration of audience psychological participation. No longer could we absorb Jar Jar with our own informed history, for he is so over-characterized that there is no room for interpretation. We were gifted with a coloring book that had already been filled in. Take Chewbacca, on the other hand. Now there was a character. He was not only wildly accessible from a filmmaking perspective (put an actor in a fur suit), but he set off tiny sparks of emotional access, like our first family dog, our childhood teddy bear, and our instinctive desire to connect with something that cannot speak to us in words. That puppy-like throttle-mourn that emanates when Chewy learns of his best friend's demise? Wait, stop … apple in the throat just thinking about it.

So, will audiences continue to regard execution as the pre-eminent aspect of visual effects work? Does reliance on the power of VFX dull or delude our emphasis on storytelling? The craft of VFX has its best days ahead. There is a wealth of untapped power waiting in the form of personal memory, psychology, and tangible connection to the image on the screen, and the real magic lies in our ability as viewers to bring our own experiences into the story. Here's to the expectation that we as audiences will begin to scrutinize and question visual works that play stand-in for story and experience. Our imaginations are not seeking a surrogate. We're still hungry, but not for more rations of empty-calorie, over-rendered fare. We'll settle most days for the beautiful flaw of a Wookie suit and a chipped platter of mom's macaroni and cheese. It just tastes better.

Artists have been manipulating images since the birth of photography in the 1820s. From the beginning, mattes, superimposition, and dodging and burning techniques were used to alter images with stunningly convincing results. Visual effects have continued to evolve over time and now utilize miniature sets, models, animatronics, CGI, motion matte paintings, global illumination, and ray tracing among other newer practices, in addition to the original techniques that began these visual illusions so long ago. Those who produce this magic with an ever-growing arsenal of smoke and mirrors strive to create the new illusion, one that has never been seen or achieved before. In a world where there is so much beyond our scope of view and understanding, it is no surprise that we are smitten with the magic of visual effects. This realm allows the human race to master forces that otherwise remain beyond our comprehension and control.

Eadweard Muybridge is considered by many to be the father of visual effects. This happened purely by chance. He was hired by railroad tycoon Leland Stanford to settle a bet over whether all four hooves of a galloping horse ever left the ground at the same time. Muybridge successfully photographed a horse in fast motion using a series of 12 cameras controlled by trip wires. Muybridge's photos showed the horse with all four feet off the ground. This series, "The Horse in Motion" (1878), helped push the boundaries of the photographic process as well as break down the physiology of movement to smaller units than were previously possible. We can see a similar, albeit more high tech, version of this process being used today, 130 years later, in the special effects of *The Curious Case of Benjamin Button* (2008). The head of "old Benjamin" is entirely computer generated. It was created using a new camera system, Contour, which was developed by former Apple Computer engineer Steve Perlman to capture facial deformation data. The use of this new camera system combined with the skills of talented artists and engineers allowed director David Fincher and the artists at Digital Domain to achieve, over the course of two years, something that was previously deemed impossible.

This concept of entertainment being a driving force in the development of new technologies is common. The need for better visual effects to entice audiences combined with the wish for cheaper production costs (on both the studio and personal level) led to the move toward digital film processes. The digital production of films eventually led to the digital projection of films. Digital projection, in turn, led to the resurrection of the 3D movie and an overhaul of the 3D process, another evolutionary step in visual effects. On January 16, 2009, Lionsgate released *My Bloody Valentine 3D*, the first horror film and the first R-rated film to be projected in RealD 3D. The RealD 3D system is based on the push-pull electro-optical modulator called the ZScreen, conceived by Lenny Lipton, an American inventor and film innovator. As an interesting side note, Lipton also wrote the lyrics to the song Puff the Magic Dragon as a 19-year-old at Cornell University and has been granted 25 patents in the area of stereoscopic displays.

Unlike the 3D technology from the 1950s, RealD cinema does not require two projectors.

Instead, a high-resolution digital projector using Texas Instruments' DLP Cinema technology is used. A RealD 3D movie can be projected with a single Christie, Barco, or NEC DLP cinema projector at 144 frames per second, six times as fast as a normal movie. This single projector alternately projects the right-eye frame and left-eye frame and circularly polarizes these frames, clockwise for the right eye and counterclockwise for the left eye, using a liquid crystal screen placed in front of the projector lens. The very high frame rate, 72 frames per second per eye, guarantees that the image looks continuous, and each frame is projected three times to reduce flicker. The source video is typically only 24 frames per second. The result of this technology is a 3D picture that seems to extend behind and in front of the screen itself without the imbalance of colors that occurs with the old form of 3D, a new and improved visual effect that has the potential to revolutionize film viewing.

Much of the current innovation in the visual effects field is possible though proprietary methodologies, dynamic algorithms, and faster hardware. The effects in the later films of the Harry Potter franchise look much more sophisticated and natural than those in the first film, *Harry Potter and the Sorcerer's Stone* (2001); this is mostly due to the speed increase in computer processors. Visual effects in films have become so prolific that we take for granted the fact that there are visual effects in almost every film produced today. This saturation of effects combined with the speed at which they are improving have led many a production down the path of "more effects, less story." It is tempting to use the shock and awe of visual effects to stand in for a good plot. Unfortunately for those who succumb to this strategy, these films usually underperform at the box office and are quickly forgotten.

In some instances the visual effects are so spectacular that they trump the story. This can be seen in Michael Bay's *Transformers* (2007), based on Hasbro's Transformers franchise. Bay's dedication to a realistic portrayal of the robots transforming into and out of vehicle form resulted in the creation of extremely intricate digital models of each Autobot and Decepticon. Even the simplest notion of turning a wrist needed 17 visible parts. Each of the guns of the character Ironhide is composed of 10,000 parts. The photorealistic look of the Transformers was achieved by utilizing the ray tracing technique, wherein an image is generated by tracing the path of light through the pixels in an image plane. The audience became enamored with the immensely complex, realistic-looking robots and as a result, that is what was remembered when they left the theater. The story of Transformers may not be that memorable, but this film reminds us how visual effects have evolved to encompass a dramatic range of techniques, from a green screen shoot to the creation of extremely complicated algorithms, all of which serve to create scenes that surprise and delight viewers. These processes, while new and highly technical, evoke the same reactions as Georges Méliès did with his groundbreaking effects film *Voyage to the Moon* in 1902. The rate of advancement in both visual effects and other technologies over the past century has been exponential. It is inspiring to think about how the media landscape will look in another 100 years.

Our imaginations are infinite. Humans love to fantasize, and visual effects provides a vehicle with which to transcend time and space. The use of visual effects in film, commercials, and television makes the ordinary extraordinary and enables society to connect on levels that are both primitive and futuristic. We share knowledge and wisdom through storytelling. Our mechanisms of control and simulation within this tract of shared stories is what sets the human experience apart. Visual effects heighten the drama and intrigue of such narratives by employing techniques to make an otherwise simple narrative more engaging on screen. Effects are much more than entertainment; we stand at the edge of human potential at an intersection where art, science, and technology all converge and continue to drive us toward radically new innovations that never fail to surprise and delight viewers.

STUDIO PHILOSOPHY

Eyeball is a multifarious design agency located in Soho, New York City. For 16 years, the team at Eyeball has designed and produced compelling strategic communications for corporations, broadcast networks, and advertising agencies. Our work ranges from commercial and film direction to branding, experiential, and interactive projects.

We take pride in keeping a fresh perspective while taking responsibility to tell unique stories. Our philosophy is to work simply to convey the chosen message. We do this artfully, thoughtfully, emotively, and most importantly, without ego. Ultimately, we provide a creative solution to overcome a business challenge.

TARGET: "ART FOR ALL"

Creative and Production Process Design/production studio Eyeball has completed a stunning new live-action spot "Art Expands," the latest in the "Art for All" campaign from Target and agency Catalyst Studios, Minneapolis, MN.

Bringing together the ancient Japanese art of origami and the movement of dance, "Art Expands" (:30) creates a world of expanding, twisting, and unfolding beauty. Beginning with a single dancer, the piece ventures into surreal landscapes and bursts of unusual movements that feature a whole troupe of amazing performers riffing on the expanding concept.

The first key to bringing the concept to life was selecting the renowned MOMIX dance company to star in the spot. MOMIX, and choreographer Moses Pendleton, were on both Eyeball's and Catalyst's wish lists, and are famous for their highly visual and surrealistic approach to modern dance. Eyeball's directors worked with Moses to select certain signature moves from MOMIX's many performances and cull them into a new sequence for this piece.

Eyeball then explored the world of modular origami, constructing many elaborate "paper" models in 3D that would bring dimension to the expanding and contracting concept. A minimal elegant world was set up to surround the dancers with different types of origami that would enhance and accentuate their movements.

The whole thing came together with a beautiful track from composer Michael Picton of Expansion Team, with a delicate, yet full of power and poise, mood.

"Working with the dancers was a blast," says Jory Hull, director and creative lead on the project. "Shooting physical performers at the peak of their abilities is always great fun. Being able to take all the of these great MOMIX visuals and creating a new piece out of it was really rewarding."

Credits
Director: Jory Hull
DP: Joe Arcidiciaono
Producer: Jenn Pearlman
Chief Creative: Limore Shur
Creative Director: Jory Hull
Executive Producer: Mike Sullo
Producer: Allison Pickard
Editor: Tom Downs
CG Director: Carl Mok
CG Modeling and Animation: Anthony Jones, Jin Yu

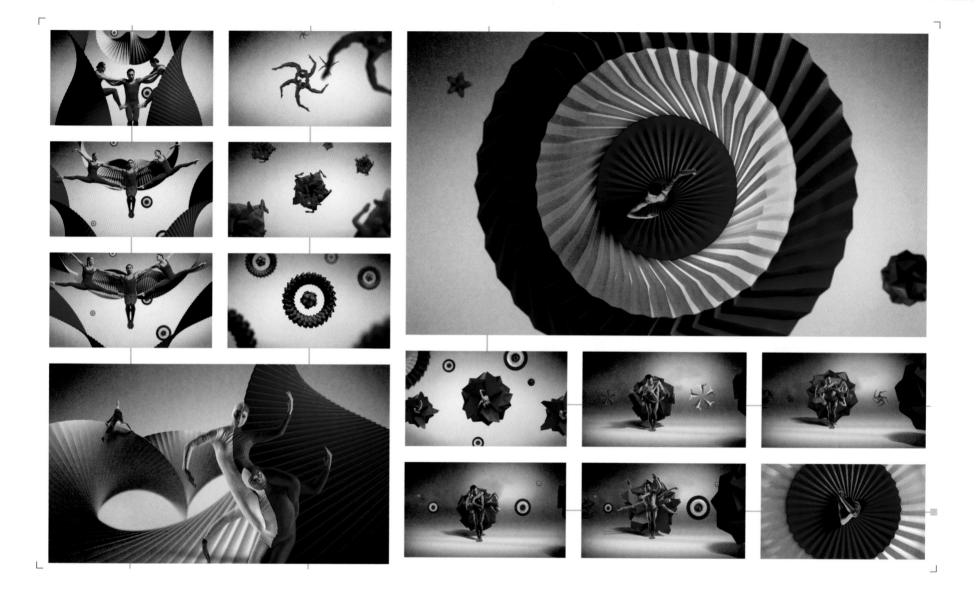

Animation and Compositing: Neil Stuber,
 Johan Wiberg, Mauricio Leon
2D Design: David Pocull
Rotoscoping: Ghazia Jalal

BIOSHOCK: BEYOND THE SEA

Creative and Production Process BioShock "looks so creepily fascinating" it may make the upcoming holiday season "an especially happy one" for Microsoft, according to *The New York Times*. With its thought-provoking plot, "unprecedented" levels of interactivity, and mind-blowing graphics, this 360 exclusive is being called "one of the most gripping, creative visions brought forth in video games for a long, long time." Considering the level of insider hype and advance praise for the game itself, the pre-launch commercial for the August 21 store release is expected to raise the buzz level even further.

Working in collaboration with ad agency RDA International on behalf of their client 2k Games, CG/design studio EyeballNYC has crafted a compelling visual story to entice those anticipating the game's release. Challenged to distill BioShock's visual and graphic complexity into a 60-second spot, Eyeball set out to create a commercial that would entertain general viewers, tantalize fans, and do justice to the ground-breaking nature of the game.

"This isn't just a commercial—this is an interpretation, a foreshadowing of [game creator] Ken Levine's epic story," said Eyeball's Creative Director and Founder Limore Shur, who co-directed the spot. "We wanted to thread together dramatic snippets that would give a real sense of what players will actually encounter in the game."

Forsaking the usual game trailer conventions—linear story arcs or all-out action—Eyeball takes the viewer on a cinematic romp through the mean streets of Rapture, the undersea city at the core of BioShock's plot. Creating suspense through erratic pacing and the power of suggestion, the Eyeball team took a nuanced approach befitting a game inspired by the likes of George Orwell and Ayn Rand. For example, in one of the spot's early action "snippets," the viewer is pulled face-to-face with a bubble-headed menace known as "Big Daddy." Without a trace of gore or violent spectacle, a well-timed fade to black communicates everything about what it's like to tangle with one of these bio-mechanical monstrosities.

"This spot is more about surprise and grappling with the unknown than it's about shock value or any overt attempt to be creepy," Shur explained. "It's really more dramatic when you leave something to the imagination."

Animated "from scratch," the scenes in the spot were essentially built around Ken Levine's "wish list"—specific features he hoped would be highlighted in Eyeball's 3D visual summary of the game.

Because Levine put so much effort into constructing a gaming environment that would "behave" in a realistic manner, the BioShock commercial was expected to follow suit. Whether meticulously color scripting, fitting mannequins with clothing to accurately depict the movement of a character's garments, or tracing light rays, Eyeball's design team went to great lengths to achieve a level of realism seldom seen even in gaming commercials.

"We pulled out every trick and technique for this one," said Eyeball CG Director Stuart Simms, the spot's Co-Director. "The characters had to hold up visually even in extreme close-ups so displacement and normal maps were sculpted using Z-Brush and Mudbox. We had some very talented artists creating the soup of VFX—gunfire, explosions, smoke, sparks, and water effects from foot splashes to ocean surfaces—we wanted to get it all in there to give the viewer a true sense of the experience they would have playing the game."

Lead Animator Rick Vicens said, "This was all about collaborative effort—with all the talent here, everyone brought something to the table. We really pushed the boundaries of CG on this one— I hope people will want to watch this spot again and again."

Credits

Creative Director/Director: Limore Shur
Creative Manager: Hyejin Hwang
CG/Animation Director/Co-Director:
 Stuart Simms
Art Director: Mauricio Leon
Character TD: Joe Gunn
Lead Modeler: Caius Wong
Modeler: Joon Lee, Dustin Hansen,
 Henry Minott, Johannes Kraemer
Lead Animator: Ricardo Vicens
FX TD: Allan Mckay
Lead FX Artist: Jacques Tege
3D FX Artist: Steve Green

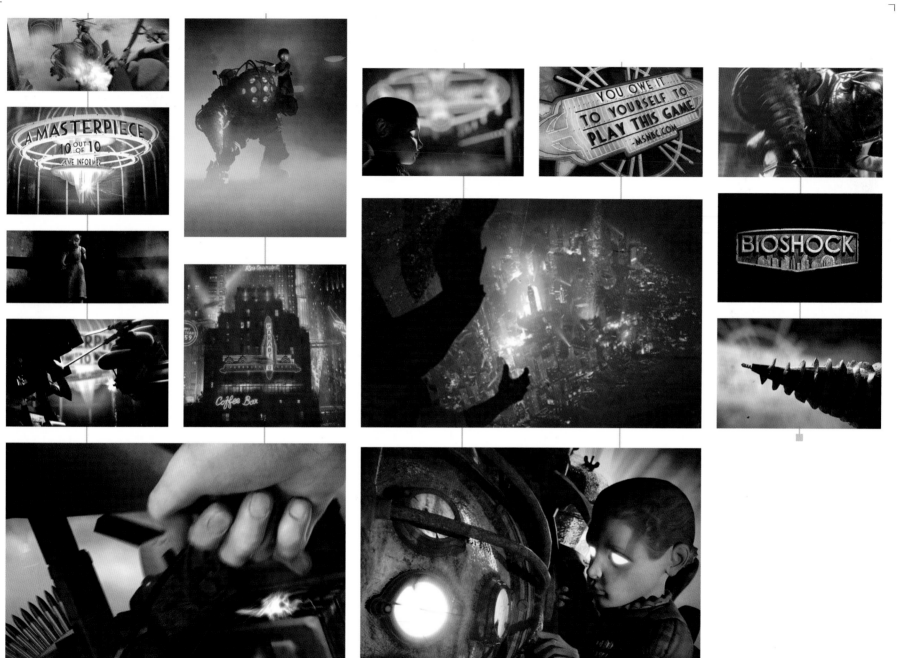

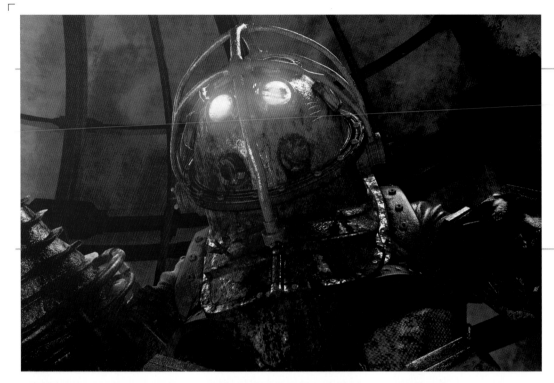
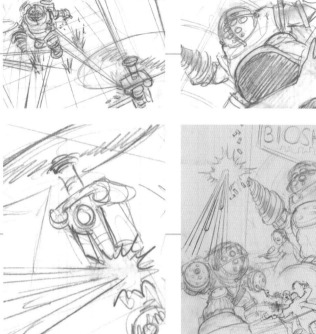

STUDIO PHILOSOPHY

Intelligent Creatures is an artist-driven visual effects house dedicated to helping some of cinema's finest directors tell some of their most compelling stories, working on such films as *Mr. & Mrs. Smith, Stranger Than Fiction, Babel, Hairspray,* and *Watchmen*. With a fully integrated 2D compositing and 3D animation pipeline and a wealth of on-set experience, the company stands among the industry's most progressive VFX creators. We work closely with our clients to ensure that both creative and budgetary needs are met. Intelligent Creatures relentlessly pursues its mission to be the leading company in the world providing visual effects that play a strong supporting role in high-end, creatively driven feature films.

BABEL

Creative and Production Process One of the most challenging shots Intelligent Creatures tackled was the final scene in Alejandro Gonzalez Inarritu's *Babel*. Intelligent Creatures recreated the entire Tokyo skyline digitally to replicate a helicopter shot. Logistics weren't working in favor for production, so VFX was called in to support the Director's vision.

The concern for IC's Visual Effects Supervisor Lon Molnar was that the plate was being shot at 31 stories, minimizing his flexibility. Also at stake was a tight schedule so *Babel* could be delivered in time for Cannes.

This shot was going to be the exclamation point for the Director—it was placed as the last shot leading to the credits, so the pressure was on to keep the audience caught up in the emotional moment and keep the shot completely unnoticed as a visual effects shot.

They had a crane mounted to a dolly track on the roof of the building, with a Libra head so we could swing it over to the floor below. Says Molnar, "We pushed the dolly slowly out, extending 30 feet, then locked the camera down, yet kept rolling so we can pick up the move in 3D."

Lon then scouted an "end" position within another high-rise, and shot plates and high-resolution images from there so we could map the entire hero building and surrounding area. He also spent some time shooting film footage of moving elements such as cars, boats, and helicopters, knowing they'd have to give this shot life once ported over to the digital world. In addition, he took high-resolution stills mapping a 360-degree panorama from the roof to build a texture library for recreating the cityscape back at their Toronto studio.

Back at the studio, the collective of skilled artists utilized tools mainly by Photoshop for matte painting, Boujou to track the plate, Maya to model the city and to create the extended helicopter camera move, and then Digital Fusion for final compositing. At IC's studio, Associate Visual Effects Supervisor Lev Kolobov devised a map layout of the actual area, thanks to Google Earth, to begin planning the construction of blocks and the completion of the camera move.

A "post-vis" of the shot was constructed to help block in the move for editorial timing and composition. During this time IC's combined braintrust realized the execution would be better treated entirely in CG, meaning that the live action plate of the actors would have to be brought in to

help transition the handoff of the live action camera move to the digital camera move.

"The main challenge with the rig was timing. How we were going to get the camera to slow to a stop that could be easily transitioned to our CG takeover; at the same time we had to capture the performance of the actors that was preferred by Alejandro," VFX Supervisor Lon Molnar explains. "The handoff needed to have a smooth transition. We also needed the camera move to speed up over time so we can pull out to a wide shot of Tokyo within a certain time. We realized this ramp was going to be impossible unless we brought the entire shot into the digital world to give it more flexibility in order to deliver the director's vision."

Our lead modeler had an architectural background and was put to the task of leading a team to rebuild the city, taking into account compositional changes. At this point, it still needed to feel like Tokyo, yet we took some creative liberty to improve the composition over the entire move. The main building was important to nail perfectly, as were some of the surrounding buildings, to blend in with other shots in the film.

IC also had a team of excellent matte painters to create textures for multiple projections. The actors were roughly modeled to project back into 3D, and the main plate was required.

According to Molnar, "Most of my attention was focused on level of realism. I spent a few nights on the roof in Tokyo, just taking in the view, studying the skyline for details. One thing that became very noticeable was the reflections and the air traffic lights everywhere. The city was lit up like a Christmas tree." Replicating that back at the studio was a priority. These elements would assist IC with selling the shot to the audience. They also supported the fact that location shooting needs to exist in some capacity in order to absorb the location to help recreate the reality.

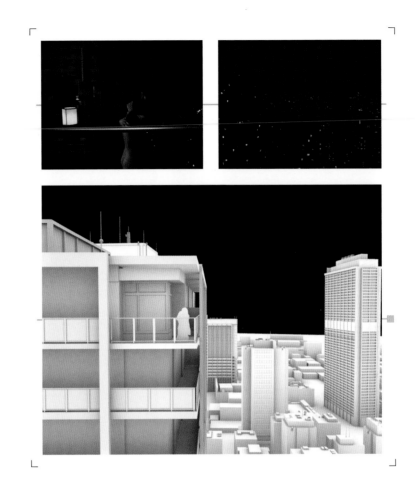

Lev Kolobov mainly focused on motion. He recreated moving lights, streetlights appearing and disappearing, street level traffic—"pin light passes" as he coins it, simulating a real moving camera.

Tools Adobe Photoshop CS2, Eyeon Digital Fusion 4, Autodesk Maya 7, Re:Vision Twixtor and ReelSmart Motion Blur, Google Earth

Credits
Visual Effects Supervisor: Lou Molnar
Associate Visual Effects Supervisor:
 Lev Kolobov

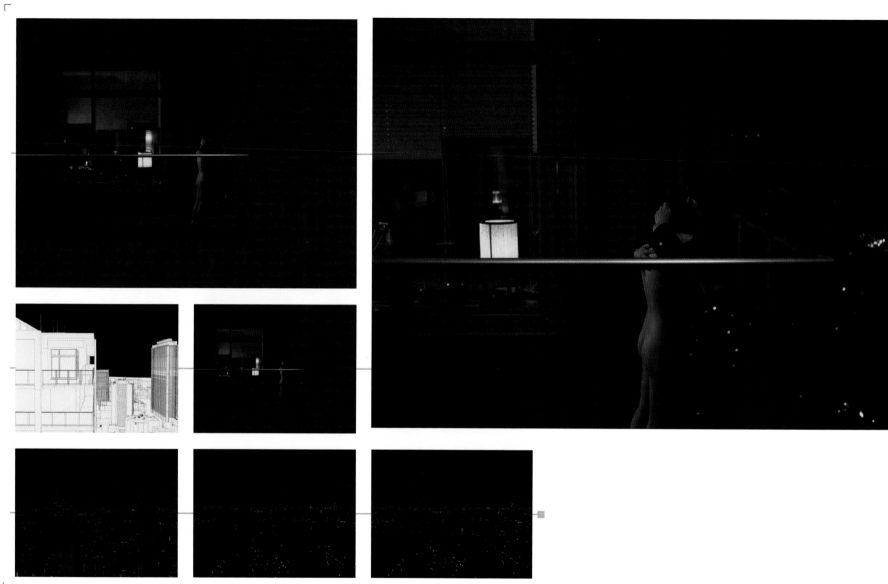

THE FOUNTAIN

Creative and Production Process The idea was that Darren Aronofsky wanted to create this whole nebula with filmed elements, so that it wouldn't have a CG feel to it. Through the use of macro photography, Peter Parks created a series of elements for us, shooting high-speed macro footage of chemical reactions, yeast, and various other elements. Our artists then took these elements into Eyeon Digital Fusion 4 and manipulated them through color correction, warping, displacement, and repositioning to create backgrounds that had the look, feel, and scope of a vast nebula. Hubble telescope photography was used as reference. Our artists often put several dozen elements together to create huge moving backgrounds that would have enough unique detail that different pieces of the same plate could be used for multiple shots. We created six unique backgrounds for traveling through the bulk of the nebula. These plates were then manipulated and tweaked further to add more/different detail in some shots. We also created elements for shots where we would be traveling through the nebula, almost from the perspective of the ship itself, so that elements would need to be traveling toward us, and we would need to create a sense of enormous depth.

Another set of backgrounds was created for breaking through the final area of the nebula and into the core, where the dying star was located. Again, macro photography elements were used to create this interior "bowl" where the star was located, as well as the star itself. This was almost a pure compositing show for us, as the only 3D that was used by us in the movie was for external shots of the ship, where we needed to create reflections and refraction through the bubble of the ship.

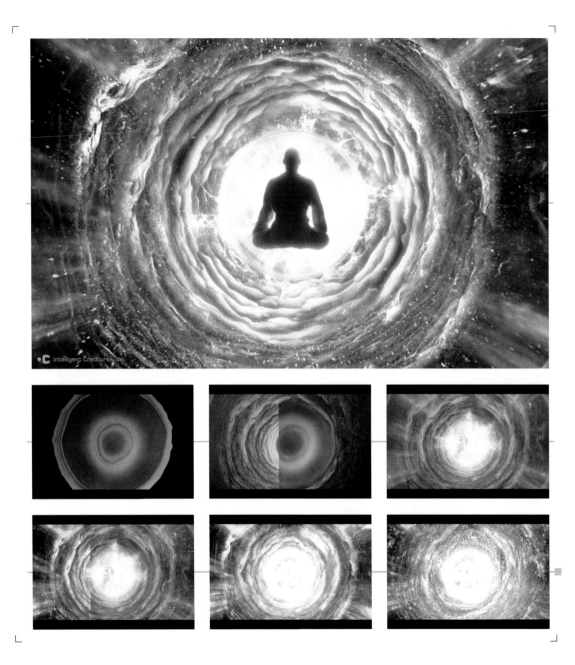

Tools Adobe Photoshop CS2, Eyeon Digital Fusion 4, Autodesk Maya 7, Re:Vision Twixtor and ReelSmart Motion Blur

Credits
Visual Effects Supervisor: Lou Molnar
Associate Visual Effects Supervisor:
 Lev Kolobov

THE NUMBER 23

Creative and Production Process For this shot, the idea was that as Jim Carrey's character begins to read the book, we would travel into the world of the book. We would travel through the various locations mentioned in the narration, transitioning seamlessly between one scene and the next. To start with, the live action portions of the sequence were filmed, mostly against greenscreen (with the exception of the first and last parts of the sequence). Concept art was then created by our matte painting department using Photoshop to establish the feel of each location. Once a look had been signed off on, we tracked all of the live action cameras with PFTrack. We then imported these cameras into Autodesk Maya. An overall layout for each section of the sequence was modeled, and a camera move was created that incorporated the tracked cameras and the sections in between. Getting this camera move to be smooth and not jarring was especially tricky in the transition areas of the sequence, where we would have to reconcile one tracked camera's motion with a fairly different move in another tracked camera.

Once the camera move was established and approved, we set about creating the world and integrating the filmed elements. Matte paintings were created in Photoshop from photographed elements, which were painted to have a stylized,

storybook feel, as well as elements the artists painted entirely from scratch. These were projected onto cards in Maya, and set up so that when we passed them, there would be both a feeling of reality and a feeling of being in a pop-up book. Grass and plants were created with Maya Paint Effects. In some areas, geometry was created to match matte-painted elements in order to pass god rays through them (e.g., trees).

The filmed elements were keyed using Primatte in Eyeon Fusion 5. In some cases, these elements were also placed on cards to seat them into the 3D world we had created. The sequence was composited entirely in Fusion 5. We did a great deal of color correcting and massaging to fit the live action elements into the stylized storybook world, and also to help ease the transitions from one section to another. In the schoolhouse, the students in the room needed to be have a sense of hectic motion, yet remain perfectly still. To do this, we took filmed footage of the children and averaged the frames to create the look. In the case of the dog running through the backyard, several plates of the dog were combined to create a plate of the dog running long enough to cover the entire distance of the yard.

Tools Adobe Photoshop CS2, Autodesk Maya 7, Eyeon Fusion 5, The Pixel Farm PFTrack, Re:Vision Twixtor and ReelSmart Motion Blur

Credits
Visual Effects Supervisor: Lou Molnar
Associate Visual Effects Supervisor: Lev Kolobov

STUDIO PHILOSOPHY

A freelance CG artist now working at Psyop/Mass Market New York as a 3D Look Development Artist/Lead Lighting, Marco Iozzi was born in Italy in 1976. With a passion for cinema and video games, he started studying CGI when he was 18. After three years of design at university, he attended a Softimage Animation course in Milan, and started working in 1998 in the advertisement industry in Italy. He soon developed a strong interest in photography and CG lighting. While working in Italy he kept on studying and improving his portfolio and skills, and was soon offered a position at The Mill London. That was the beginning of a career that saw him collaborating with some of the best studios in the world. Work with The Moving Picture Company, Rising Sun Pictures, Digital Kitchen, and Method Studios, among others, led him to win important awards like the Gold Clio Award, BAFTA for TV Craft Achievement in Visual Effects, and the VES Award for his leading role in a famous BBC TV series.

DARKLANDS

Creative and Production Process This matte painting is a part of a series I'm working on. They're paintings/concept artwork for a short film I'm developing. I consider them halfway in between final matte paintings and mood boards, always looking for new interesting looks and environment. I like to work on dark, almost stylized pieces of work, where the immediate feeling is more important than the technical side of it.

My first step was to create simple geometry for the foreground in Softimage XSI, my general tool of choice when I need to create 3D elements for paintings. After a very rough sketch on paper or directly in Photoshop, mainly for composition and layout purposes, I modeled the ground and tombs with polygons, ready for proper sculpting in ZBrush. This was my next step, and thanks to this amazing piece of software I can just sculpt the models to get many more tiny and interesting details out of them, much more easily than in the main 3D package.

I did not care too much about resolution and, as this was meant to be a still frame, I directly exported the full mesh out of ZBrush, instead of bump and displacement maps.

Back to XSI, I kept on working on the layout and combined different elements. After that I started thinking about lighting with the mood in mind, and parallel to that I went to Photoshop to build basic textures for all the elements. I didn't need to go so much into detail during this stage, cause I was going to add much afterward in 2D.

In the meantime I was doing a research for photographs and reference that could help me first better visualize the idea I had in mind, and second to be ingredients for the actual painting.

I shot several stormy skies in Australia and used lots of them for the background painting, building the mountains and volcano from different sources found in libraries and over the Net.

A good amount of time was given to the final color correction, to find that heavily contrasted black-and-white feel it has.

Tools Softimage XSI, Zbrush, Photoshop

EQUILIBRIUM

Creative and Production Process The idea for this artwork came while shooting some macro photography. The environment for this comes from a photograph of a piece of wood with a spiderweb in between. This very thin spiderweb made me think about life and the very fragile equilibrium we live in so often. The piece itself is actually a general metaphor for life. I wanted to put this elegant beauty on this string and did some research to find the proper model/picture. I eventually found this beautiful statue in Berlin of a naked female figure and I brought it to Photoshop where I slightly changed the proportions. I did not want to leave her completely naked so I went to 3D to create a simple cloth simulation. I modeled some veils and created a dummy object for the character, so that I could run the cloth simulation of these veils floating, moved by winds. This is actually a single frame from a small animation with a camera pullout from the scene.

I loved the idea of keeping the scene with a narrow depth of field, no matter if there's a human figure inside. I felt it was more interesting, style-wise, and was helping the audience concentrate more on the main focus of the shot.

While taking the picture with my camera, I put some lights on top of the set, because I wanted to sell the idea of this Godlike type of lighting. So, both in 3D and 2D I had to recreate the same lighting for all the elements, be they 3D or 2D, so that everything matched. I also created 3D volume light passes and combined them with footage particles and dust. Smoky 2D layers helped me touch up the general mood of the final image.

Tools Softimage XSI, Photoshop

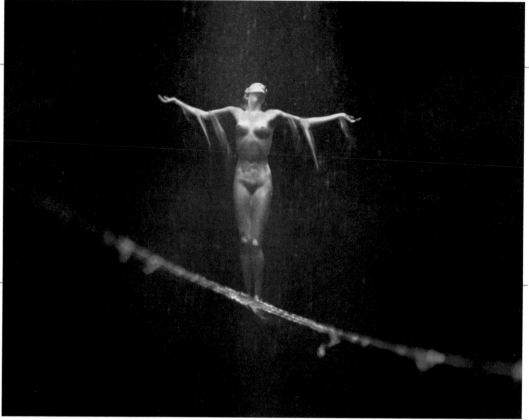
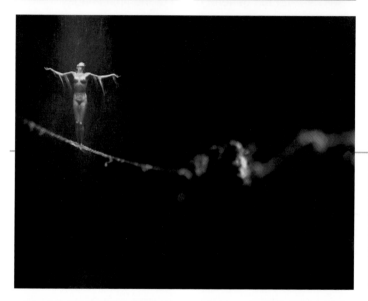

INFINITI

Creative and Production Process Infiniti was one of the first commercials I worked on for Mass Market. The spot was a "re-style" of the one aired in 2007. At that time the car were shot on stage and then composited into a full CG environment.

To match this, the artists needed to create proper reflections and lighting so that the cars seemed integrated into the digital environment, and this led to creation of CG cars for extra passes, like reflections, to be composited in Flame on the live action cars.

For the 2008 new version of the commercial, Mass Market proposed the creation of full CG cars that would have allowed much better choreography and flexibility in the workflow. To do that we had to create some styleframe to show the clients we could actually build a photoreal CG car. As

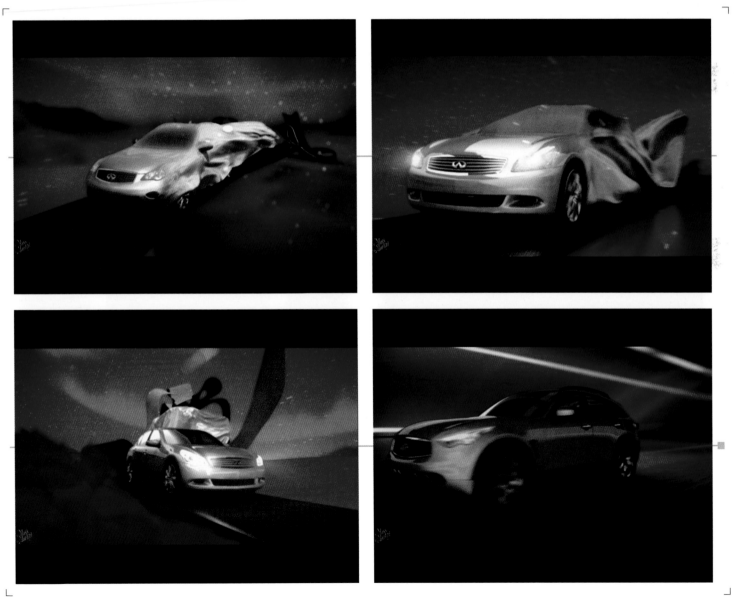

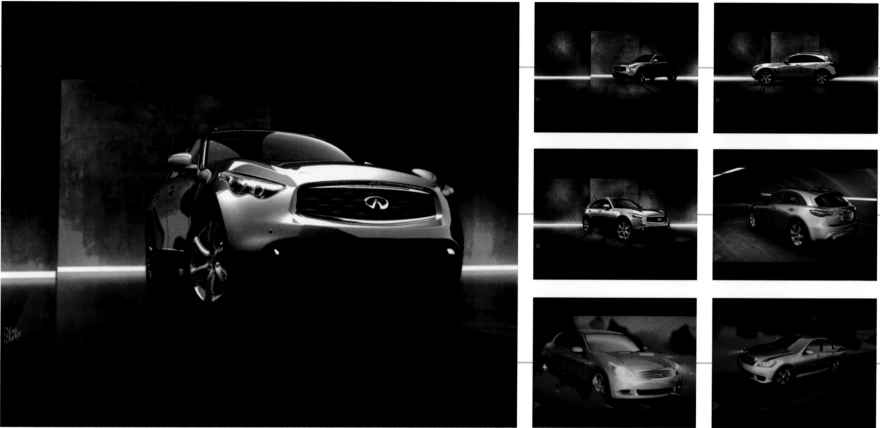

Look Development Artist for the company, my job was to start creating these stills on a general, appealing set to test shading and lighting and ultimately find the proper look.

As expected, the clients wanted their cars to be perfect, shiny, and beautiful, something in the subtle threshold between real and hyper-real. The main challenge for me was creating a convincing reflection scenario full of sharp and more diffused reflected objects that could better enhance and underline the cars' shapes and slick contours. The metal and the car paint in certain areas live off of the surrounding environment so I could not rely too much on texture painting and adding the dirt and imperfections that always help the realism of everything CG created; this time I had to stay "clean"!

During my look development time, as a rule of thumb, I work on styleframes but I also try to address a single sample shot from the script so that I test shading and lighting on a "real" production scenario, on something that is closer to what the team will face when shot production begins.

Although I dealt with some technical difficulties and shot-specific special requirements, as in every production, I'm satisfied with the final look of this commercial, which introduces new Infiniti cars in a stylized and appealing way.

Tools Softimage XSI, Photoshop, Shake

NEVE

Creative and Production Process A close friend of mine once gave me as a gift a small book by a French writer, Maxence Fermine, called *Neve* (Snow). This short novel is a beautiful, elegant, and poetic story that I have always thought would become an awesome short film. So I started thinking about it and putting some ideas on paper, and as I'm used to doing in my everyday job, I tried to come up with some look/concepts for the environments, which is the first thing I generally address.

As usual, my initial step is deep research of appropriate visual material. I imagined these beautiful eastern landscapes with large establishing shots and small, almost silhouetted characters facing these huge untouched lands, suggesting a world where nature is still wild and respected, and where a young poet can really find inspiration.

At that time I was living and working in London and I asked a concept artist friend of mine, Antonio Mossucca, to come up with simple sketches for the characters of the book.

I used his sketches and other reference to build the model in 3D with some simple clothes on. The hairs are 2D. I designed a simple camera movement so that I could push the painting of different elements without running into perspective issues. While I had in mind a desaturated stylized look, I wanted to put in some camera motion, like in a proper establishing shot, so after the initial matte painting I imported all the elements in the 3D package and recreated the scene so that I could have proper parallax. On the foreground I also created some grass moved by the wind.

The second matte follows the same rules, but I personally went and shot high-res 35 mm digital stills of some areas around the city I was born in, and then added 2D painted snow and a combination of footage and 3D particle system for the snowstorm.

I always think that matte paintings don't necessarily need to be super detailed or technically difficult to express emotions and mood, and find new visual styles, which is always the first goal for me when I want to create these fantasy worlds.

Tools Softimage XSI, Photoshop

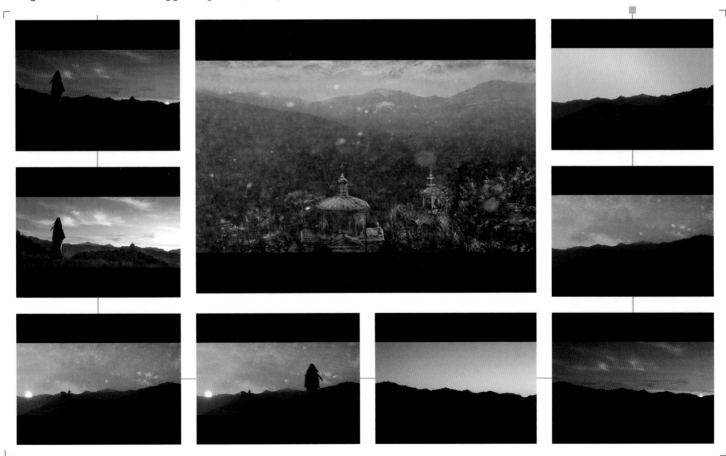

FIGHT FOR LIFE

Creative and Production Process I came on board this project in pitch phase, rendering the sample shot that eventually led Jellyfish to win the project. After this Philip Dobree asked me to lead the look development in preproduction and eventually lead the shading and lighting for the organs and babies shots. The project was very demanding in terms of CG content, because during the episodes the directors wanted to cut the live action footage with photorealistic CG to show what was happening inside the body, at micro- and macroscopic levels, using a virtual small endoscopic camera. Of course, we had to face different challenges from the start; we know and are used to seeing images of organs but we had to recreate lots of environments and situations that have never been shot, maintaining visual but also scientific believability. So we started doing lots of research, and used that as the base for our digital content, having also artistic freedom in creating visual solutions. One of the most important steps was the breakdown of the scripts and storyboards, trying to narrow down all the main visual FX shots. Based on this, I started working with Photoshop, Softimage XSI, and Shake on the look development of the show. I was aware we had to develop and produce more than 200 shots in 8 months, time, and these requirements and time constraints had to become the base of all my work.

I needed to create a pipeline that could give realistic results and be flexible at the same time. We knew we would face many changes and take different roads during the production, and we could not afford to have a perfect but extremely fragile workflow. We needed to have a proven production process that allowed last-minute changes with overnight turnarounds. This meant tight integration between 3D and 2D.

The shading process went hand-in-hand with lighting. I wanted to go for a dark, moody atmosphere. I took lots of reference for this, plus added a little bit of artistic freedom to make things look believable, but appealing. This is the final purpose of CG when correctly used: to bring you to worlds otherwise not possible while keeping the audience interested in the story, helping it, serving it. Particular care was given to the shots involving babies. Human skin has always been a difficult area to explore and render in CG, and while cinematography was helping us by keeping a general dark environment, we would have ruined everything if the babies were not rendered realistically. What you're used to seeing nowadays in CG babies is perfect translucent skin, probably to sell the idea of beauty and pureness, but our babies were in danger, and as lighting had to express this, we had to do shading and of course animation and shot staging. I went for a more complex skin approach, trying to find the right balance between beauty and realism. I started with lots of high-res photos from babies and combined them in a giant Photoshop file made of different layers, again to be able to modify them as needed. This plus other textures were piped into my XSI shader tree and then rendered in multiple passes to feed a Shake compositing script. It was a long journey with difficulties and satisfactions, but now that I can look back and see all those months' work and the final result, I can't but be proud.

Fight for Life won the best Visual FX category at the Royal Television Award, the Bafta Award, and the VES Visual Effects Society Award in Hollywood.

Tools Softimage XSI, ZBrush, Shake, Photoshop

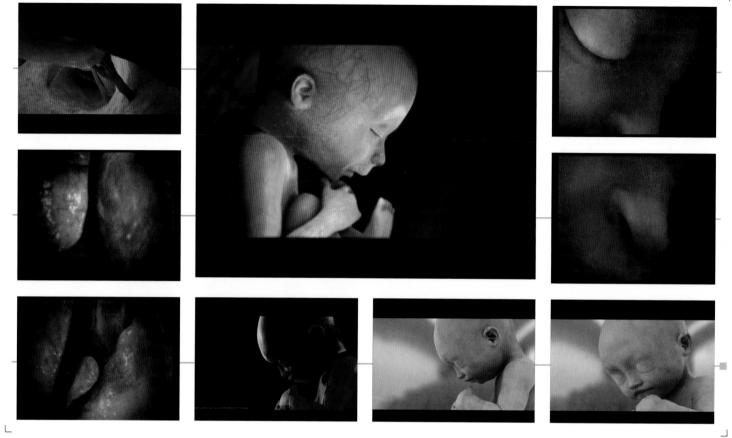

STUDIO PHILOSOPHY

Jesse Jacobs is a Director who combines live action filmmaking, visual effects, animation, and design. He works in commercials, music videos, and broadcast design. With his background as a trained performer at Second City, extensive hands-on postproduction experience, and skill with comedic talent, his integrated approach to production, motion, and storytelling often explores characters in absurd surreal situations.

SKITTLES: "MINDBENDER"

Creative and Production Process Skittles "Mindbender" is an award-winning comedy and effects spec commercial for the controversial Mars candy brand Skittles. It won a Silver at the international film festival Worldfest and has been featured in international blogs and online magazines. We brought a variety of industry talent to bear on this showcase spot, including leading Hollywood visual effects company Eden FX; editorial house Edit 89 in New York; and to serve as co-creative director/co-copywriter, Brian Nash, former Creative Director at Draft FCB in Chicago

and currently a Creative Director at Maddock Douglas in Elmhurst, IL.

"Mindbender" opens in a rundown Hollywood pool hall as a poker-faced pool player ends a game of 8-ball by guiding the game ball into the corner pocket with a geometrically impossible shot. "Hey, you're that telekinetic guy," notes a slightly irksome observer, clenching a pack of Skittles. Without revealing his identity, "telekinetic guy" distracts his slightly dense adversary's attention by moving cue sticks across the room behind him while he opens the package, guiding Skittles into his mouth after some aerodynamic maneuvering. Finally, the "mindbender" telekinetically removes his opponent's hand to siphon off the last of the Skittles. Despite losing his hand, the guy triumphantly exclaims, "I knew it!"

In preproduction, I created a detailed animatic to serve as a rough draft of the final spot, as well as a comic book–styled multi-layered shooting board. The idea was to go into the shoot meticulously prepared for an efficient production but to leave room for improvisation and allow the actors to be in the moment as much as possible. There

was a third character in this spot—a bagful of CG-animated Skittles—and it was important to plan the effects so they integrated well with the live action performances. The goal was to give them something to play off of to drive the comic timing.

I hired a musical improviser to create sound effects live on set as shooting proceeded, as well as a Hollywood model maker who rigged the Skittles bag with a small motor and used a remote control to move the bag around, one of several in-camera practical effects in the spot. Nearly everything else—the Skittles, the cue sticks, and balls—was CG-animated and expertly composited as subtle photo-real effects by the Eden FX (www.edenfx.com) team of vfx supervisor Fred Pienkos and animators John Karner and Sean Scott.

I've done a lot of effects work, but here my goal was to create a simple concept where the humor comes from characters that are placed in an absurd, bent reality. This is a concept that, for me, fits into that scheme because it balances the real with the surreal using an offbeat sensibility in an entertaining fashion.

When people think of visual effects in movies and even in commercials they often assume that everything was just created magically on the computer. But a visual effects production requires a lot of planning in advance so that the performance integrates seamlessly with the animation. When you design a live action effect you first visualize how each layer will fit together in post. You determine what elements or layers you can capture photographically and which layers will be created digitally using both compositing and CGI.

In the climax of the commercial the telekinetic uses his mind to remove the man's hand. The following section includes a description of two main effects scenes that comprise most of the techniques used throughout the commercial.

We started with the in-camera performance, which is often referred to as the back plate. The observer watches his hand break off and float away, as the telepath cups his hands. We showed the actors how the layered elements would fit together so they could visualize the performance and physically imprint the invisible effect into their sense memory. Practically, we rigged the talent's sleeve so that his hand was inside his shirt, which was removed later. This gave the 3D artists reference in texture and lighting to recreate the CGI sleeve.

In the next step the original arm is painted out. This allows us to remove his arm and hand and add a CG sleeve and composite a real practical hand later. This is achieved using cloning and compositing.

A CG sleeve with armhole is modeled, textured, and lit to replicate the look and feel of the actor's velour striped shirt. What makes this effect work is having the shirt react in a naturalistic way as the hand detaches. The CG element is then composited and blended back into the original sleeve using a combination of the original background plate and the painted clean plate.

We shot a close-up of the hand performance. The actor was instructed to imagine his hand was floating up and pouring. This was filmed from a locked position. Once composited the hand would be animated to look as if it were actually floating.

The hand was rotoscoped in post using a standard series of masking and bezier curve tools.

The final composite combines the background, the CG sleeve, and the hand. The CG cloth reacts to the hand detaching. The hand is animated to float off matching the actor's sight line. The result combines all these layers and elements for the final effect.

For the second part, we started with the filmed back plate. The man's hand floats over to the telepath and pours Skittles. As he does so, Skittles fly into the telepath's mouth. We had talent imagine the action so they could perform the invisible. The actor's arm was rigged again to conceal the hand.

In post, the original arm is painted out and the fabric from the belly is grafted on top. This is done using cloning and compositing techniques, which allow us to remove his actual arm and replace it with a CG sleeve later.

A CG sleeve is modeled, textured, and lit to match the original fabric. The CG element is blended using a combination of the cleaned plate and the original back plate. Next, the front of the telepath's hand is rotoscoped. CG Skittles are added into the scene, and the left hand is composited on top of the Skittles that fall into his hand. The arm is fitted with a greenscreen sock and filmed against a greenscreen background. The hand is keyed and isolated ready for compositing. The final composite again mixes the background, the CG sleeve, the hand, and the pouring Skittles. All the elements and techniques meld to create a surreal illusion to serve the comic premise.

Credits

Director: Jesse Jacobs
Creative Directors: Jesse Jacobs, Brian Nash
Art Director: Jesse Jacobs
Copywriters: Jesse Jacobs, Brian Nash (FCB)
Line Producers: Bruce Devan, Merilee Newman
DP: Brian O'Connell
Editor: Bryant Wang
Visual Effects/Compositing: Eden FX
Visual Effects Director: Fred Pienkos
Principal Performers: Bill Chott, Josh Murphy

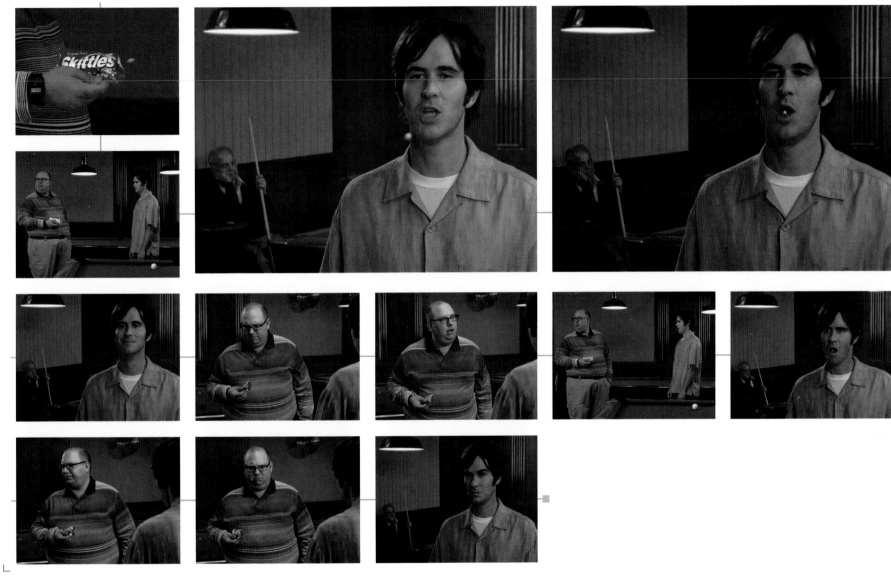

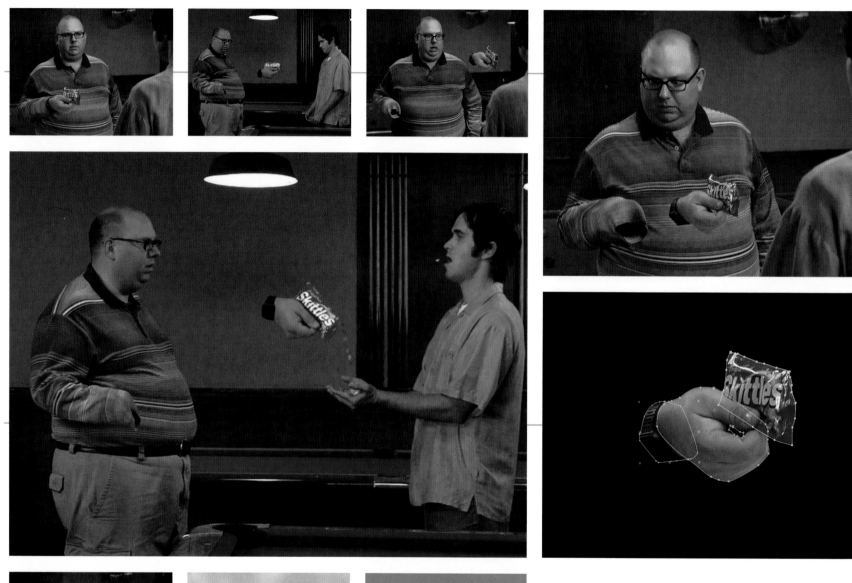
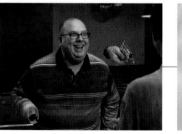
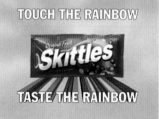
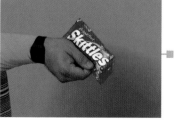

STUDIO PHILOSOPHY

Thornberg & Forester is a creative agency based in New York City. T&F specializes in advertising, design, branding, interactive, animation, live action, and content. T&F's core belief is that all projects must start with a powerful message and be coupled with the right medium to communicate it. T&F prides itself on bringing together innovative people who deliver bold ideas by generating compelling creative solutions with a strategic backbone. T&F's roster of talent includes directors, animators, 3D artists, digital programmers, mixed media artists, illustrators, and photographers. Consequently, T&F's portfolio is quite diverse, with an emphasis on distinctive ideas that achieve our clients' goals.

TARGET: "FALL FOR LESS"

Creative and Production Process We were honored to take part in one of the most recognizable marketing campaigns of today—the Target commercial. This spot offers a fun and playful 3D device for celebrating fall fashion Target style. This project was a tough one for us, as we were up against a tight timeline and a tight budget. While the initial pitch was more 2D, it quickly evolved into a much more elaborate plan. We made our initial style frames in Modo and Photoshop, and then took those boards to our 3D team to interpret the look into Maya. We came across a number of obstacles while working on this job, especially in working with the footage itself. Dealing with the motion of the cubes and picking

footage that fit into the cubes without making the scene feel overcomplicated was quite tough. There were also changes made to the edit as we were animating the cubes, which was challenging because the length of each clip dictated the motion of the cube.

One of the hardest things about this project was that it required a lot of compositing, so once the footage was locked there was a ramp-up time to get the footage on the 3D cubes. It was a slow process because putting the footage in Maya as a texture was the only realistic way to make this look high-end. To beat the problem, we ended up making over 150 Photoshop frames that looked close to the final 3D cubes to get a much more accurate feel for the edit.

Another very important factor was that we had to do quite a bit of compositing of the actual shot footage. We mixed shots together and created interesting compositions to give it a much more graphic feel. We ended up making our own system of timecode to place the footage inside these cubes.

Once we had a good grasp of the edit to put inside Maya, we took all of the passes rendered from Maya and began to composite them in After Effects. It was a series of rendered passes that were all put together to give a final look. Once we had the composite finished, we rendered the movie.

However, we were not done. We then took the final composite and added a stop motion effect to the final render. We did this manually with hold key frames in After Effects because there was no filter that could achieve this look we needed. We ended up going with what we ended up calling a "hyper real stop motion look." It was complicated and time consuming, but turned out great in the end.

Tools Modo, Maya, Photoshop, After Effects

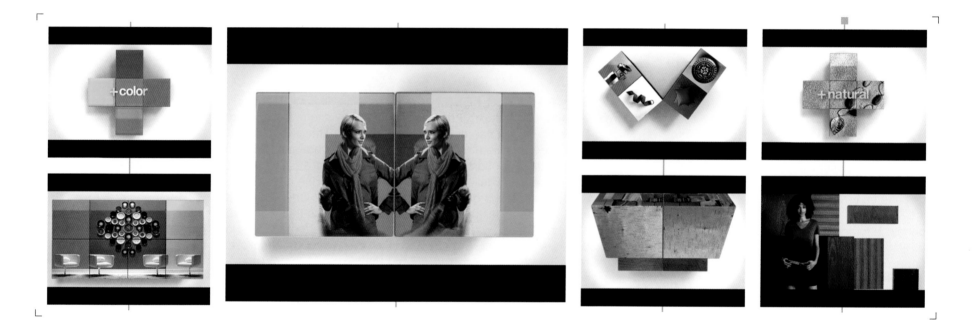

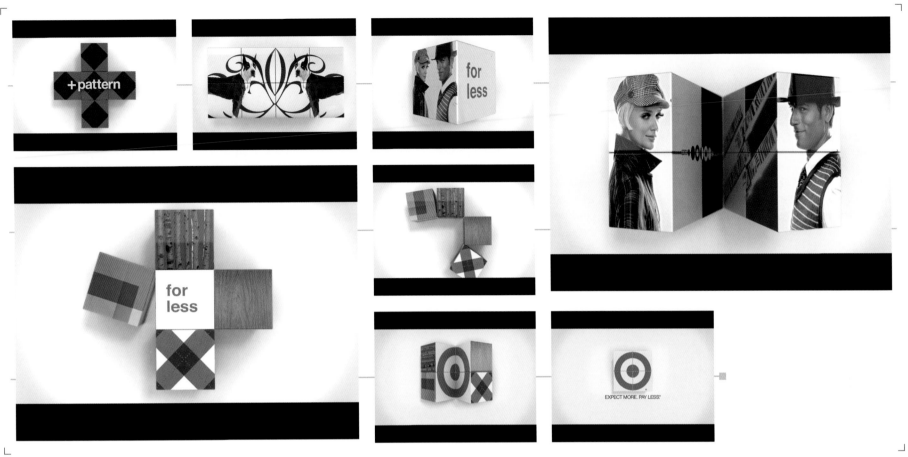

AICP 2008 SHOW OPEN

T&F was honored to design the opening titles, interstitials, and end credits for the Association of Independent Commercial Producers 2008 awards show. There was quite a bit of pressure to make this look amazing and timeless, as it was show-cased at awards ceremonies across the country and is now preserved in the permanent archives of the Museum of Modern Art's Department of Film and Media. The piece was first showcased at the New York ceremony, which was held at the MoMA. We started out with a two-week-long concept phase. After visiting the MoMA and taking pictures of the space, we decided it would be really cool to do something with the typography of museum installations. We sketched a lot, and made Photoshop frames to get the green light to move ahead with this idea from AICP. We took the Photoshop frames and sketches and made a boardamatic with an editor, which helped us to determine the scene amount and priority of work. Once we got a grasp of what needed to be done, we started the task of building all of the pieces to make this a reality.

Something we were very proud of in working on this project was remaking the Helvetica type-face in 3D. This was important to get a beautiful extrusion of the type and not have weird artifacts and tessellation occur. Once we had the typeface recreated, we built the rooms in 3D and passed these elements off to the animators who started animating the letters. We paid a lot of attention to the velocity and speed of the letters animating. We wanted them to feel very heavy and powerful. It took four artists three and a half weeks to map out all of the animation. We then really focused on perfecting the lighting and texturing of each shot, and passed the playblast edit back to the editor for final tweaks. Finally, we began the task of rendering out each scene. We composited these in After Effects, using Frischluft, Composite Suite, Trapcode, and some other little tricks. We also used Qube for our renderfarm software on eight core Mac Pros, which saved us a lot of time. We thoroughly enjoyed working on this and are extremely pleased with the final product.

Tools Photoshop, After Effects, Qube

presents

Art &

Technique Commercial 2008

STUDIO PHILOSOPHY

DK is a full-service production design firm. DK fuses live-action, visual effects, graphics, and editing to tell brand stories in groundbreaking formats. Major brands, TV networks, and advertising agencies call upon DK director/designers to navigate the confluence of branding and entertainment.

The company's slate of award-winning projects encompasses the emerging arenas of rich video and nontraditional advertising as well as motion graphics, design, filmmaking, commercials, and network branding. An indispensable creative resource for major ad agencies on campaigns for Budweiser, Target, and Coke and for clients including Nike, HBO, Showtime, Sundance, AT&T, Microsoft, and Screenvision, DIGITALKITCHEN is a vital force in the world of advertiser-driven production.

MINDQUEST VIDEO

Creative and Production Process MindQuest is a space-cult–inspired recruiting video complete with horrible compositing and bad 3D. Its function is to lead potential employees to Microsoft's recruiting site, hey-genius.com.

The agency, Wexley School For Girls, interfaced directly with Microsoft's HR department, which meant we were able to bypass the usual chain of command. We seized this opportunity to represent Microsoft with light-hearted self-deprecation, something we felt the target audience of hard-core coders would appreciate. We did some healthy self-referencing of our own, turning away from the photo-real, ultra-finessed status quo of the VFX industry.

To recreate the cutting-edge video production values from the late '80s, we used all the effects that are usually forbidden fruit: find edges, poster-ize, dancing dissolve, etc. A nod was given to the early days of 3D raytracing with the ubiquitous checkerboard floor and reflective primitives. For the finishing touch we dumped the video to VHS (multiple times) on a $5 VCR from Value Village.

Tools Adobe Premiere Pro CS3, Softimage XSI 6.5, Adobe After Effects CS3

Credits
Executive Producer: Mark Bashore
Creative Lead/Director: Brad Abrahams
Talent: Arnold Kay
Lead Designer/Animator: Cody Cobb
Original Concept and Design: Ben Grube
Animator: Jayne Vidheecharoen
Modeler: John Foreman
VHS Machine Operator: Dave Molloy
Producer: Carrine Fisher
Original Score: Danny Wolfers

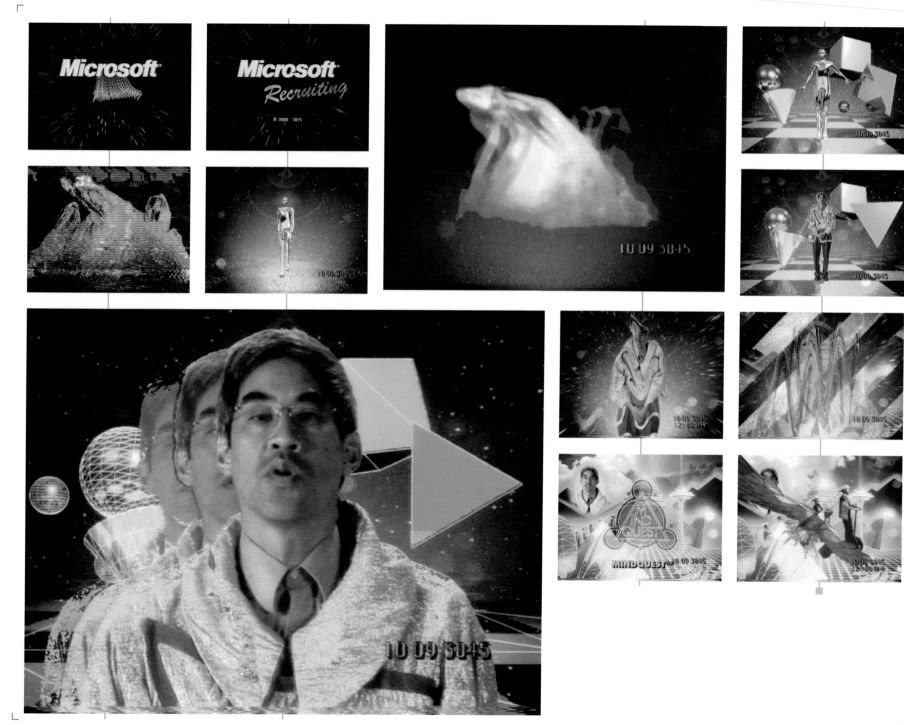

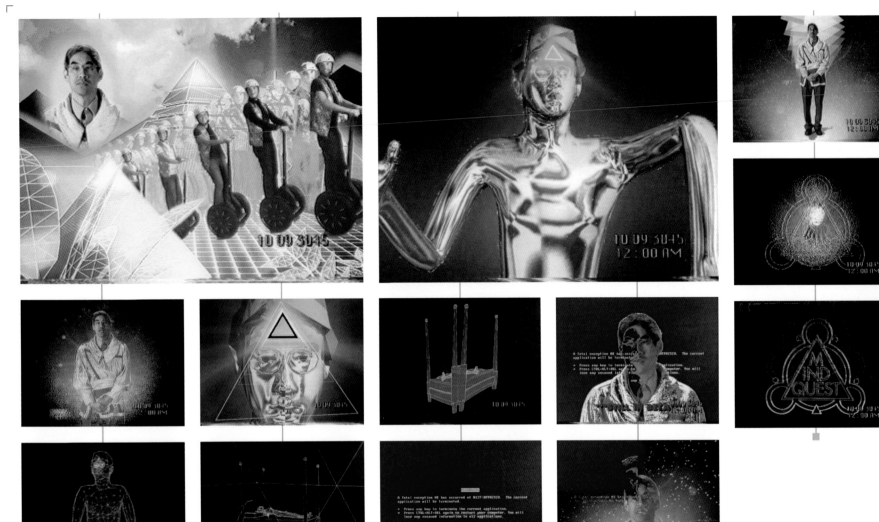

TRUE BLOOD MAIN TITLES

Creative and Production Process *True Blood* is a series for HBO about vampires set in contemporary small-town Louisiana. We created a title sequence that puts the audience through a crash course on sex, violence, religiosity, and the supernatural they are about to dive into. The project used a mixture of in-camera effects, practical effects, and postmanipulation combined with a variety of film and video formats to create an emotional journey.

Instead of the typical tightly storyboarded approach, we developed a visual shot list that represented the general metaphors and tone we were aiming to create. Armed with these, a small team traveled to Louisiana and Chicago in addition to shooting around the Seattle area. The footage was purposely shot with a mixed bag of cameras including Super 8, 16 mm Bolex, 35 mm Arriflex, and Pro-sumer HD cameras.

We purposely steered away from any high-end VFX treatments, relying instead on capturing our moments in-camera. However, we did create effects based on analog techniques, including the multi-step process of reshooting images with Polaroid film and transferring the emulsion to Plexiglas so that we could use canned air to create the "sloughing skin" look. Among the in-camera effects seen in the title was the streaked footage that we captured using a shutterless 16 mm Bolex. The footage of the Pentecostal worshipers was shot using HD for convenience. However, we wanted it to feel archival as if

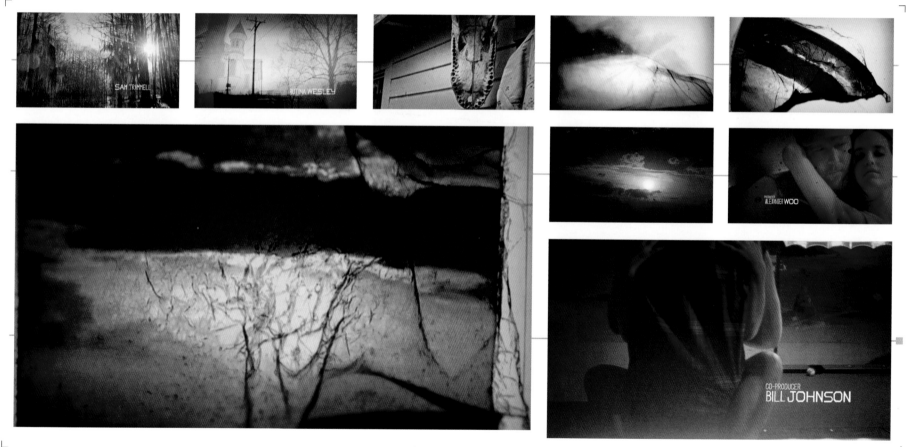

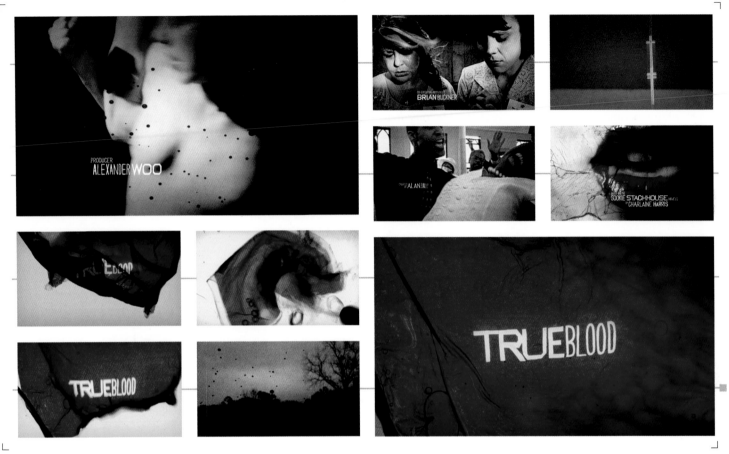

shot with an '80s consumer video camera and degraded the footage in After Effects to achieve this.

Ultimately, we wanted the raw, visceral, unvarnished subject matter to bubble up rather than be overly processed from camera to screen.

Tools Adobe Photoshop CS3, Adobe Illustrator CS3, Adobe After Effects CS3, Avid

Credits
Concept: Rama Allen, Shawn Fedorchuck
Creative Director: Matthew Mulder
Designers: Rama Allen, Ryan Gagnier,
 Matthew Mulder, Camm Rowland,
 Ryan Rothermel
Editor: Shawn Fedorchuck
Compositors: Ryan Gagnier

Live Action Direction: Rama Allen,
 Morgan Henry, Matthew Mulder, Matt Clark,
 Trevor Fife
Producers: Morgan Henry, Kipp Christiansen,
 Keir Moreano
Executive Producer: Mark Bashore
Executive Creative Director: Paul Matthaeus

THE COMPANY MAIN TITLES

Creative and Production Process We were asked to create a 30-second main title that metaphorically conveyed the dark world from post-war espionage to the fall of Communism. Based on the novel by the same name by Robert Littell, *The Company* is laced with references to *Alice in Wonderland*. Our intent was to include some of this aspect in the titles without directly filling it with characters from Wonderland. Ridley Scott was enamored with a certain cross-hatched style of illustration that we adopted as we brainstormed concepts.

Our intent was to create a symbolic microcosm of a secret underworld that represented the dynamics in this epic story. Instead of just moving a camera across illustrations, we developed a nervous cross-hatching animation style to create a creepy storybook tone that added an uncomfortable psychology that fit with the whole spy story. Before moving a pixel, we invested a great deal of time in getting the illustration style just right as well as working closely with Ridley Scott to firm up the main title screenplay using traditional hand-drawn storyboards and rough cuts made directly from the storyboard frames. This "cinematic"

approach ensured that we would create a story arc for our hares as they run from the initial rocket blast to disappearing down the rabbit hole, which in turn sets us up for the climax of the atomic explosion that becomes the Mad Hatter's toadstool at the very end.

The biggest challenge was how to develop a production technique that simulated a cell animation look without actually doing the work via traditional cell animation techniques. We didn't have the time, manpower, or expertise for that. Our solution was to create this world in 3D using XSI. Parallel to this effort, a separate 3D team modeled,

rigged, and created run cycles for the two hares featured throughout the sequence. Once the scenes and characters were merged, we rendered several passes of the entire sequences. These renders were split into the various shots to then be taken through series of custom procedurals in After Effects, which gave the basic cross-hatched look. To achieve the final look, we then literally drew on top of the frames to create a better sense of the randomness of the cross-hatch stroke and to emphasize more shadow and

highlights throughout. In the final shot the show creators wanted to seamlessly transition to the shadowy figure walking down the street. So we recreated the bookstore pullout in 3D from the original live action element so that we could essentially dissolve into the walking action at the end of the title sequence.

Tools Adobe Photoshop CS3, Adobe After Effects CS3, Softimage XSI 6.5, Autodesk Maya, Avid

Credits
Executive Producer: Mark Bashore
Creative Director: Matt Mulder
Designers: Cody Cobb, Noah Conopask, Ryan Gagnier, Matt Mulder
Animation: Cody Cobb, Ryan Gagnier, David Holmes, Pete Kallstrom, Matt LaVoy, Davyd Chan
3D: Cody Cobb, Igor Choromanski, Gordana Fersini, Thiago Costa
Editor: Dave Molloy
Producers: Colin Davis, Jill Johns

STUDIO PHILOSOPHY

Royale was born out of the idea that creativity comes in unexpected ways, a process of exploration and discovery inspired by the real-world people, experiences, and things around you—or conjured from the most fantastical corners of the imagination. The three partners bring a combined 20+ years of diverse knowledge and hands-on involvement in the advertising industry, which means that no client walks away without the Royale treatment: innovative and expectation-topping creativity from a multi-dimensional team of talent. This is all supplied within a comfortable, relaxed environment with a generous supply of fun.

THE DAILY SHOW

Creative and Production Process Comedy Central approached us to create a toolkit of elements that could easily be used by their in-house department. On top of these elements, we were tasked with building custom one-off animations that would support the specific show promo. Comedy Central's in-house team works in Cinema 4D; however, most of the 3D elements we built were in 3D Studio Max. There was quite a bit of back and forth using the .fbx format to get everything looking identical in Cinema 4D. Some of the textures were rebuilt, some of the geometry was cleaned up—but all in all we supplied them with a carbon copy of Max files in Cinema.

We certainly had more control over the one-off animations. For these, we were asked to build a "News Scrapper" that constructed itself onscreen, similar to time-lapse footage, and a *"Daily Show"* rocket that sat on the launchpad and flew through the air. For the rocket, we ended up modifying a model of a Saturn V, and used it as a base for a digital matte painting in Photoshop. In Photoshop we built the launchpad as well as surrounding environments. That was then composited in After Effects as a 2D layer. Because the rocket was so far away from the talent, there was little need to build a true fully 3D rocket for this shot; however, we did render out a full pass of the rocket for the aerial shots (which were then composited in a similar way in After Effects).

The "News Scrapper" was a different story. It was a much more complex animation, in that we had numerous 3D elements extruding out to create the superstructure, and then a different set of objects creating the shell of the building. For this sequence we started with an animatic, a wireframe preview that gave us a good sense of timing. After that was agreed on we moved into more detail-oriented 3D work, the neon was added, as were the billboards, and the news tickers. All of this was then composited with a similar background plate used in the rocket composite. Most of the building remained backlit so we could add a few more details in After Effects, and the final render used a slew of subtle color corrections to punch the displays out from the building.

Tools 3D Studio Max, Cinema 4D, After Effects 7.0, Adobe CS 2

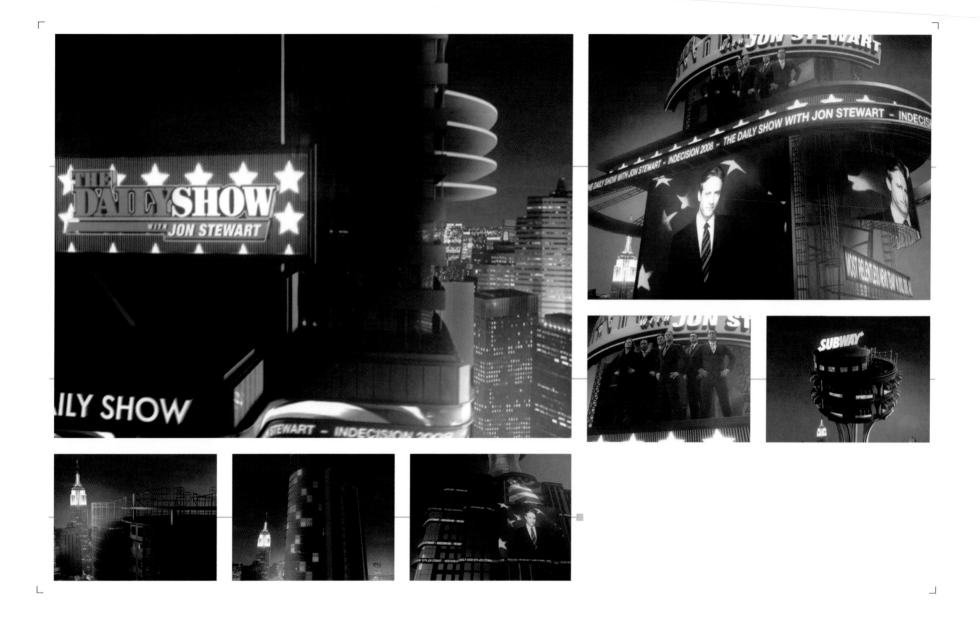

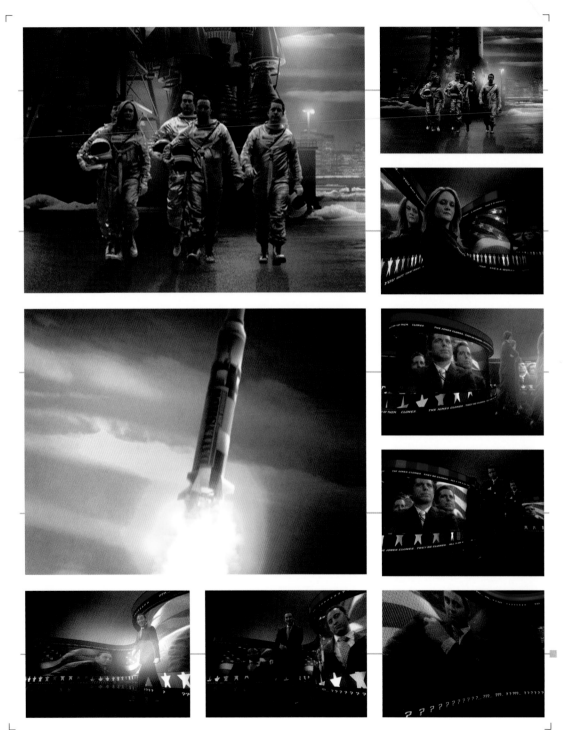

FLAUNT MAGAZINE AND DIESEL: 9TH ANNIVERSARY

Creative and Production Process *Flaunt* was a pet project of ours. We had a tight schedule—but creatively it was up to us to define for ourselves. We knew we wanted to mix mediums, from stop motion, cell, to fully realized 3D environments. We also knew that, because of the nature of the project, we were going to have many artists working on little pieces of the animation, which we would then need to assemble into a full piece. This way of working applied to the design as well; many different designers designed different vignettes that were all used in the final piece. In order to create a unifying look, we came up with a simple design restriction that helped us pull everything together: use torn pages from a *Flaunt* magazine for color and texture, and use Diesel models as subject matter. So if we needed the color blue for gasoline, we'd scour through *Flaunt*, tear out a blue page, scan it, and use the resulting texture for the gasoline.

We attacked the animation from a couple of different fronts. We made some keyframes that helped guide a team of cell animators working on the flame elements and the beginning/ending animations. While this was going on, we had 3D artists building models of stylized cars, complete with torn textures, gasoline pumps, buildings, and 3D pages of a 3D *Flaunt* magazine. These were all built in both 3D Studio Max and Cinema 4D, using .fbx as our medium between the two programs. We also had an artist photographing torn *Flaunt* pages that were taped with wire to allow them to bend and still hold their position. These became the basis for the stop motion tears. We had a light one-day shoot to get all the model photography in there—we opted for a more step frame animation for the talent, figuring that it would meld much more nicely with the largely stop motion environments. While all this was going on, we were blocking out timings and overall scenes in 3D and After Effects. At the very end we began to composite all of these elements together, sewing a complete piece from many little pieces of animation.

Tools 3D Studio Max, Cinema 4D, After Effects 7.0, Adobe CS 2

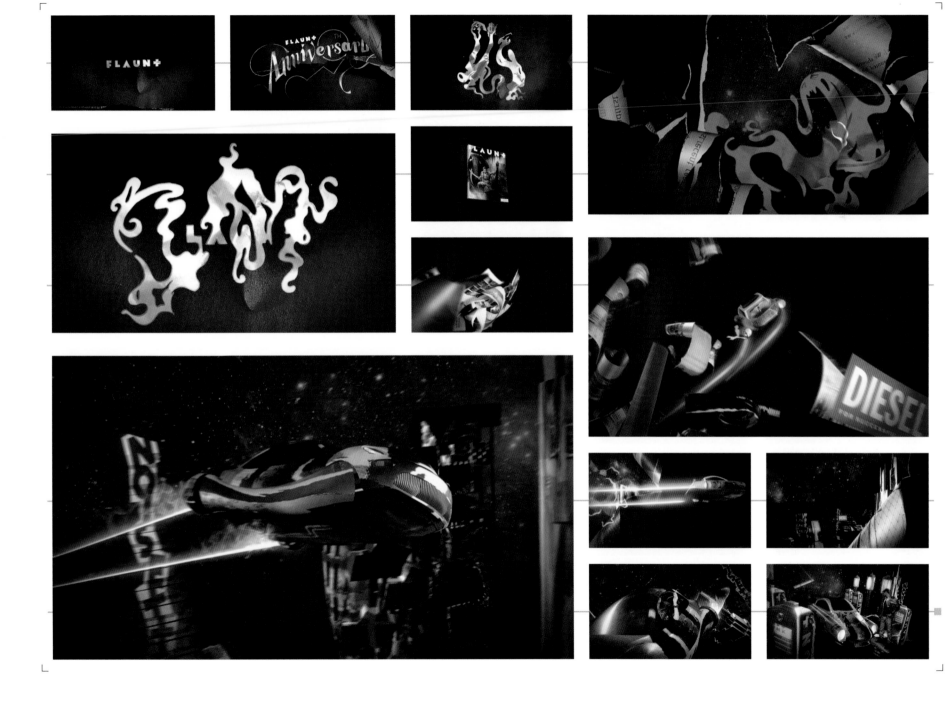

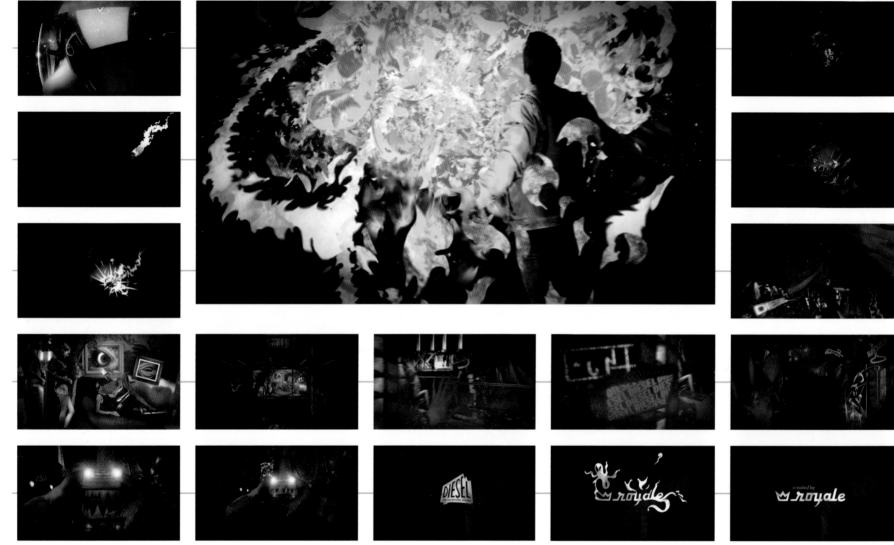

JET BLUE: "HAPPY JETTING"

Creative and Production Process JWT NYC had been building a design language for Jet Blue's "Happy Jetting" campaign before our involvement in the project. We were approached with print design and web mockups—but nothing was clearly set in broadcast, and that's where our assistance was in order. We used the existing print design as a jumping off point, and elaborated on it for the broadcast spot. After the initial design phase we began to track basic 3D text and ribbon animations to each shot, playing off of the motion

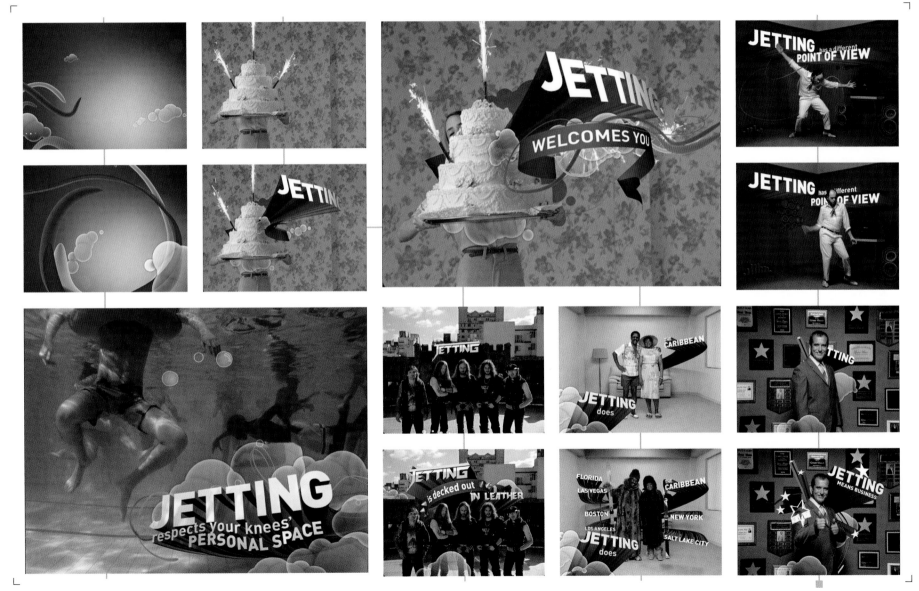

inherent in the movement of the shot. Most of the animation took place in Cinema 4D, with basic tracking of shots being done by hand with placeholder geometry. Take the initial cake shot, for example. We built a 3D cake (a series of cylinders, really) and tracked the motion of the cake and camera in 3D space. Once we had that roughed out we placed in the 3D animated text and ribbons and used the rough cake geometry as a matte object to make the ribbon feel like it was wrapping around the cake in the shot. This was done for just about every shot, some more complicated than others.

Apart from the 3D elements there were plenty of 2D elements built in After Effects. Background textures, stereo equalizers, hand-drawn elements, clouds—even the birds were all created as After Effects elements. We built a toolkit for ourselves of large pre-rendered elements that we could pull from to composite each scene. Final compositions were rendered from After Effects and implemented into the edit for final delivery.

Tools 3D Studio Max, Cinema 4D, After Effects 7.0, Adobe CS 2

MCDONALD'S BEST CHANCE MONOPOLY

Creative and Production Process McDonald's Best Chance Monopoly was a unique project in that it had to encompass many things. On the one hand you have McDonald's branding, golden arches with established red and yellow colors. And on the other, you have Monopoly, whose brand encompasses many strongly branded elements, and many individual colors as well. Not only did we need to merge these two brands together, but we needed to have the flexibility to include the branding of all the sponsors. The challenge was to maintain a clean sense of design and animation on one level, while showcasing each brand (which usually means making each logo as big as humanly possible without crossing title safe on all four sides).

Sponsor logos aside, the overall aesthetic of the spot was arrived at through some back and forth with the amazingly talented people at Leo Burnett UK. We all wanted something that felt tactile, felt real, and was a mixture of mediums—from cell, to stop motion, to full CG. To get the feel that we wanted, we opted to not build EVERY-THING in 3D, and instead we tapped into the talents of a model maker to build us miniature buildings, restaurants, and typography—all of which we photographed in sequence. These stop motion sequences became the backbones of our animations. From there we shot additional elements, from Monopoly pieces to cotton ball clouds, in the perspective of the particular shot. These elements were brought back into the After Effects composition and were layered with 3D elements and other 2D After Effects elements to create the final piece. The last and final touch was to add custom shadows to each scene. These were created in Photoshop as gradient layers and were brought into 3D space in After Effects and tracked to the motion of the hand-animated elements. These shadows are what grounds the animation, and are the most important part of making everything feel like it shares the same space.

Tools 3D Studio Max, Cinema 4D, After Effects 7.0, Adobe CS 2

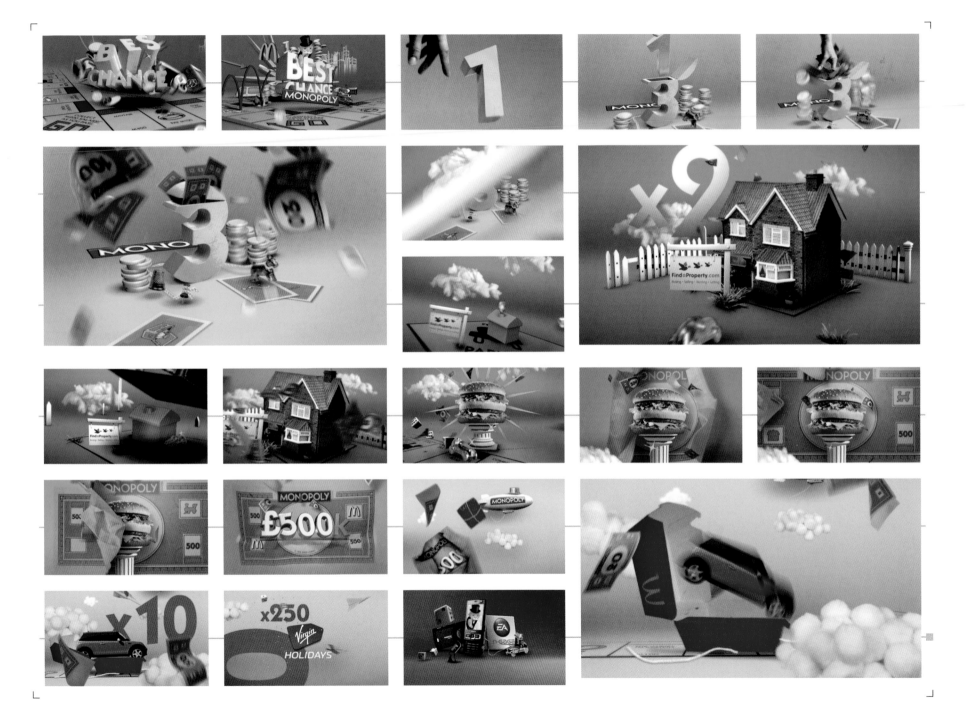

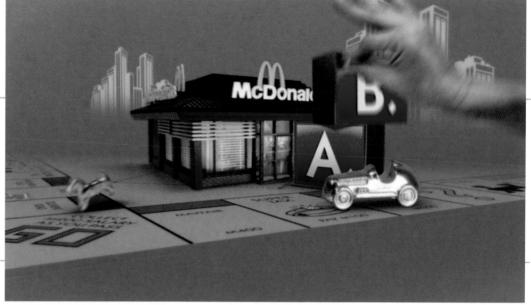

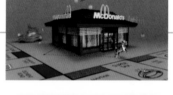

STUDIO PHILOSOPHY

adolescent are Man-Wai Cheung and Mina Muto. This New York-based image and animation collective is all about exploring new and exciting ideas; neither trends nor borders dictate their work. They have a very genuine approach in their work ethic; they are fascinated and stimulated by the world around them. adolescent is a multidisciplinary design studio based in New York City, with an international presence. They design and direct for motion, print, and brand content for broadcast, entertainment, and music organizations. They pride themselves on their unique, thought-provoking ideas and are all about exploring new and dynamic concepts. Some of their recent works include *New York Times, W Magazine*, Kids' Choice Awards, MTV Movie Awards, PUMA, Cartoon Network, Sci-Fi/Virgin, and HBO.

PEAK

Creative and Production Process In our everyday working life, we have frustrations about being creative. adolescent wanted to tell a story while creating a signature piece to show the obstacles that we go through on the way to the top of the heap.

We simply wanted to visualize this, and the best way was to create a story of someone trying to make it to the PEAK, going through crazy obstacles while getting there. We decided to create a fun mixed media animation with 3D/2D graphics and photographic elements. We first thought of making a character, focusing for a few days on sketching and designing it. Style frames and loose narrative were created.

We picked the best one out of almost 20 ideas, and started to build a set in our studio. Building the set took us about two days. We started by creating an obstacle course out of random objects found around the studio such as books, paper, rubber gloves, and fruits. Step by step, we shot stop-motion photography of our character's journey. We followed the character over treacherous mountains, through crocodile-infested water, and over a waterfall to near death, eventually climbing to the top of a sugar cube mountain and meeting like-minded friends and enemies.

We shot the set with a digital SLR still camera in high-res and then storyboarded it out in Adobe Photoshop, integrating the characters and obstacles together. This was then brought into Adobe After Effects to create the basic animatics to get the timing and pacing for the animation. Further shots and storyboard frames were created to help with the flow of the narrative. We continued developing the animatic until the edit was firmed and completed with final design. We composited in Adobe After Effects.

Once we locked down basic animation, we started working on 3D character animation in Maya. Tracking and rotoscoping the environment were done in Adobe After Effects. As we started animating, we were also adding more interesting "obstacle" ideas such as other enemies, so the piece was also evolving. Once we got closer to the end, we started working on audio. Since we had to find time to work on it on and off, the whole process spanned almost four months, but we are very happy with the results and hope people can get inspired and relate to it!

Tools Illustrator, Photoshop, After Effects, Maya

Credits
Creative Director/Director: Man-Wai Cheung,
 Mina Muto
Design/Animation: Simon Benjamin,
 Shu-Han Yang, Kenny Yee, Radhames Mora
Executive Producer: Monique Robertson
Audio: Cypheraudio

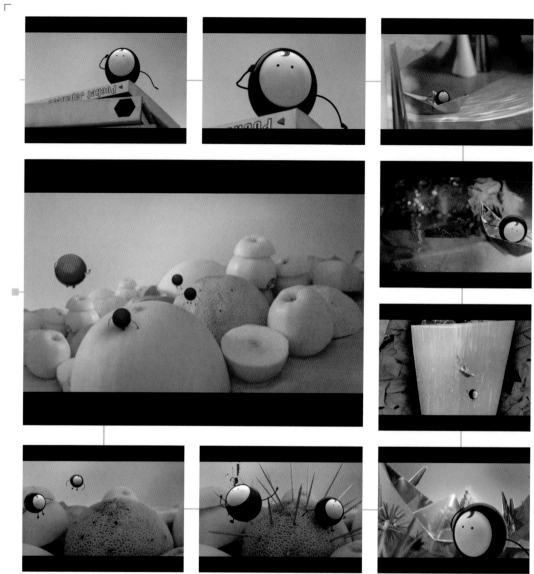

THAT 70's SHOW

Creative and Production Process adolescent designed, co-directed, and produced these live action spots, shot at Silver Cup Studio in New York. Through a series of traveling mattes, adolescent integrated the talents' actions with graphics and clips from the show. We transition from "real" scenes to "t-shirt" scenes: teens are hanging out together, doing what they do, while clips from the show play on their t-shirts. The smooth integration of the graphics gives a smart nod to '70s glittery, iron-on t-shirt designs. The setting is minimalist and clean, foregrounding the people and the colorful etch-a-sketchy graphics that connect them. Viewers' attention moves effortlessly from the real-time young people to the characters depicted on their t-shirts. The flow of action from the contemporary teens to the characters reflects the relaxed, lazy-dazey, and funny feel of the show as well as a stylish appreciation for witty vintage t-shirts.

The t-shirts and the environments were designed in Adobe Illustrator and Photoshop and then composited in Adobe After Effects with the live action.

Tools Illustrator, Photoshop, After Effects, Maya

Credits

Creative Director/Director: Man-Wai Cheung, Mina Muto
Design/Animation: Sam Feske, Simon Benjamin, Kenny Yee, Shu-Han Yang, Radhames Mora
Executive Producer: Monique Robertson

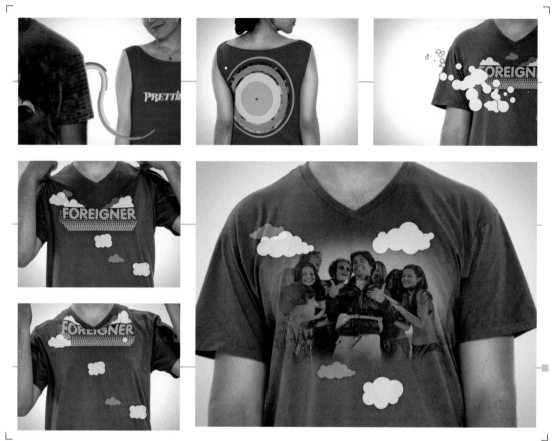

STUDIO PHILOSOPHY

Freestyle Collective is a collaborative design and production studio recognized for its distinctive artistic sensibility. Specializing in exploratory and innovative design, Freestyle Collective delivers creative advertising and branding solutions to a broad range of commercial, broadcast, and corporate clients. At Freestyle Collective, we believe that great design is born from observation. To that end, we're more than designers. We're illustrators, photographers, painters, filmmakers, collectors, curators, and storytellers who want to tell your story. Ultimately, the Freestyle Collective experience is defined by the collaborative process we share with our partners, and by our dedication to maintaining an environment where inspired ideas manifest themselves through broadcast, print, web, and product design.

THE GOOD WITCH'S GARDEN

Creative and Production Process Freestyle Collective pitched Hallmark Channel and won the chance to do a promo for the premiere of their Hallmark Channel original production *The Good Witch's Garden*, the sequel to the popular original production *The Good Witch*. The result was a 30-second spot that combined 3D animation and a live shoot of the movie's star, Catherine Bell.

The movie is built around Cassie (Bell), who may or may not be a witch. Either way, she casts a charming spell over the people in the small town where she lives, and affects the lives of everyone she touches. The themes of home, magic, and change are what the spot captures, while communicating the basic story of the movie, based on a script provided by the client.

In the spot, Cassie is at the center of a series of highly stylized graphic vignettes that suggest settings from the movie. The scenes change around her, as if on a turntable, and she interacts with graphic elements as they move. The colors are rich and the look is fluid, feminine, and subtly magic, like the movie itself. The endpage transitions on over a bed of evening stars that suggest the tranquility of her small-town life.

Creating that sense of calm and magic took a tightly organized battle plan. After watching the first movie to get the backstory and a sense of the characters, the whole team read the script for the new movie, still in production, and began brainstorming.

From our brainstorming sessions we went into designing detailed storyboards. Our design incorporated a live action shoot, so we needed to have the talent's movements mapped out. Every detail of Catherine's movements and lighting needed to be relayed to the client and the Director of Photography. No detail could be left to chance.

We directed a greenscreen shoot in LA with Catherine Bell, and composited the footage into a 3D world generated by Freestyle Collective artists. Our 3D team played a huge part in making this project a success. They did a pre-vis and built the different environments for the spot. This aided in the detailed boards and with the shoot preparation.

After the shoot, the footage went back to New York and into Flame for matte cutting. Editing was done at low resolution in Final Cut Pro. The edited footage went into After Effects, where an artist composited it with the environments generated by the 3D animation team. Our client was kept in the

loop at every stage with style frames and motion tests—we believe it is very important that your client is your creative partner.

The finished composite was imported into Flame for final color correction. Subtle visual effects were added at this stage as well.

Tools Photoshop, After Effects, Maya

Credits
Producer/Writer: Chris Gattanella

Creative Director: Victor Newman
Director of Photography: Andrew Turman
Editor: Greg Slagle
Lead Designer: Arisu Kashimagi
Compositor: Gary Tam
3D Artists: Entae Kim, Christina Sodoti,
 Yong Ho Cho, Zsolt Derka, Victor Robeiri,
 Ekene Nwokeke
Flame: Aron Baxter
Producer: Tricia Chatterton
Executive Producer: Linda Powledge

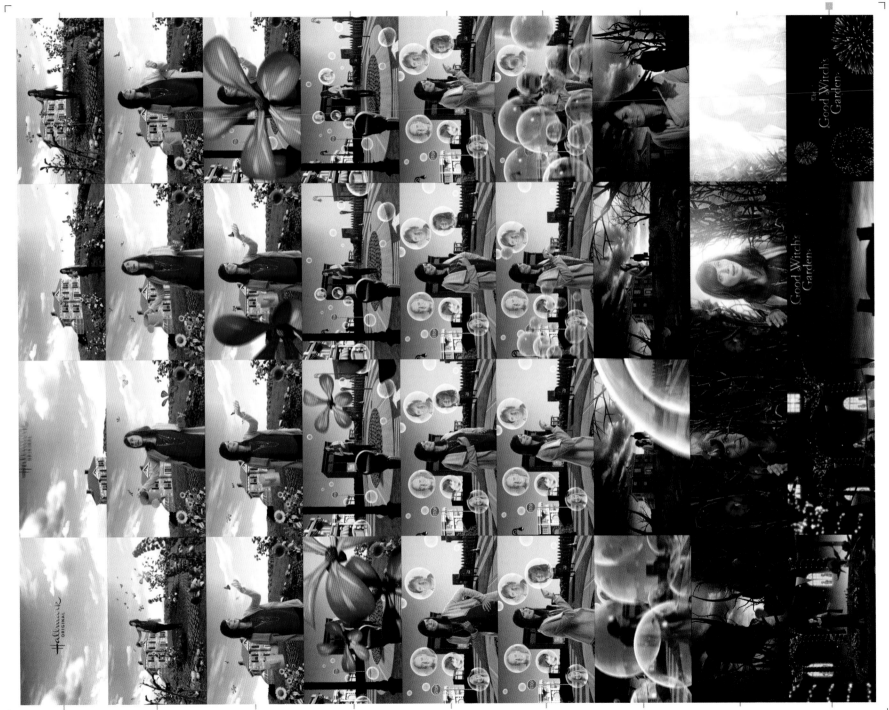

KUNG FU HD: CAT FIGHT

Creative and Production Process When VOOM approached us to collaborate on the launch of Kung Fu HD Network, our principal goal was to capture the excitement, drama, and energy of Asian action cinema. We decided to incorporate live action scenes with 2D and 3D HD animation. For the network ID sequences, we hired, choreographed, and filmed martial artists to capture their challenging acrobatics in HD. To bring a genuine martial arts action movie feel to the project, we shot certain fight scenes at high speed to achieve the desired slow-motion effect.

We chose the Panasonic VariCam. Footage was edited and mattes were cut from the select greenscreen footage to be used as silhouettes in the final composites. We used After Effects and Flame for the final compositing.

Tools Photoshop, After Effects, Maya, Flame, Final Cut Pro

Credits
Creative Director: Jason Bylan
Producer: Jana Morales
Creative Director: Victor Newman
Director of Photography: Andrew Turman
Designers: Gerald Soto, Ders Hallgren
Compositors: Gerald Soto, Ders Hallgren, Cassidy Gearhart, Paul Villacis
3D Artist: Entae Kim
Flame: Alex Catchpoole
Producer: Melissa August
Executive Producer: Suzanne Potashnick

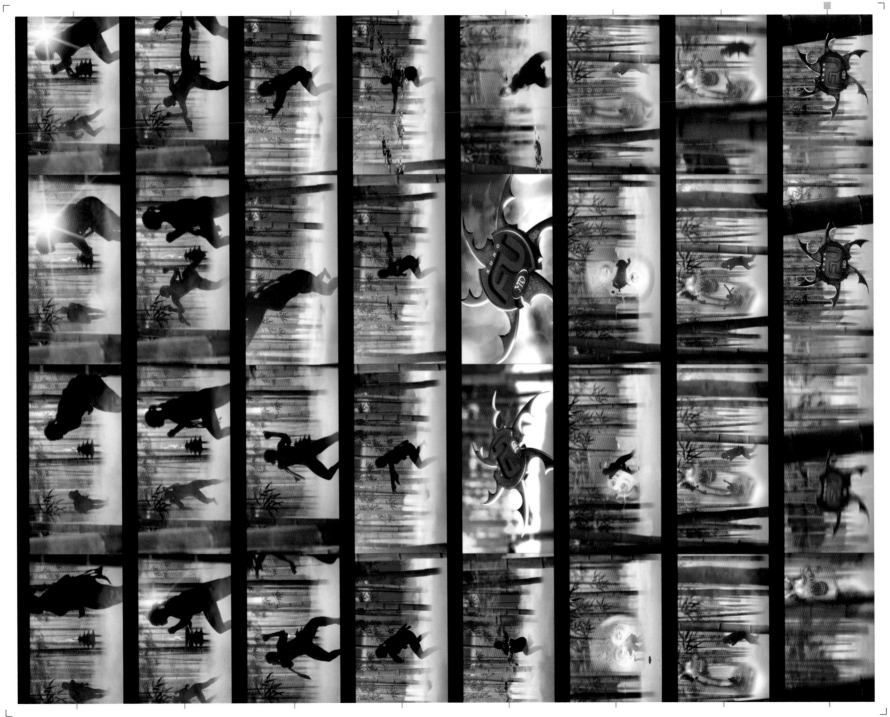

CRISS ANGEL: MINDFREAK

Creative and Production Process For the second season of the highly successful A&E series *Criss Angel, Mindfreak*, Freestyle Collective worked with the Glen Schubert Company to concept and execute the promotional campaign. In addition to running on air, these spots were also run in movie theaters as trailers.

Every part of the spot—the visual design, effects, set, editing, wardrobe, and makeup—was designed to achieve two goals: connect with Angel's younger audience and be true to Angel's lightning-quick, urban style of magic. The spot starts with a bang (literally an explosion that highlights the A&E logo) and then transitions to a dark, vaguely dangerous urban environment. Angel walks out of the fire, into the frame, and performs one of his famous card tricks to camera, asking the viewer to pick a card. He pops out the queen of hearts, holds it up to camera, and asks, "Is that your card?" In spite of the gritty set, the lighting on Angel is luminous, keeping all the visual focus on him as he does the trick. Flash frames and subtle, layered graphics give the spot an unpredictable energy and keep the viewer engaged and off balance.

As Angel finishes his illusion, the camera does several 360-degree turns around him, the alley spinning by in the background. Translucent graphic layers add depth and complexity to the move. A quick cut to extreme close-ups of Angel's eye metaphorically places him inside the viewer's mind. Then the camera does a split-second pan up the buildings for a frenetic transition to the endpage.

The endpage combines time-lapse footage and 3D graphics. It flickers and stutters in the gate, giving it a nervous energy. The Mindfreak logo flies out to reveal the A&E logo and then ends with a flash of cards and the URL. All the font is constantly in motion, adding to the dynamic feel of the spot.

We supervised the spot on a greenscreen stage and composited the footage into the dark alleyway setting. The 3D artists built the CG stage from scratch. Practical smoke elements heighten the surreal quality, pushing back the set and adding focus to the card trick. The endpage title animations were designed in Photoshop and animated in After Effects. The 3D scene, practical elements, color-corrected footage of Angel, and graphic animations were composited in Flame. The final touches, including the burst of fire and lens flare, were also added in Flame.

We had a blast on set with Mr. Mind Control himself. And yes, we did pick the right card.

Tools Photoshop, After Effects, Maya, Flame, Final Cut Pro

Credits

Director: Glen Schubert
Creative Director: Hoon Chong
Editor: Greg Slagle
Lead Designer/Compositor: Hoon Chong
3D Artists: Entae Kim, Christina Sodoti, Cedrick Gousse
Flame: Aron Baxter
Producer: Javier Gonzalez, Katie Boote
Executive Producer: Elizabeth Kiehner

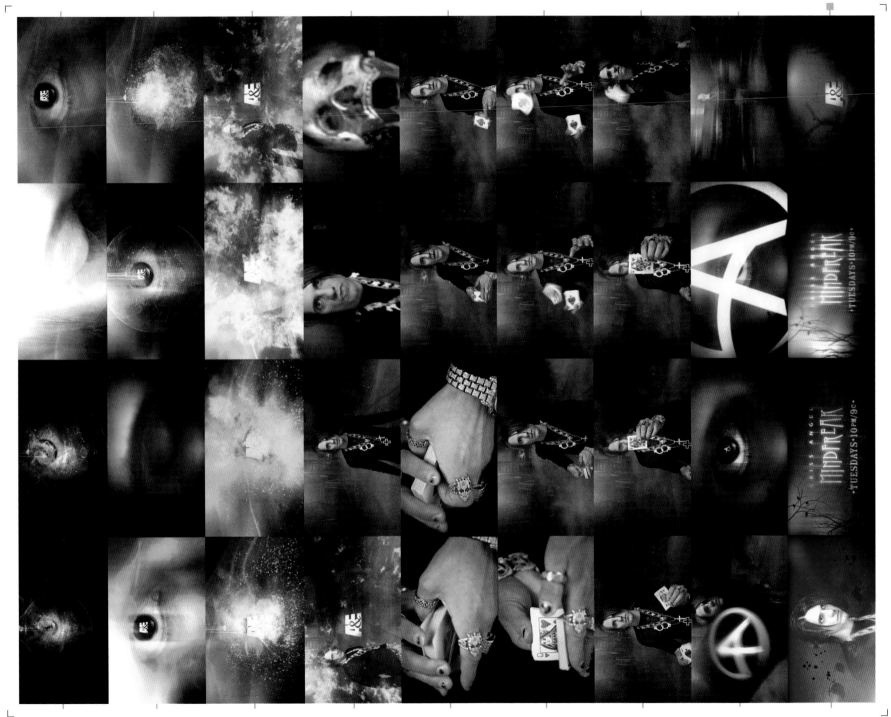

MTVK NETWORK LAUNCH: "LOKATION"

Creative and Production Process Freestyle Collective collaborated with MTV Network to launch MTVK, the first premium channel under the MTV World banner geared specifically toward young Korean-Americans. Like its intended audience, the MTVK network package is an eclectic one.

The provocative combinations of live action video, still photos, and vibrant animations evoke the young, cool lifestyle that has become synonymous with MTV culture. "Lokation," the featured spot, is a show open that speaks to the idea of a night out in the city. Specifically, we created an abstraction of Korea Town in New York City. To present an authentic look and feel for lighting and neon signs, we explored K-Town at night. We visited many restaurants, karaoke bars, and clubs, for research, of course. During our exploration, we shot several hi-res photos of practical elements to be used as background environments in our animation. The next phase of our production was a greenscreen shoot. Using a viper HD camera, we shot young Korean hipsters to populate the "Lokation" world. To complete the project, all the elements were composited using After Effects. Shooting in HD gave us a lot of flexibility in the compositing phase. After a lot of karaoke and japchae we completed a great network launch.

Tools Photoshop, Illustrator, After Effects, Final Cut Pro

Credits
Producer: Lem Lopez
Director: Hoon Chong
Director of Photography: Joe Botazzi
Creative Director: Hoon Chong
Lead Designer/Compositor: Hoon Chong
Producer: Beth Vogt
Executive Producer: Suzanne Potashnick

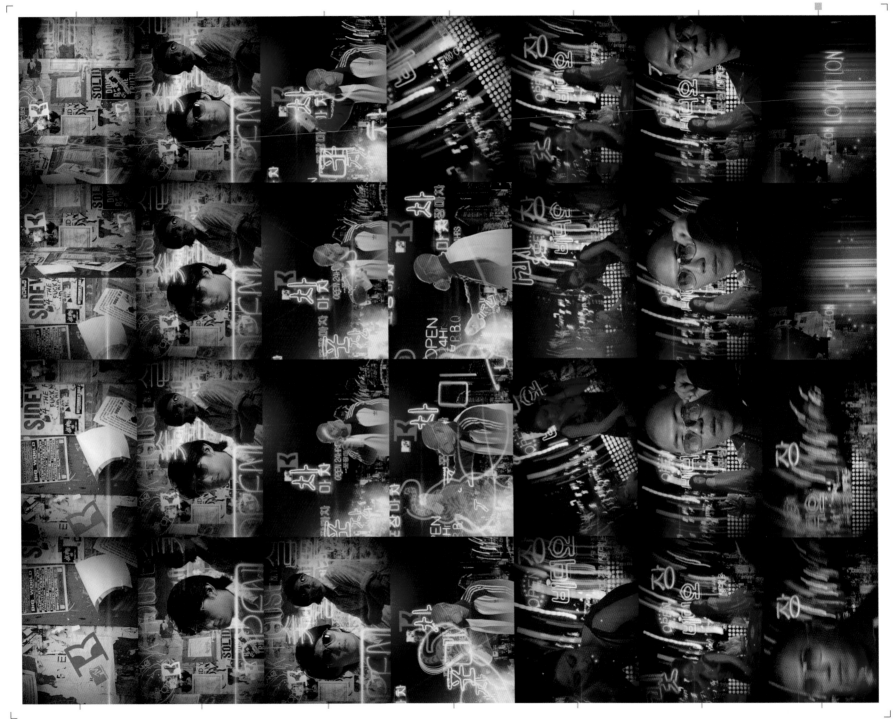

STUDIO PHILOSOPHY

Troika Design Group is an award-winning design agency based in Hollywood, CA. Catering to clients in media and entertainment since 2001, Troika engineers large-scale brand campaigns notable for their innovative design, writing, and high-end production values. A team of more than 25 designers, producers, 3D and 2D animators, and effects artists, editors, and conceptual thinkers work from Troika's state-of-the-art studios for clients including ABC, ESPN, TNT, Starz, FOX, the CW, NBC Sports, Oxygen, truTV, Animal Planet, HGTV, and the Golf Channel. Capabilities include end-to-end live action and digital production, from conceptualization through to final delivery.

GOLIATH: SPORTSCENTER REBRAND

Creative and Production Process In 2004 Troika created an identity package for ESPN's flagship SportsCenter show as it went into high definition. Four years later we were asked to refresh the package concurrent with the launch of a West Coast SportsCenter studio and show in

Los Angeles. This was a unique opportunity to take an existing design to new heights that couldn't have been imagined earlier.

Evolving from our original "Revolution" 3D sports turbine concept, we introduced GOLIATH, a hi-tech, futuristic sports-machine world with beyond-imagination-scale and deeply detailed turbine elements. Our concept was a prequel to "Revolution," taking viewers on a warp-speed journey from the birth of the fiery, liquid-hot, red "sports sphere" that lives at the heart of the SportsCenter logo to the moment of impact at the logo's resolve. This immersive journey catapults sports fans from the massive download center "Base Camp" through a three-tiered world of activating turbine rings and video screens showcasing clips, straight into the set with an intense energy that is uniquely SportsCenter.

While our goal was to bring colossal scale to the SportsCenter identity, GOLIATH also had to be user-friendly. In addition to creating many final animations for ESPN, we also needed to provide them with working elements, which we call a toolkit, that will be utilized by their internal team

to meet the ongoing needs and the extreme production demands of a daily nine-hour block of high-profile, live television programming.

Thus, our true innovation was building the expansive, multi-dimensional world of GOLIATH to perform as a 3D virtual set, allowing the ESPN team to use the model as delivered with all lighting, textures, and materials in place, or simply rearrange, scale, or combine any elements to create new staging areas with unlimited possibilities. It became a living toolkit and creative philosophy: composed of design and animation elements, delivered as project files, and built with the ultimate level of artistic flexibility and production efficiency.

GOLIATH wasn't "built in a day"; in fact, it took multiple sketch 2D and 3D teams months to realize its massive, overscaled world. Concept artists created initial development boards and rendered pencil-sketched frames to inspire 2D vector line work for the toolkit of turbine rings, logo elements, and environment components.

Our creative teams designed and modeled hundreds of individual components, each engi-

neered with unique functions and performance. Every element had to be independently successful while also able to combine or lock together, like puzzle pieces, to create the full GOLIATH environment. Several artists worked across dual Maya and C4D platforms during this phase, which was technically challenging but had successful results.

Mood boards and style frames were then created in Photoshop along with motion development in Maya and C4D to model elements for pre-visualizations. Rough Maya and/or C4D animatics established motion blocking for storyline development or elements, while Final Cut Pro handled editing. Once animatics were approved, we refined the environment architecture, texturing, and initial lighting pass. Each element went into final lighting passes out of 3D and into After Effects for compositing and finishing.

And because we were using multiple 3D platforms with Maya as the primary, we had to create a workflow that would maintain continuity among software. Models were exchanged by exporting FBX formats, and lighting, rigs, materials, and texture maps were reapplied and tweaked to achieve an eye match for most of the dual setups.

With creative and production teams totaling 20 people, we had 12 weeks from approved design to delivery, which included all final 3D project files prepared for seamless handoff to ESPN on all requested platforms: Autodesk Maya, Maxon C4D, VIZRT, and the standard Adobe Suite of After Effects, Photoshop, and Illustrator software.

Tools Maya 2008 Unlimited Service Pack 1 (64-bit version for Windows XP rendering), Cinema 4D version 10.5, After Effects CS3 version 8.0.2.27

Credits
Executive Creative Director/Partner:
 Dan Pappalardo
President/Partner: Chuck Carey
Creative Director: Gilbert Haslam
Executive Producer: Kristen Olsen
Producer: Claudina Mercado
Animators: Cory Strassburger,
 Mark McConnell, Jim McDaniels,
 Marco Bacich
Designer/Animators: Craig Stouffer,
 Ming Hsiung, Maziar Majd, Everett Campbell,
 Nick DiNapoli
Producer: Beth Elder
Design Assistant: Mindy Park

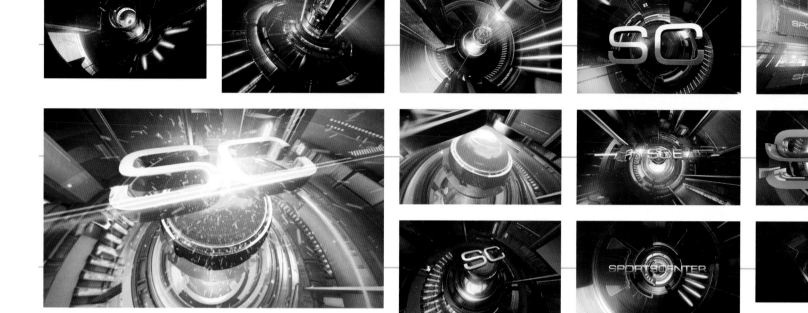

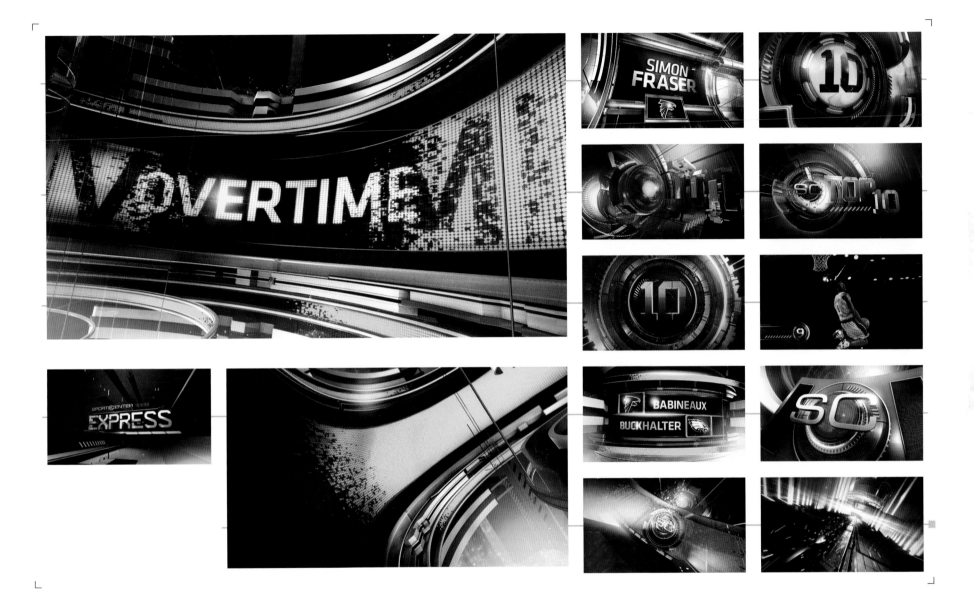

ABC

Creative and Production Process To promote the fall launch of ABC's 2008/09 season, we created a series of 30- and 60-second spots in a brand campaign that features the network's many memorable stars and personalities and represents a contemporary version of the big, feel-good, celebratory TV network promotions of a generation ago. The campaign brought together over 80 of ABC's top talent using a combination of live action, CG environments, and digital compositing.

The spots create a seamless visual journey through the many stories, characters, and personalities on ABC. A consistent camera move was used throughout every scene as a unifying device. The camera pulls back in space to reveal one iconic show environment after another while introducing an endless stream of ABC stars.

The notable lineup of stars included Donald Sutherland, William Shatner, James Spader, Eva Longoria-Parker, Felicity Huffman, Marcia Cross, Matthew Fox, Kate Walsh, Sally Field, Jimmy Kimmel, Patrick Dempsey, Sandra Oh, and Christina Applegate. We created nine spots in all, each featuring a different group of shows. For example, one spot focuses on primetime hits while another combined the full scope of programming on ABC, including primetime, daytime, late night, and ABC News.

The sheer number of talent was daunting. The project required eight days of shooting to accommodate the primary cast members from all of ABC's top shows, each of whom was on a different production schedule and filming in a variety of locations around the country. To accommodate their schedules, ensemble cast members were often filmed at different times, requiring additional compositing in postproduction to make it appear as if the entire cast were together.

We shot 35 mm film on greenscreen over the course of six weeks on stages in Los Angeles and New York. The seamless camera move was created using a 50-foot Technocrane, which enabled us to travel the camera very quickly and accurately over a significant distance. It was necessary to capture each scene in a brief two- to four-second shot with the camera operator and the talent hitting their marks at the exact right moment. This was tricky, and we were working within a limited block of time with each of the stars.

Motion control was an option, but the pace of the shoot, with a schedule of up to six show casts in a day, made the extended setup time impractical. Instead, we opted for speed on set, in which time with the stars is precious. This left us with a considerable task in postproduction, as practically every star had to be tracked and animated by hand to construct the scenes.

To further complicate things, the spots could not be built as complete linear pieces. Editorial flexibility was critical, so each ABC show had to be built as an individual modular scene. Camera movement, action within the scene, and secondary CG elements were all used to create invisible transitions that allowed the shows to be arranged in any order while still flowing seamlessly from one to the next.

Pre-pro was essential to the process. We began with hand-drawn animatics and 3D motion tests to work out the structure of the spots, including the camera move linking all the modular scenes together. We then composited rough versions of each scene for blocking purposes prior to shooting, using a combination of existing footage and pencil drawings. The composite scenes were updated with actual footage as it became available, which provided us with the most accurate reference for shooting any remaining talent.

The main scene compositing was achieved in Autodesk Flame over a nine-week, 24/7 schedule. All editorial and final compositing was done in Apple Final Cut Pro and Adobe After Effects. The entire process from conception to completion spanned seven months and involved a design and production team of over 50 people.

Tools Maya 2008, After Effects CS3 version 8.0.2.27, Final Cut Pro version 6 [w/Twixtor], Autodesk – Flame [with Sapphire plug-ins], PF Tracker, Adobe PhotoShop CS3

Credits

Executive Creative Director: Dan Pappalardo
Executive Producer: Kristen Olsen
Producers: Chris Gernon, Kelley McDermott, Jess Ferguson
Designer/Art Director: Earl Jenshus
Coordinator: Christopher Belanger
Editor: Chris Gernon
Flame/Compositors: Jeff Heusser, Maribeth Emigh, Andy Edwards, Matt Trivan
3D Animators/CG Artists: Jason Mortimer, Cory Strassburger, Candida Nunez, Adrian Dimond, Jeff Sargeant
Animators: Jun Kim, Jim McDaniels
Tracker: Michael Moorehouse
Assistant Editor: Marisol McIlvain
2nd Assistant Editor: Jeff Hayford
Storyboard Artists: Chad Glass, Kaz Mayeda, Elizabeth Colomba

STUDIO PHILOSOPHY

Trollbäck + Company, a New York—based creative studio, weaves compelling narratives using motion graphics and live action to create innovative campaigns for the advertising, broadcast, and entertainment industries.

Led by Creative Directors Jakob Trollbäck and Joe Wright, Trollbäck + Company has produced content across the broadcast, print, and interactive mediums. Whether rebranding a TV network or designing the title sequence for a film, what remains constant is the belief in immersive storytelling—the idea that a focused, compelling message is essential for successful communication.

ESPNEWS STEPS TO CREATION

Creative and Production Process When ESPN approached our studio, the network had already developed the message for its on-air brand: ESPNews is the center for a vast amount of sports data, coverage, and information that is updated continuously and available at all times.

Conceptually, we focused on the most basic aspects of sports: speed, movement, and emotion. In sports, every movement generates new data and new statistics. This information changes constantly, and always remains in a state of flux.

Visually, we utilized the notion of light trails to convey the speed and movement of both the action and the data it generates. Each motion leaves a trail that looks like light waves from a distance. As we get closer, we realize that rather than photons, the waves are composed of bits of data. To show the emotional aspects of these sporting instances, we decided to juxtapose these energetic bursts of light with still moments, namely, what the athlete thinks just before a play happens.

From a technical point of view, we can break down the project into three parts.

The first part is footage. Since all data is generated by motion, we knew that this was going to be a footage-heavy package. ESPN supplied us hours of sports footage for our disposal. The use of genuine sports footage had its pros and cons. While it gave us real action that could not be faked, say, in a greenscreen shoot, it also meant that we would have to rotoscope the footage and figure out a way to stylize it. We would prepare montages of our selects in Final Cut Pro and send it to ESPN for approval on a daily basis. Once we had approval for the shots, we would start with rotoscoping the athletes in After Effects. If it was a prop-based sport such as football or baseball, we always isolated the prop separately, as it would either be replaced by a CG ball or was used by itself as a source of the light trails. Since the main aspect of the package is light trails, the environment and the athletes had to be dark to provide contrast for the lights. Once the footage was rotoscoped, we had a lot of flexibility in that regard. By playing with levels, overlays of color, and desaturation we could get an approximation of the look. At the final compositing stage, when we combined the footage with the light elements and background, we did another pass of overall color correction and lighting. One good trick we discovered in our research and development phase was in faking a backlit look. By blurring the alpha channel of the footage and using it as a luma matte for itself we realized we could achieve such

a look. We masked different parts to have control of the amount of light that was reaching the edge and the interior parts of the shot.

The second part was representing the thoughts of the athletes. Play diagrams, sports terminology, arrows, paths of possible plays, and various abbreviations represented the mental preparation of the athlete before the action. These were perfect for setting the mood and creating anticipation for the scenes that we utilized in the promos. We designed these 2D visuals in Illustrator as separate layers and brought them into After Effects to convert these layers into 3D layers. This gave us the ability to play with depth of field to convey a sense of order for these thoughts. These visuals were then tracked to the athlete using the After Effects tracker.

The third part was the particles that form the light trails and the data. As our particle generator, we used Trapcode Particular for its flexibility of controls, its ability to integrate into After Effects' 3D engine, and its 32-bit rendering capabilities. Since the package had a contrast of light and dark and these lights overlapped to create even brighter areas on the screen, our After Effects projects were set to 32-bit to have as much overhead space in the brights and to avoid banding problems that are very common in 8-bit contrasting material. We used After Effects 3D lights as particle emitters. These lights were turned off and acted merely as Nulls that were animated in 3D space, providing position information for Particular. One advantage of using lights was that we could push the limits of where this positional information came from. For example, for a baseball generating these particles through its motion, we modeled the ball in Cinema 4D and placed the lights among the seams of the ball. Once this was animated along the path of, for instance, a curveball, we could then export this project and all the 3D data into After Effects and get the 3D positional data of these lights. Applied to the emitters in Particular, the results from this information were simply beautiful: spiral-shaped intricate trails that communicated the complexity and elegance of the motion of a baseball pitched in a certain way.

We had two main particle systems: one for the light trails and one for the bits of data. The light trails were created by using a custom particle that slowly evolved its amorphous shape in time. The emitter would emit these particles with zero velocity, thus marking its place in space and time. For various effects, we used turbulence and other physics simulations that are available with Particular.

The bits of data had two uses in the package. First, as the light trails were fading out in time, they would turn in to streams of data. Second, any time an impact happened, the result would be an energetic burst of this data. Again, we created our custom particles for this purpose. In a small composition of roughly 300–400 frames, we had numbers, stats, abbreviations, etc. In this composition, on each frame only one bit of information was visible, hence creating an instance of a particle in each frame. In Particular, we used this comp as our custom particle source from which we pulled a random frame for each particle. Therefore, we had hundreds of different data emitted any time this particle system was used. This system was applied to different physical situations. For the inside of light trails, they'd be emitted using the same source, but would emerge slowly later in the lifetime of the trail. For impact, we would use these particles with higher velocity emitters with various qualities, such as emitters that generated particles in a disc form, in multiple directions, or spherical shapes to add volume.

We did our final compositing in After Effects as well. All of these elements were brought together in a 32-bit composition and we added several effects such as glow, depth of field, and color correction to give the final touches. The package was rendered in 1080 HD at 59.94 fps and SD in 29.97 for two different broadcast specs. Of course, like all network redesigns, we created hundreds of smaller elements, such as transitions, bumpers, and lower thirds with fill and matte passes. Especially since these elements were then overlaid on sports footage by ESPN on air, we cannot stress enough the importance of working in 32-bit and its wider range of provided color information, especially in the full glory of HD broadcast.

Tools Adobe After Effects, Adobe Illustrator, Final Cut Pro, Cinema 4D, Particular, Maya, Photoshop

Credits
VP Creative Services: Rick Paiva
Creative Director: David Saphirstein
Senior Art Director: Wayne Elliott
Creative Directors: Jakob Trollbäck, Joe Wright
Assistant Creative Director: Matthew Tragesser
Designers: Tetsuro Mise, Tolga Yildiz,
 Paul Schlacter, Lloyd Alvarez, Dan Degloria
Animators: Lloyd Alvarez, Dan Degloria, Lu Liu,
 Fu-Chun Chu, Peter Alfano
Producer: Danielle Amaral
Executive Producer: Marisa Fiechter

STUDIO PHILOSOPHY

With a strong belief that great art derives from making bold creative choices and sticking to them, Creative Director Michael Waldron and Director of Animation + Editorial Erik van der Wilden launched creative design/production studio nailgun* (www .nailgun.tv) in 2003. Since then the multiple BDA Gold-winning creative shop has been pushing boundaries and exceeding client goals with standout work for top advertising agencies and broadcast networks. Recent clients include such companies as NBC/Universal, FOX, HGTV, ESPN, National Geographic, TV Land Crispin, Porter + Bogusky, Publicis, McCann-Erickson, and Ogilvy & Mather.

UNIVERSAL CHANNEL REDESIGN

Creative and Production Process With a strong live action narrative that abstractly recalls such classic films as *Rear Window* and *The Conversation*, nailgun* created the comprehensive HD redesign of Universal Channel, the NBC Universal–owned network seen by millions throughout Latin America. The redesign included network IDs, bumpers, menus, promo templates, specialized movie animation opens/interstitials, and more, all produced in HD, and focused on the network's character-driven programming.

"Universal is an iconic brand that has been around for a long time, and Universal Channel is one of the top networks in Latin America, so they've obviously been doing some things well in terms of their branding," says Michael Waldron, nailgun*'s Creative Director. "While we wanted to revitalize the network's look and feel, we didn't want to mess with what was working."

The Universal Channel's current branding featured two iconic elements that had worked well for them: a silhouette image of a man running and an urban landscape.

"They had some equity built up in those icons so we decided early on rather than reinvent the brand we would significantly refresh those icons to make them more modern and interesting," Waldron said. "We delved further into Universal's relationship with the cityscape and the mantra became 'Universal belongs to the city and the city belongs to Universal.' In terms of characters, the 'running man' is a great image because you don't know if he is chasing someone or being chased, whether he's a guilty man or one wrongly accused. It provides a lot of dramatic possibilities."

In the main IDs, short, suspenseful vignettes unfold amidst the new Universal cityscape. In one, a man emerges from a building carrying a briefcase only to be confronted by two police cruisers. Another depicts a man and woman in a passionate embrace, not suspecting they are being watched by a stranger through binoculars. Another shows a woman sharpening a knife while standing behind a man seated on a couch blithely reading a newspaper. The IDs end with the POV turning and pulling back to reveal a reflective glass cityscape bathed in a warm red light, and the familiar, yet completely modernized, Universal "globe" logo.

Tools Autodesk Maya, Adobe After Effects, Apple Shake

Credits

Creative Director + Live Action Director:
 Michael Waldron
Director of Animation + Editorial:
 Erik van der Wilden
Managing Director: Elena Olivares
Creative Director: Alex Moulton
Executive Producer: April Jaffe

SUNDANCE CHANNEL—"ONE PUNK UNDER GOD" PROMO CAMPAIGN

Creative and Production Process If you were around in the 1980s, then chances are you remember Jim and Tammy Faye Bakker. What you might not know is the former leaders of PTL Ministries had a son before prison and divorce parted them. Jay Bakker is now a minister in his own right with his very own church, known as the Revolution Church. He's also the subject of *One Punk, Under God: The Prodigal Son of Jim & Tammy Faye*, a six-part observational documentary on the Sundance Channel. nailgun* was called in to create the show's hip, provocative promo campaign.

"We basically did everything for the on-air promotion of the entire show," says Michael Waldron, nailgun* Creative Director. "We created the concept, wrote the scripts, directed the live action, and developed the overall look of a campaign that includes one main spot and several variations that will air after the show premieres. Sundance showed a lot of faith by giving us almost complete control to come up with ideas and follow them through. It was an amazing creative experience for everyone."

The nailgun* campaign cleverly sums up Bakker's turbulent life by asking, "If these were your parents, what would you do?" accompanied by a picture of the seemingly perfect family on an '80s era television set. From there, a picture of a young Jim and Tammy Faye becomes the centerpiece of a digitally animated stained glass window featuring one possible answer: "Love and stand by them." A second window reveals Jay as a boy and suggests he might "Follow in their footsteps." The camera dramatically zooms in before offering a third possibility: "Question all you've been taught, briefly self-destruct and turn religion on its head."

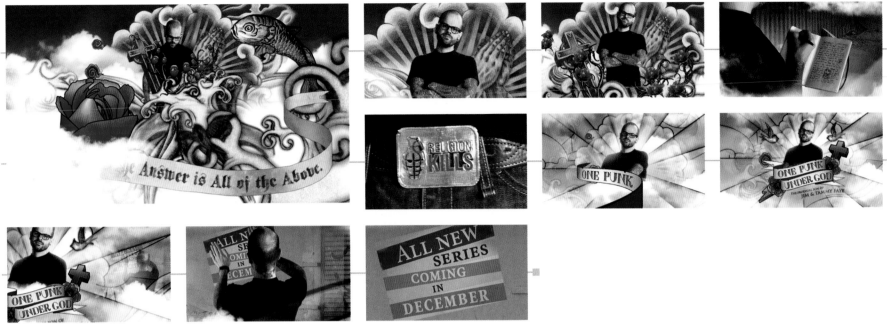

Suddenly the photo of Jay explodes, and the camera seemingly freefalls through animated clouds and a detailed array of religious imagery based on his own plentiful tattoos. The spot ends with Bakker crossing his arms defiantly before providing the correct answer: "All of the above." The last image we see is a shot of Jay against a warmly lit stained glass window with clouds and tattoo illustrations swirling around him.

Shot entirely in HD, the spot is visually striking —a dynamic collage of still photography, illustration, and digital animation that effectively paints a compelling portrait of Jay Bakker's past and where he is today.

Tools Autodesk Maya, Adobe After Effects, Apple Shake

Credits
Creative Director + Live Action Director:
 Michael Waldron
Director of Animation + Editorial:
 Erik van der Wilden
Managing Director: Elena Olivares

HGTV—*DESERVING DESIGN* WITH VERN YIP SHOW OPEN

Creative and Production Process HGTV's *Deserving Design*, hosted by designer Vern Yip, is a design show unlike any other. Each week Yip brings his talent and warm sense of humor to families in need and attempts to help them by improving their homes with his unique style. For nailgun*, the challenge was to create a show open/package that conveyed Yip's style and personality, and the overall tone of the show, in just 10 seconds.

"The idea with Vern is that he creates in a very natural way that is based on what the families featured on the show need, rather than any particular style of his own, and his unique ability to create something out of nothing," Michael Waldron, Creative Director at nailgun*, says.

The open begins with a live action shot of Yip holding out his hand, which holds a glowing orb of 3D animated yellow light. From that light springs a small animated goldfish and a gold-colored vine that quickly grows upward. More live footage of Yip is intercut with the animated vine growing and sprouting an array of interior design elements such as decorative lamps, throw pillows, and chairs. At the top of the vine, more warm yellow-colored flecks of light form the title of the show.

"We liked the idea of him putting his hand out and all of this life springing from it," Waldron adds.

"We wanted to show his personality and wanted the look of the open to reflect his overall philosophy about design, which is very organic."

Tools Autodesk Maya, Adobe After Effects, Apple Shake

Credits

Creative Director + Live Action Director:
 Michael Waldron
Director of Animation + Editorial:
 Erik van der Wilden
Managing Director: Elena Olivares

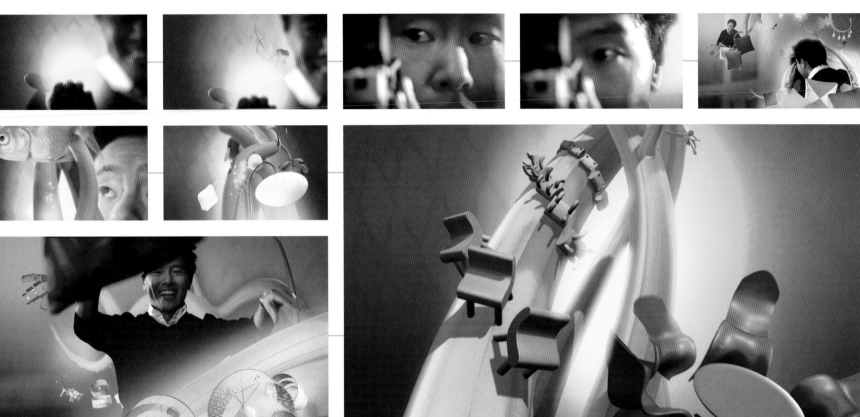
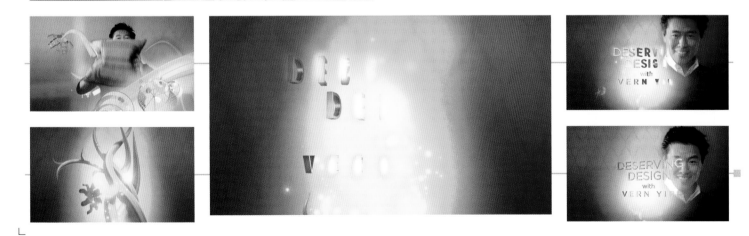

STUDIO PHILOSOPHY

Velvet is a design, studio, and film production company. Flexibility is essential to our philosophy in order to adapt to the specific needs, requirements, target audiences, and strategic objectives of each client. We create tailor-made designs and produce challenging commercials/movies by means of production, usability, and costs.

Matthias Zentner, Designer/Director, and Andrea Bednarz, Creative Director, founded Velvet in 1995 in Munich/Germany. They established Velvet in order to be able to further their complementary experience, shared passion for design and quality, and constant search for varied creative stimulus.

Rather than a company face and name, we see ourselves as a group of individuals each contributing his or her know-how and experience, interacting and united under a clear company mission: obsession, passion, a sense of humor, aesthetic values, and technology research.

In terms of methodology, we work within adaptable and highly skilled creative teams that cover all the stages from conception to fully fledged design. Each project changes the team constellation, redefining the use of designers, concept makers, creative directors, animators, 3D specialists, operators, directors, producers, editors, copywriters, musicians, and software developers.

This teamwork allows us to keep tight control during the creative process in all its phases and guarantees the quality of the design we strive for. Our goal is to find all-encompassing design solutions in order to implement the client's vision.

We coordinate concepts and storyboard layout, direction and production, editing and post. Our in-house technical equipment allows for a controlled, top-quality workflow from conception to completion. Along with direct personal contact with the client/agency, we also work actively through the Internet and our own ftp server to overcome the time differences and distances that sometimes exist.

GRAN CENTENARIO: THE CALLING

Creative and Production Process In the late 1800s, Lazaro Gallardo, a tavern owner and tequila producer, named his specially produced tequila Gran Centenario to mark the beginning of the new century and also the beginning of tequila sales at his tavern. Inspired by French art deco, the exquisite bottle deserved a new campaign to show the outstanding quality and the grand heritage of the product.

In the commercial, the Centenario angel summons an outstanding angel party with its powerful trumpet. A diner in the evening is the target of its call.

From a calm, normal evening atmosphere, with the sound of the trumpet comes a big blast, causing complete destruction of the diner. The pressure of the powerful sound causes tables, lamps, chairs, objects, and people to start to tremble and shake and, finally, fly through the air, drawn outside against all laws of gravity.

Only two characters, a man and a woman, stay calm and resist the power. They seem to recognize each other as different beings. Now alone, they move closer, transforming into dark angels with huge wings, flying off to their meeting point, still following the conspirative music.

It is the Centenario angel statue, calling all angels with her horn to a secret meeting, a wonderful, gentle angel made out of stone, coming to life and transforming into the angel on the label.

After weeks of precise planning, the shooting of the destructive diner scene took place in a huge film studio in Prague, leaving a taste of caducity behind. The mansion in the final scene was found on the outskirts of the city. The actual angel wings were built just for the main actors in Italy with a costume designer and sfx house. The Centenario angel was built out of leather, and in order to age the angel, body painting was used. To keep the leather in pleats, silicon was used to reinforce the stiffness, while still allowing her to move. The two main actors were wearing immovable rigged wings, which were attached to the costumes. All other angel wings were done in CGI. During the lengthy postproduction period, the integrity of the effects was naturally implemented. The actors had tracking sticks coming out of their backs in order to get the spatial tracking from their bodies. Feathers were individually photographed to get the same texture as the actual model.

The destruction scene was challenging due to the mix of real sfx and vfx. The more we could obtain on camera, the more credible the 3D effects were. All of the flying rigs (three in line) were built on set to make the lighting more credible, and a large number of explosions, rigging, lighting strikes, and dust fans were practically integrated into the real set, like a choreography of destruction. Many rigs were retouched on Shake later. The CGI artists had the challenge of working with the fast flickering light and the color changes.

The compositing used a combination of Shake and Flame. On Shake, a lot of retouching, masking, and rotoscoping was done, while on Flame, all the layers of plate shooting, CGI objects, and particle dynamics had to be brought together. My task was to give the whole commercial a magical look; like classic paintings, it should stay firmly in the audience's minds. "Made differently" is the claim of Gran Centenario, and this is exactly what the surprising plot of the commercial reveals: one glass of this tequila can evoke an impressive impact, not only on the liver.

Tools Shake, Flame

Credits
Director: Matthias Zentner
DOP: Torsten Lippstock
Editor: Jochen Kraus
VFX Supervisor: Abdelkareem Abonamus
Technical Directors: Daniel Stern, Tobias Ott
Artists: Yuta Shimitzu, Bastian Traunfellner,
 Adam Wesierski
Shake: Manu Voss, Christian Stanzel,
 Martin Tallosy, Christian Deister,
 Dagmar Ammon
Flame: Sylvie Roessler

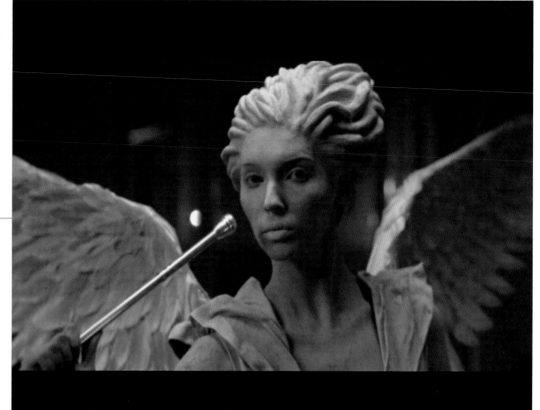

CLOROX: MERMAID

Creative and Production Process In this commercial, you are invited to dive into your bathtub and daydream underwater with a mermaid and her mermaid friends. You accompany the mermaid to her mermaid school: a place of happiness, a playground for other mermaids.

The shooting took place in Bucharest in an inside pool in a studio. The challenge was to construct the mermaid school and then to flood it. Everything needed to be done on camera, and CGI was needed to replace the girls' legs with CGI mermaid tails. The set was built underwater and the visibility needed to simulate deep water with particles and atmosphericals. I used a special underwater DOP, experienced with lighting underwater as if it were a normal stage. The next big task was to find girls the age of the young mermaids who were brave enough to dive underwater, keeping their eyes open, and without a scuba set, with safety divers nearby with air tanks.

After spending two days underwater myself for the casting, I found courageous, adventurous girls who were thrilled to dress like mermaids. We used green leggings with tracking marks for the later replacement of the legs.

The 3D relied on real fish texture and shadings; the challenge was to adapt the waist movement to the tail movement. We needed to retouch all the girls' legs, which were larger than the eventual mermaid tails.

The caustics and the behavior of the refraction were difficult to adapt to CGI in real surroundings. The ink effects were done on set; the bottles were moved with wires, which needed to be retouched later. The sponge fishes were inspired by the world above the water in the bathroom. I wanted to give hints of the real world behind the fantasy starting from the beginning of the story. The shaving brush worked as a jellyfish in the underwater world and found its place next to the basin in the real world. I shot both on wires, but underwater. The additional bubble layer, shot as extra plates in front of black, added a touch of credibility in the underwater shots.

When the rebel mermaid girl comes up in the bathtub, she needed to control her feet, as we had to enhance the tail coming out of the soapy water. The lighting of the tail with the shimmer of water was the next challenge. By studying a fish texture over the water, we decided to show the iridescent reflection and wet surface.

Tools Flame

Credits
Director: Matthias Zentner
DP: Stefan Von Borbeléy
Producer: Andras Rothenaicher
3D: Blackmountain, Stuttgart
Compositing and Flame: Sylvie Roessler,
 Lene Hoenigschmid
Rotoscope: Manuel Voss

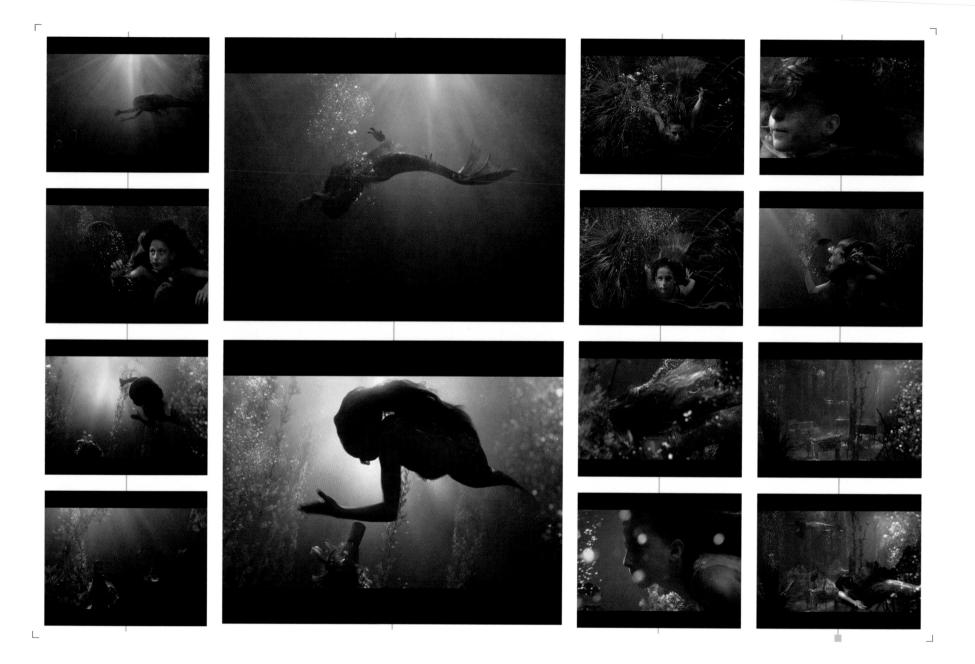

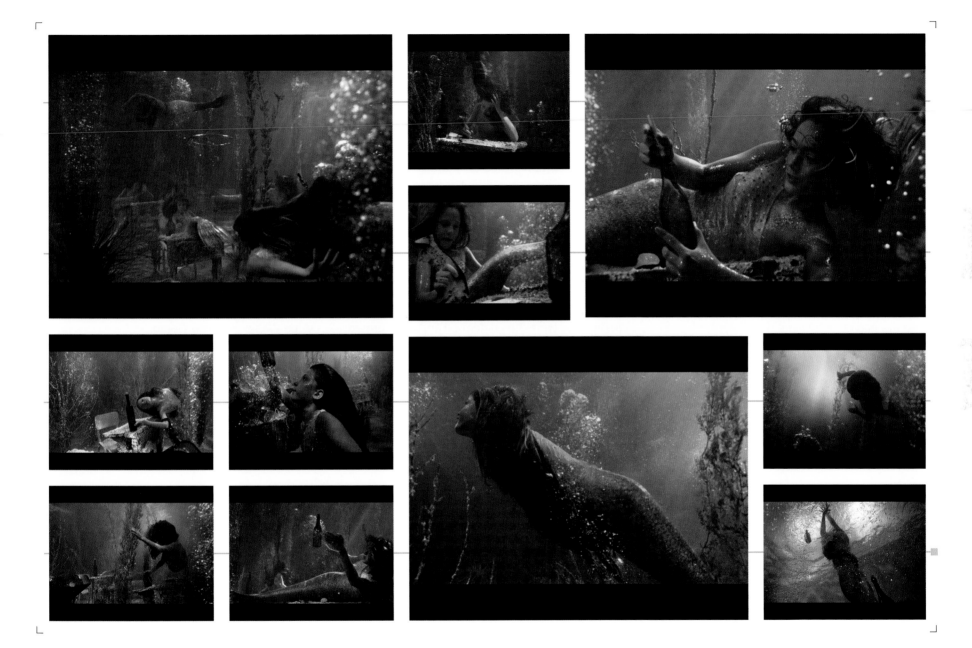

MATTONI: STAR (WATER DRESS)

Creative and Production Process For the new mineral water campaign for Mattoni, which is the largest producer of mineral spring water in the Czech Republic, the goal was to awaken the visual heritage of the 1930s into our modern age and film the whole commercial in a dandified Carlsbad of the Czech Republic.

"He wants some water!" whispers a waitress to a colleague, leaving him behind with an astonished face. This begins conspiratorial event of serving Mattoni water. Soon we watch the Czech supermodel Hana Soukupova arriving at the historical location.

Hana, originally born in Carlsbad, plays the personalized Mattoni water, serving "herself" to the thirsty and surprised customer. Her line "Would that be with bubbles or without?" brings humor into the enchanting visual world.

She bravely wore almost nothing on the set, with a water dress added later in the 3D process by the great team of Blackmountain and Velvet. The main challenge was finding a concept for the dress that gave it both a style and volatile, liquid properties. The research and development department experimented a lot until we had a behavior that was both naturally fluid and stylized enough to be recognized as a dress worthy of a top model.

For the creative process the designers wrote their own fluid simulation force in Maya, and by carefully using particle forces they were able to give them the shape of the dress. The designers then combined several passes of particles in Houdini, created a water surface, and rendered it out using an animated version of Hana as a holdout for reflections and refractions. The resulting particles were then deformed and transformed into liquid surfaces in Houdini and rendered in Houdini's mantra renderer, using the physically based mode. Additional splashes were done in real-flow. In order to get such a perfect adaptation to the model, we relied on a 3D body scan. In the compositing, real water layers were combined with the artistic 3D water in order to get additional realism in the behavior of the water.

Tools Maya, Houdini

Credits
Director: Matthias Zentner
DP: Torsten Lippstock
Editor: Jochen Kraus
Vfx Supervisor: Andreas Illenseer
TDs: Daniel Stern, Abdelkareem Abonamus
Artists: Enrico Seiler, Stephan Habel,
 Christian Mumba, Tobias Ott,
 Adam Wasierski, Nico Conte

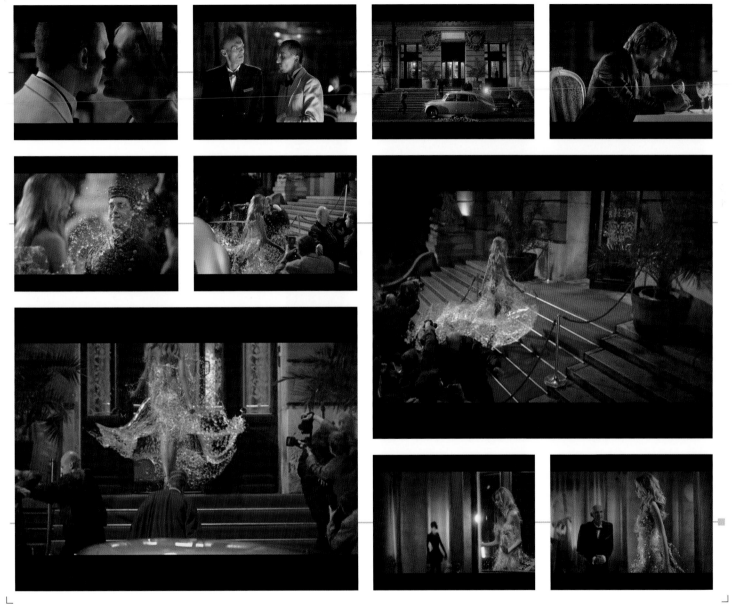

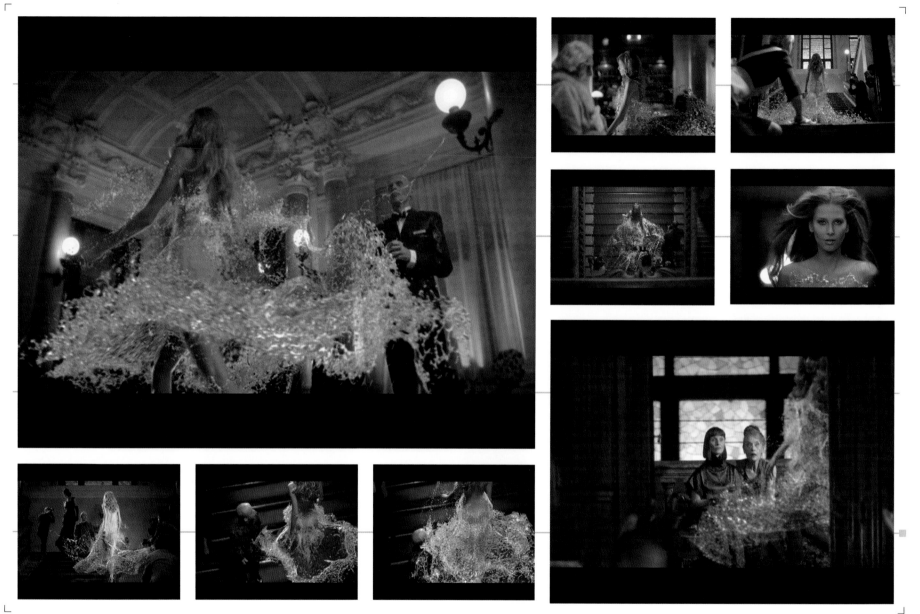

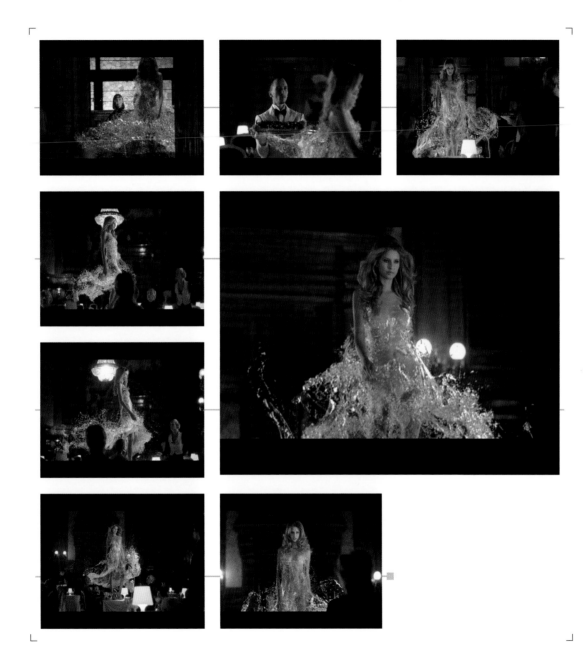

MERCEDES BENZ USA: RACE

Creative and Production Process I directed this commercial as a "branding" commercial for the USA market for Mercedes Benz USA. Visually it takes us back to late 1894 (the first known race in the history) and makes its way to the present. It reminds us that this race was won by Mercedes-Benz, but it also wants to tell us that the race against oneself is never over, not for Mercedes. So the simple plot idea was that one generation overtakes the previous generation.

The first challenge was to organize the vintage cars, which needed to be representative of each generation. Vintage cars were found in Germany in good shape. More complicated was the directive to implement the "silver arrow" of Mercedes, because the only one we had access to came from a museum and had no motor. We needed to use a tracking car for this portion. The classic 300 SL was found in Spain. The modern cars came from the United States, including the new SLK.

Then the choreography of the cars overtaking the curve had to be planned carefully. The only banking curve in condition enough to be restored was located in Northern Spain. The speed for the perfect curve needed to be 80 km/hour. If the driver went any faster, then he would go over the lip. If he went slower, he would automatically fall down the curve. The maneuver of overtaking in the curve was done by a specially trained driver with a racing background.

Everything was shot in real time on camera. For the old cars we shot partly undercranked, like in old times, with 18 fps. It is an adult fairytale, dipped in the full moon scenery, mysterious with a magical background. I decided to shoot this like day for night, as I wanted to achieve a good light on the car coming from the daylight. Then the sun had to be replaced by the full moon and reflection

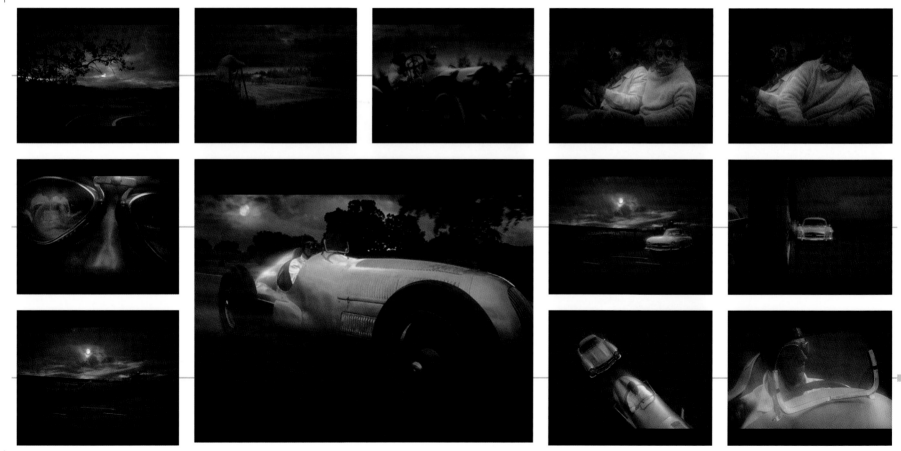

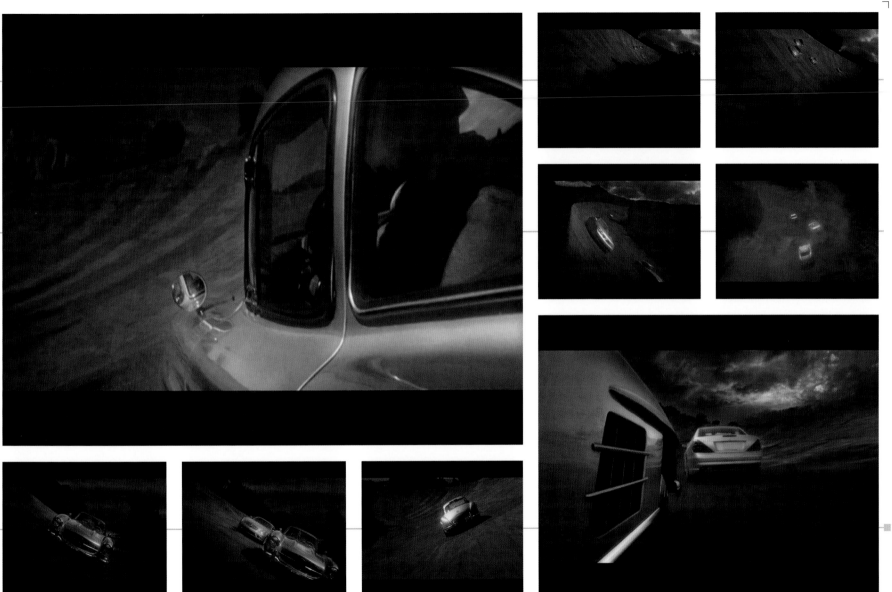

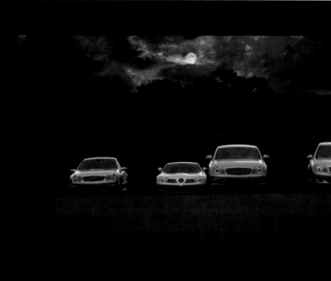

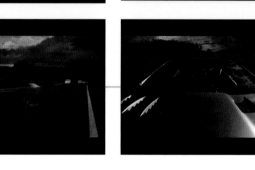

from the sun on the air needed to be retouched. The exposing was done like low key light photography, to give more light on the object and put the exposure on the objects, thus making the background darker. In Telecine we did two passes, one for the car and one for the background. We had to rotoscope the cars and give them a glowing effect for the magic world in the moonlight. The moon sky was done by a very high-res digital matte painting. In the compositing we added some moving cloud layers.

The three locations for the period race tracks were found in Spain. The three-day shoot included 11 cars altogether, starting with real vintage beauties like a 1907 60HP, a 1937 silver arrow, a 1955 Gullwing, then a modern McLaren, all in order to communicate Mercedes' love for competition, the race, adrenalin, passion, and energy.

Credits
Director: Matthias Zentner
Art Directors: Andy Hirsch, Kirk Mosel

Producers: Gary Grossman, Chris Ott
THE RACE:
ART DIRECTOR: Kirk Mosel
PRODUCER: Chris Ott
DP: Stefan von Borbeléy
Producer: Andreas Rothenaicher
Edit: Jochen Kraus
3D: Blackmountain
EFX/Online: Alex Lemke, Lene Hönigscmid, Sylvia Roessler

STUDIO PHILOSOPHY

Ntropic is a boutique VFX company with offices in San Francisco and Los Angeles. Since opening its doors in 1996, the studio has thrived on creating 2D and 3D visual effects for cinematic high-concept work from feature films such as the *Underworld* trilogy and *The Matrix Revolutions* to commercials for Chevy, Coca-Cola, Nissan, Mercedes, SF Giants, and Kohl's to music videos for My Chemical Romance, Justin Timberlake, and Green Day. A staunch believer in creative collaboration and integrating all aspects into the whole, Ntropic partners with filmmakers to envision and design shots, and incorporate music and sound design.

CHEVROLET–GENERAL MOTORS: "DISAPPEAR"

Creative and Production Process When we were first approached with the project, we were asked to create a time-lapse view of a single gas station over the past 80–100 years. This quickly evolved from not only being about the gas station but the life and times that existed in each period.

We worked very closely with the director in Maya using 3D to determine the exact layout of each gas station prior to shooting. After exploring several alternatives we specifically chose to create this piece through a single lock-off as if someone truly planted a camera back in 1920. This created some interesting challenges for design and layout on how to best showcase each gas station with its ever-expanding size while still being able to feature the Aveo, Tahoe, and Volt without ever cutting or moving the camera. There was also the continuing discussion of how much is too much. We wanted to balance the spot so the viewer felt a continuing progression of time with all of the activity that would take place, but still be able to concentrate on our hero vignettes that truly iconize each time period. Also, there is the varying concept of time throughout the different elements. The mountains in the background are moving at one rate, the gas stations are at another, and the vignettes are at another. Each one is designed to tell the story of progress while maintaining all the key moments in each section.

Technically we had several major challenges to overcome, mostly with the actual shooting of the elements. While we had our camera position already determined from our 3D pre-visualization, we still had to shoot a massive amount of elements in multiple locations. Our background was shot in Wyoming over a 24-hour period with exposures taken roughly every 5 minutes, except at sunrise and sunset where we exposed the film every 30 seconds to capture more detail in the changing landscape over these specific periods. The foreground elements were shot at a parking lot in Los Angeles on three 40' x 120' exterior greenscreens held up by seven cranes, and the Volt had to be shot at Chevy's facility in Detroit. Shooting the foreground elements posed a particular challenge because the lighting conditions needed to match as time evolved for each element. The director wanted to use real sunlight to illuminate the foreground elements. To meet this challenge, in our 3D pre-visualization we determined that we would have a sun cycle of roughly 2 days so each time period had to be shot linearly in its appropriate section of time. In addition to

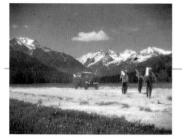

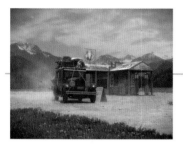

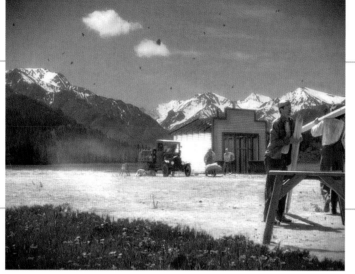

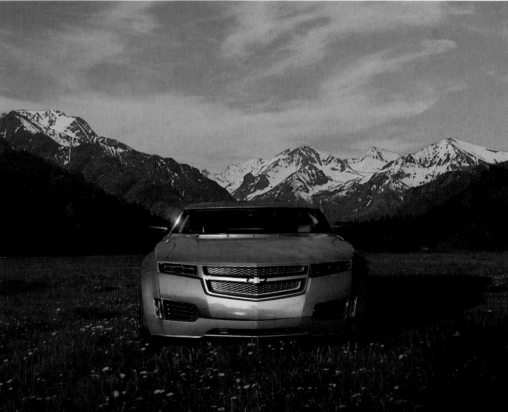

lighting challenges, we shot elements at different frame rates. Some of the background elements were shot between 1.5 fps and 6 fps, while hero foreground vignettes were shot at 24 fps, with the knowledge that we would throw away a lot of frames. The reason for shooting 24 fps was that we knew there would be only a few frames devoted to each element, so we could pick and choose the exact moments in time that will tell the story. During the entire production a team of CG artists created each gas station from scratch in approximately five levels of construction and disarray.

These levels were then animated over a sequence of time as our lighting shifted to match the time-lapse sun. After all of the plates were shot, we brought the elements into Flame, where each piece of action was roto'd and composited together with the CG gas stations. As the final piece started to come together we added many small details through 2D and 3D to round out the visual complexity of the spot.

Tools Autodesk Maya, Shake, AfterFX, Flame, Inferno

Credits
Creative Directors: Nathan Robinson,
 Andrew Sinagra
Lead Inferno Artist: Nathan Walker
CG Supervisor: Peter Hamilton
Inferno Artists: Dominik Bauch,
 Maya Korenwasser-Bello, Matt Tremaglio,
 Jesse Boots
CG Artists: Deb Santosa, James McCarthy,
 Dustin Zachary, Javier Bello, Thomas Briggs,
 Robert Hubbard
Compositors: Marie Denoga, Ed Anderson

STUDIO PHILOSOPHY

Blind has been turning out award-winning design since 1995, reinventing itself a few times along the way. What remains constant at this bicoastal design/production shop is an ability to engender surprise.

Leading brands such as McDonald's, XBox, and Scion, and recording artists including Gnarls Barkley and Justin Timberlake, turn to Blind for attention-grabbing design, motion graphics, animation, editorial, visual effects, and print and broadcast design. With live action capabilities, the multi-faceted company can produce projects from conception to completion.

Blind pushes beyond the expected, offering clients a new way to see.

RUSSELL ATHLETICS: "FOURTH AND INCHES"

Creative and Production Process In the Russell Athletics 30-second spot "Fourth and Inches," part of a two-spot campaign, we delivered a stylized presentation of one of the most dramatic moments in football as a way of asking: if you could see and hear an athlete's intensity, what would it *look* like? What would it *sound* like?

Under the creative direction of Erik Buth, we brought this idea to life by creating animated sound waves representing rapidly increasing heartbeats, heavy breathing, grunts, and other abstract and dissonant gridiron sounds.

To start, Erik and our design team collaborated with creatives from the Richards Group, Dallas, TX, to develop storyboards. We then built the animations from the sound up: identifying key moments, anticipating the sound design, and finally determining what animations best fit each sound. VFX were integrated using, among other tools, custom code that generated the tiny particles released after collisions.

For quality of image, efficiency, and integration into our FX pipeline, our team utilized a Genesis camera system and shot at 50 fps. A Super Technocrane offered dramatic angles, movement, as well as efficient camera repositioning for the two-day shoot. Once we had an approved edit, we organized the shot assignments with corresponding design treatments.

In the final product, "Fourth and Inches" opens with the sounds of football players preparing for a red zone showdown with graphic sound waves vibrating in the void. Emotions manifest as synthesizer meters and ethereal graphics interlace the live action, illustrating the defense's psychic energy. On a darkened playing field, the opposing teams line up at the line of scrimmage and prepare for attack. A massive linebacker encased in a transparent bubble slips into position.

On the frontline, radiant ribbons of energy flow from a spring-loaded nose tackle. A brief calm precedes the snap, which sends the opposing energies together in a storm of metallic grinding and eye-popping light. The linebacker levels the running back like a freight train and we transition to the tag, "Willpower has a lot to say on fourth and inches." Cutting back, we see the linebacker rise from atop the felled running back and the Russell logo closes the spot.

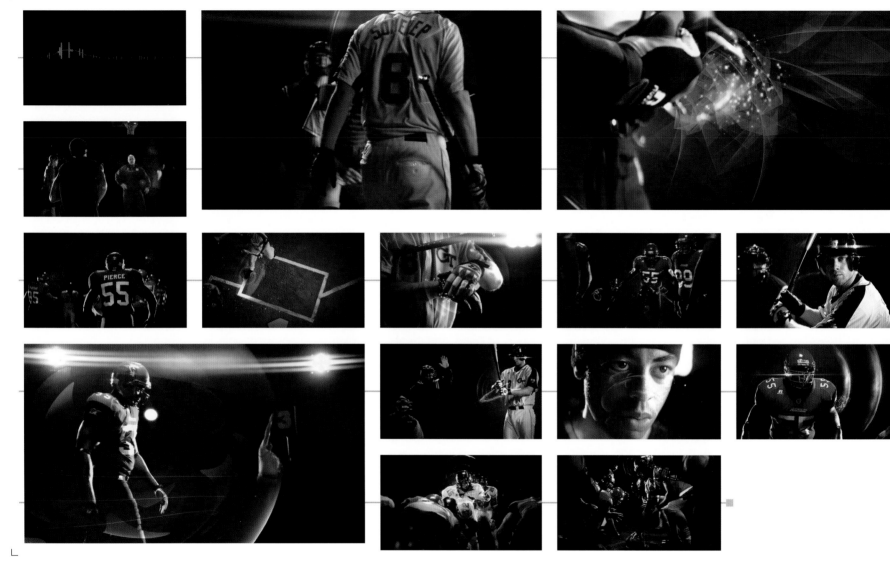

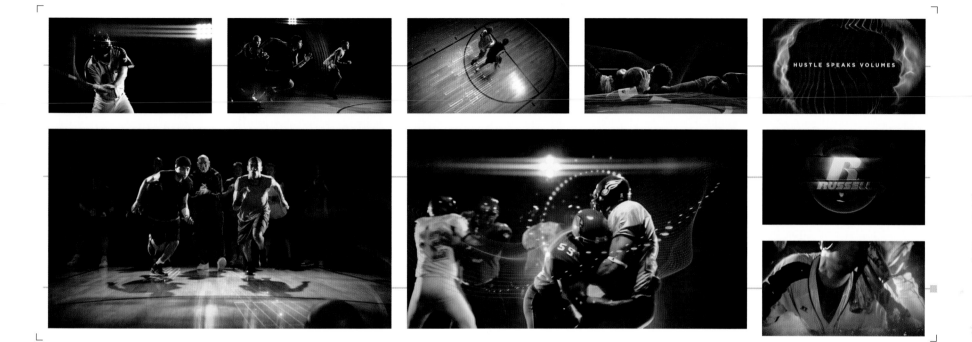

Tools Maya, Photoshop, After Effects (including the plug-in Form by Trapcode), Avid, Flame, and custom code written in C++

Credits
Creative Director/Director: Erik Buth
Designers: Shaun Collings, Lauren Indovina,
 Christine Kim, Brian Gossett
3D/2D Animators: Jason Lowe, Patrick Scruggs
 Jr., Jesse Franklin, Billy Maloney
Flame Artist: Alan Latteri
Developer/Design: Christian Cenizal
DP: Christopher Probst
Editor: Erik Buth
Assistant Editor: Lin Wilde

OPPENHEIMERFUNDS: "ESCALATOR"

Creative and Production Process In winter of 2009, we produced, designed, and edited a large-scale integrated campaign out of Euro RSCG, New York, for OppenheimerFunds that includes the 30-second spot "Escalator," in addition to two other spots and print and web design. The VFX-heavy campaign features investors thoughtfully navigating a world plucked right from the financial pages: stock ticker–covered trains, pie chart–shaped balloons, and jagged, graphical peaks, symbolically illustrating how OppenheimerFunds brings clarity to daunting financial landscapes.

Our goal was to show how financial data in the hands of OppenheimerFunds isn't simply a collection of nebulous numbers on a grid or pie chart, but a concrete way to achieve your financial dreams. We were tasked to breathe life into these numbers, and did so over a span of five months with our team of live action, animation, editorial, and VFX experts led by Creative Director/Director Erik Buth.

Says Erik, "Maintaining a sense of dimension and space was our first obstacle. Another was applying a moving typographical treatment to the talent so they could live and breathe in our 3D environment. While this sounds simple, the task of maintaining a sense of personality and a fidelity in the actors' performances was uniquely challenging."

Erik continues, "From the live action talent, we used 3D tracking and match moving as a basis for applying the 2D treatment." This campaign was extremely labor intensive. After shooting the live action on a greenscreen set we constructed of motor and pulley-animated escalators, balloons, and trains, we manipulated every solitary frame with VFX. This meant extensive rotoscoping of all elements, especially the talent, to maintain a sense of depth and structure.

In the final version of "Escalator," a woman evolves from the text and data of a financial page and then walks through charts and graphs projecting the ups and downs of the economy. She steps on a bar graph that becomes an escalator, leading her on her financial journey. With a sweeping 3D landscape revealed around her, and the escalator traveling the anticipated slopes, she remains steadfast while the voiceover intones, "You're in the market. But what do you want your numbers to add up to? Maybe a time-tested way to help reach your financial goals." The escalator reaches its summit at an idyllic vineyard and the text-based world dissolves away, leaving the businesswoman free to reap the rewards of her smart financial decisions. The OppenheimerFunds logo and tagline, "OppenheimerFunds. The right way to invest," close the spot.

Tools Maya, Photoshop, After Effects, Avid, Cinema 4D, and Flame

Credits
Director: Erik Buth
DP: Martin Sec
Editor: Carten Becker
Assistant Editor: Lin Wilde
Color Correction/Flame: Alan Latteri
Creative Directors: Erik Buth, Vanessa Marzaroli
FX Supervisor: Eric Alba
Art Director/Lead Designer: Lauren Indovna
Designers: Jason Tsai, Christine Kim,
 Kenny Kegley, Daniel Garcia, Andre Sayler,
 Jeff Baghai, Lawrence Wyatt, Rex Kim,
 Arisu Kashiwagi, Lisa Kwon, Shaun Collins,
 Wakoko Ichinoe, Brian Michael Gossett,
 Chris Sauders
Animatics: Paul Kim
VFX Production: Nathan Love
3D Animation: Kevin Phelps, David Han
2D and Compositing: Chrissy Cheung,
 Kevin Courture, Jeff the Dragon
Roto Artist: Will Frazier
Flame Artist: David Elkins
Animators: Jason Kim, Piel Phillips,
 Chris O'Neill, Paul Kim

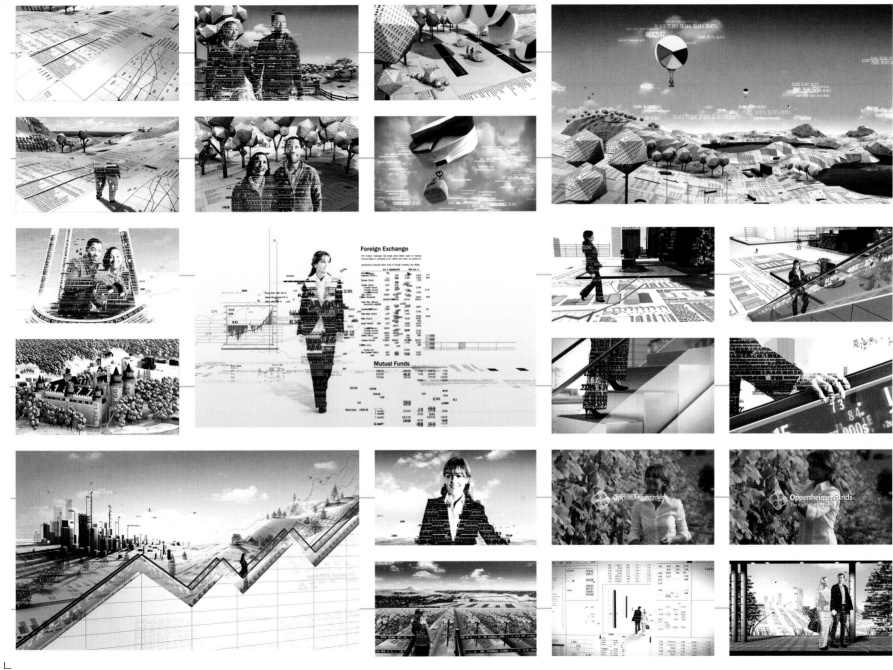

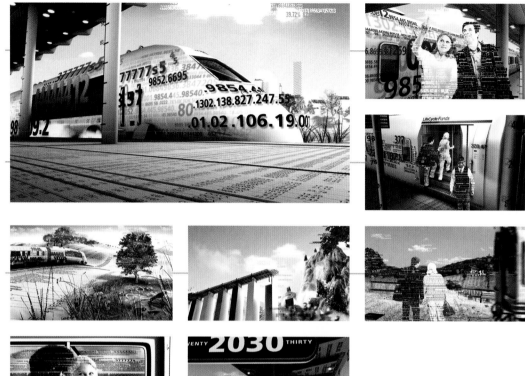

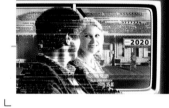

STUDIO PHILOSOPHY

In today's digital world, it takes more than just great work to create lasting impressions. Award-winning Rhino-Gravity, an international group that thrives on being creative, is home to a wide range of talent who each add their unique style to creating mesmerizing visuals.

From brand building, concepting, design, and all stages of production, Rhino-Gravity offers a worldwide presence in New York, Toronto, Tel Aviv, and Connecticut and is uniquely positioned to take on a variety of projects across multiple platforms including TV, film, web, and mobile.

PELEPHONE: "CANNONS"

Creative and Production Process "Other World" was the code name given to the launch of the new image for Pelephone, an international cellular company. The company, which was technologically inferior to its two strong competitors, felt that it needed to make a bold move in order to survive in a very competitive field.

The company decided to make a technological change and invest in a new infrastructure. It was clear to everyone that the great risk of launching a new network must be complemented by a major marketing move of a similar scale, something that would be as different, as imaginative, and as grand as the technological change itself.

The advertising agency was asked to prepare a campaign that would be appropriate for this technological wind of change. The agency recognized the need for a campaign that would present the viewer with a world that is different, magical, a world we would all want to live in, a supportive world that is free of evil and is full of love, a world so real that it could almost exist.

At this point the agency turned to us with the question of whether it was possible to create a world where special effects were present but not felt, and were believable enough to not look like magic tricks. This type of project for us, creative directors and supervisors, is the real drive behind our profession. The challenge was to create a world that does not exist. The question was where to begin.

We went directly to the script, which was abundantly loaded with ideas, but lacked any visual characterization. There were just two elements that caught our attention: a bubble gum and a car with a flat tire that caused the whole car to collapse after being completely sucked out of air like an old inflatable beach mattress. We were suddenly reminded of a car we saw years ago called the Micro Car (also known as the Bubble Car) and then boom! All the pieces fell into that 1940s era, an era that introduced these tiny adorable cars, encapsulating a charm that would be the basis for our entire "Other World."

Our world had to be a world of childhood: fresh and innocent but not childish. The first thing we did was to summon our entire art team, consisting of designers and matte painting artists, and appoint each to be in charge of a different aspect of our world. What would the architecture look like? The sky? The trees? The clouds? The designers "pounced" on their Photoshop stations until the entire bubble gum supply was gone from our studio.

When the first sketches started coming out, we set out on our second "Other World" adventure: the "Cannons" spot. In the "Other World"

Concept
Cannons

Final Design
Cannons

Modeling Sheet
Cannons

3D Model
Cannon

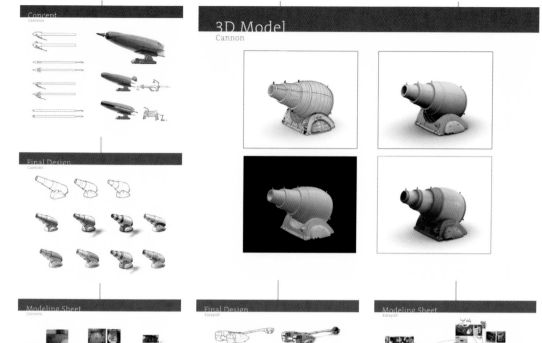

Final Design
Katapult

Modeling Sheet
Katapult

Modeling Sheet
Katapult

3D Model
Katapult

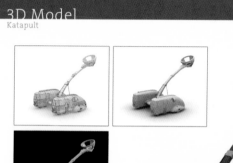

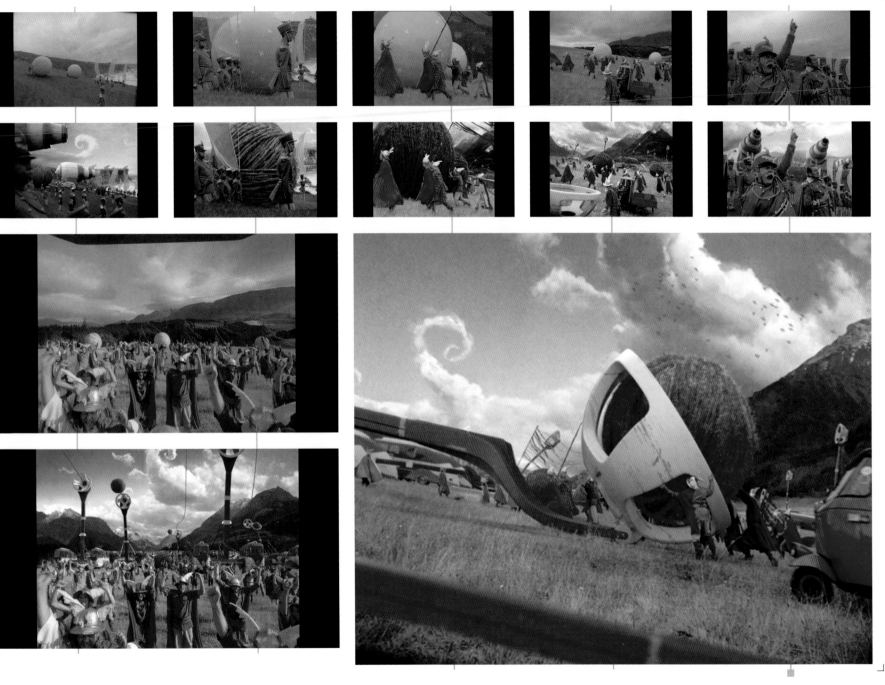

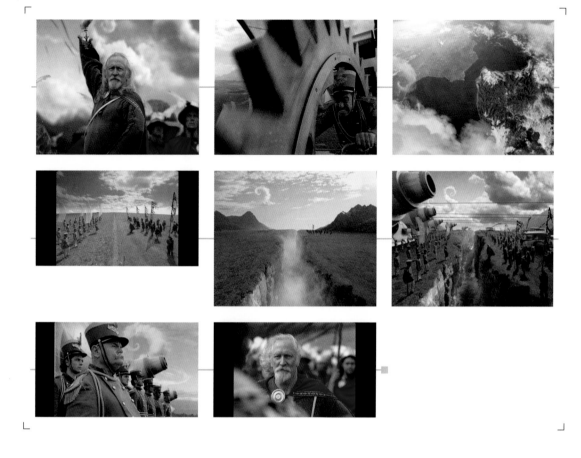

simulating how wool yarn behaves and moves when it is in the air, how it hits the ground, and of course how threads of wool would look stretching out of a roll of yarn that has been catapulted over the clouds and to the opposite continent.

The next phase was to take the 3D and art materials that included a hyper-realistic rendering of a sky with swirly clouds, snowy mountains, and cliffs from Ireland and join them together using Flame 2009 software. This was all for a final picture that would look real on the one hand, and extremely unrealistic on the other.

We managed to create the "Other World": a perfect Kodak moment that includes both a longing for another world and a reality that doesn't bite.

Tools Adobe Photoshop CS3, Adobe Illustrator CS3, Flame 2009, After Effects Cs3, Maya 2008, SP1, Mental Ray

Credits
Creative Director: Ilan Bouni
CG Supervisor: Yoav Savaryego
Producer: Mor Shahar
SFX Supervisor: Ronen Shaharabani
Head of the Art Department: Israel Breslav
Head of Productions: Shirly Gad
CEO/Executive Producer: Zviah Eldar
Production Company: Mulla Productions

there are no wars, and what looked like a battle of wool yarn was ultimately a way of getting two continents closer together, allowing old friends to reunite.

The cannons started to look like a crossbreed between the bubble car and a cannon, but still something was missing. We did not want to have cannons on both sides and make it too boring for ourselves and too confusing for the viewers. We therefore decided that catapults would be appropriate weapons for a wool yarn battle, and here, too, was a crossbreed between a car from the '40s and an ancient catapult.

The next phase was to take all our designs to the 3D department and have them build models using Maya 2008 software. They would then start

VERIZON FIOS CAMPAIGN: "ROCK STAR"

Creative and Production Process The Verizon FiOS campaign was a series of wraparounds to feature the network's variety of content. Each piece had to represent a different kind of programming. We created total of nine spots (each consisting of two different segments) representing sports, action movies, romance, wrestling, specialty programs, etc. Each spot went through an intense conceptualization, storyboarding, design, and approval process before it went into animation/production. The client also wanted these segments to be modular so they could be mixed and matched when shown on network.

Verizon FiOS required a mix of Maya's own dynamics tools, commercial plug-ins, and several new tools we wrote in house to create the look of the various shots.

Rhino wrote a set of tools to "dice" polygon geometry within Maya. The tools offered us different rules and iteration cycles for dicing polygon meshes, which allowed us a great deal of variation. The meshes were also given dimensionality by the addition of extrusions and bevels once the meshes were diced.

We also employed FerReel's BlastCode plug-in for Maya to generate procedural explosions and breaking up of geometry. BlastCode requires NURBS surfaces as inputs, so we would often create NURBS surfaces hidden under our polygon meshes. We would then attach our diced polygon meshes to these NURBS surfaces to get interesting breakups and explosions based on BlastCode's demolition abilities.

Often the animations would need to be reversed for our simulations, which gave the appearance of hundreds of pieces coming together. In these scenarios we would reverse all the animations in the scene with an in-house tool, cache a simulation with the reversed animation, and finally bring the cached simulation into our original animation scene employing a reverse time node hooked up to the simulation caches.

Our particle-based tool would take the diced pieces and control them with particles and fields. It is somewhat like Maya's own particle instancer, except with much more control over the individual diced meshes and the types of natural motions you could impart on them.

We used Maya's nCloth module to generate clothing simulations and Maya's hair module to create the rock star's hair and goatee. In addition, we used traditional particle instancing to generate trails of debris for the guitar and employed Maya's rigid body dynamics on diced pieces to generate more interaction with the breakups.

Rendering was done in several passes and rendered using Mental Ray for Maya. Each scene was made up of a minimum of 10 passes and as many as 20 passes. We would render a beauty for the stage and rock star. For these renders we used traditional CG lighting techniques along with Final Gather and HDR images. In addition, RGB matte passes for different elements in the scene were used for additional color correction. We also rendered passes for fiber optic elements, dynamics elements and debris, motion vector passes for 2D motion blur, and RGB volume light passes to give the sense of rock concert lighting.

Within Digital Fusion, clips of dust and pyrotechnics were used in several shots, again to add more atmosphere and lighting effects.

Tools Maya, Rhino, Digital Fusion

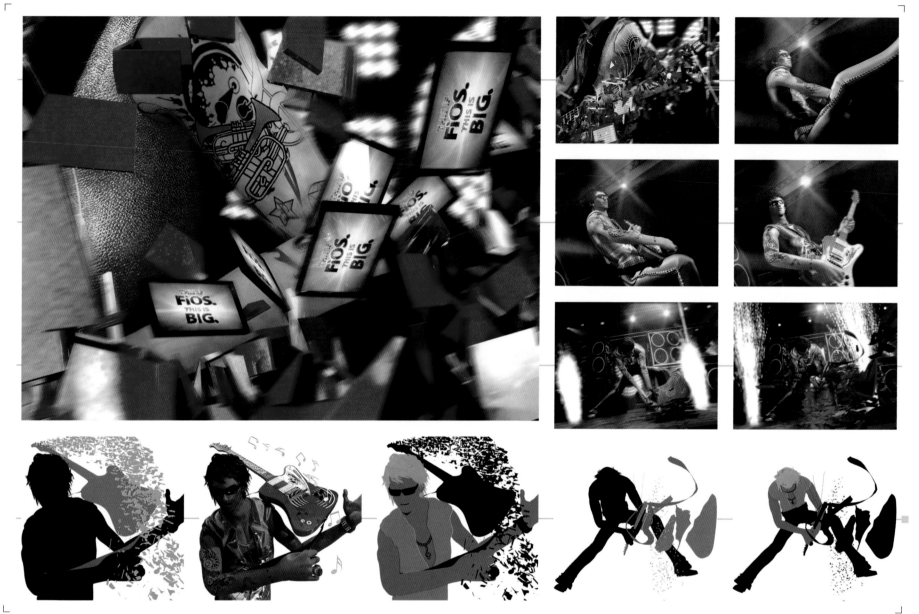

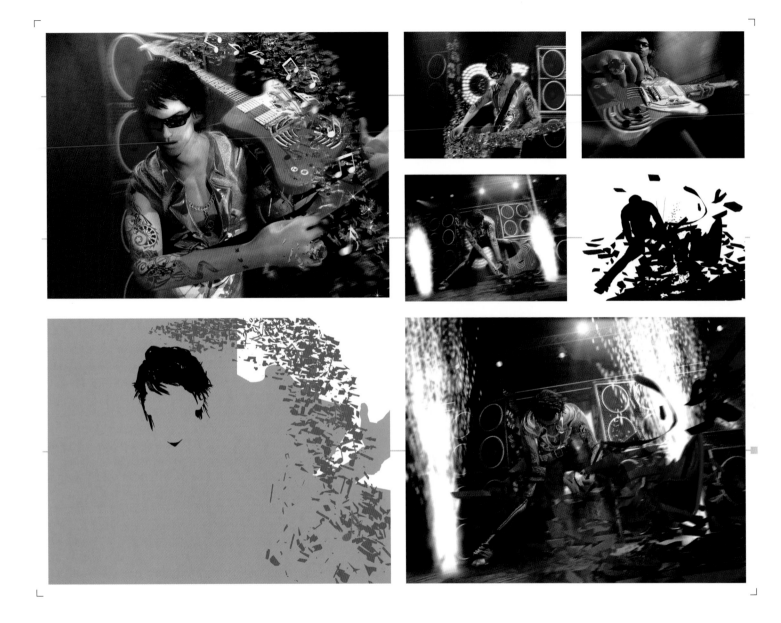

STUDIO PHILOSOPHY

New York–based Click 3X produces cutting-edge visual solutions for commercials, feature films, television, music videos, and broadcast clients around the globe. In addition to Click 3X's commercial and film expertise, their interactive design studio, ClickFire Media, specializes in multi-platform, media-rich interactive campaigns. Haunt is a division that specializes in cutting-edge motion design for music videos, virals, and installations and has worked with many of the industry's top music talent and directors. Click 3X Entertainment focuses on broadcast branding and design, rounding out the company's expertise for every screen.

GOARMY.COM

Creative and Production Process When presented with this exciting concept for goArmy.com, we were eager to be part of this new interactive campaign. The project heavily touched upon several aspects of CGI from modeling and animation to photorealistic textures and lighting techniques. Our objective was to create an expansive, high-tech, visually pleasing U.S. Army base where we could take the viewer on a dynamic journey using a series of camera fly-through moves that lead them to informational hot spots.

The first step in our process was to begin with modeling. This included everything from all the necessary buildings, entrance gates, and training facilities down to sidewalks and floodlights, all while keeping in mind that we would later go back and add refinements to these models mostly dependent on how close our cameras would come to them.

We simultaneously began to develop our base layout from an aerial view that would later serve as the viewer's central hub position, bringing them into any of the 11 informational hot spots. We wanted to be at an aesthetically pleasing distance from the base so that the viewer could see and fully appreciate all the foreground details and activities as well as keep the base expansive enough to allow for the dynamic camera moves that we planned.

After developing our layout, we proceeded on to animation, which basically consisted of all the camera fly-through moves as well as all common everyday activities such as Jeeps driving around and soldiers training. The idea here was that once the viewer goes to the goArmy.com website, there would be an introduction animation taking us to the central hub position. It is there that the viewer would see all the activity on the base and then would be given a choice on which informational hot spot they would like to explore. Once they click on it, we would seamlessly transition into one of our camera fly-through moves taking them to that spot. So it was essential that we matched all of the camera starting and ending positions. The other consideration was that all the activity on the base needed to seamlessly transition from the introduction animation as well as be a loopable element to allow for the viewers to stay on the central hub position for as long as they chose.

Upon completion of the animation process, texturing, and UV mapping, the geometry was our next integral step. Starting with various references of Army bases we were able to determine what materials and textures the various parts of the base should have. Some buildings would be made out of concrete, some would have metal rooftops,

the Jeeps and vehicles would all need to feel very diverse, and the building interiors would all serve their own purpose, down to the camouflage uniforms the soldiers were wearing. The topology of the land including the ground and sidewalks was broken out into a series of quadrants with hi-res textures stitched together, giving us necessary control to add greater resolution on the panels that the camera directly flew over. This allowed us to come as close as two or three feet off the ground at times. The same approach of having the camera distance dictate texture resolution went into everything else on the base.

At that point we were able to go in and further fill our environment with secondary elements and details such as trees, shrubbery, and grass using Vue software. This brings us to our final steps in the process, lighting and rendering.

For most of the outdoor shots our main lighting source was image base lighting where we primarily used 32-bit sky images as well as rendering out 32 bit images to allow for greater color correction control.

All of our renders were broken out into layers, giving Flame full control over compositing and color correction, the final phase of production.

Tools Maya (3D package), Vue (environment elements such as the trees), Flame (compositing)

Credits
Creative Director: Steve Tozzi
Director of CG: Anthony Filipakis
CG Artist—Animation/Rigging: Susan Taaffe
CG Artists—Lighting/Texturing: Grace Hwang, Sung Kim
CG Artists—Modeling/Animation: Jongmoon Woo, Kristin Pedersen
Flame Artist: John Budion

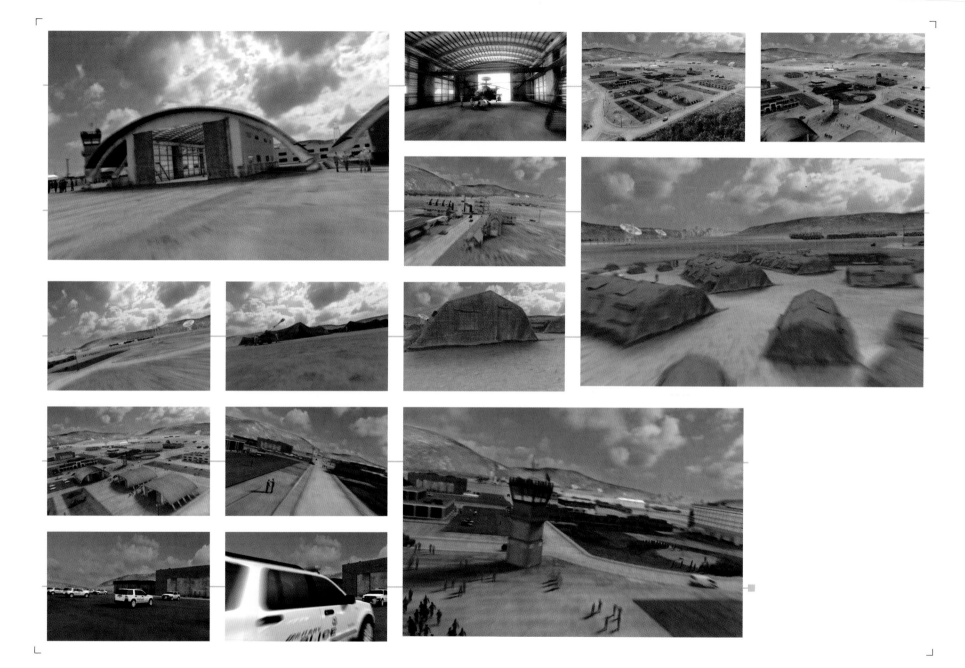

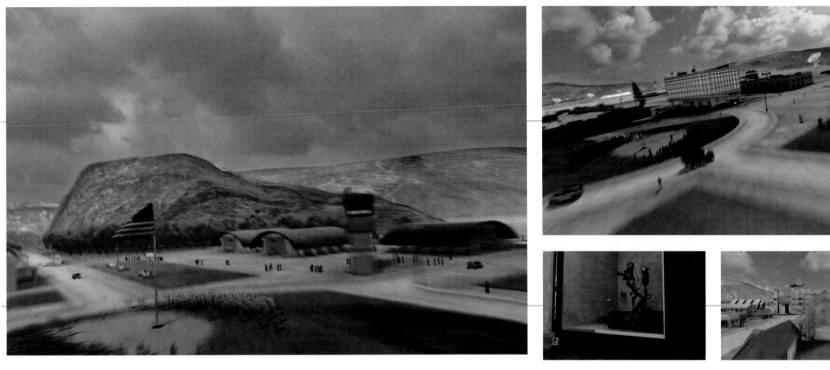

STUDIO PHILOSOPHY

Imaginary Forces (IF) is a design and production company based in Hollywood and New York. Their award-winning work spans the diverse industries of feature film production, entertainment marketing and promotion, corporate branding, architecture, advertising, and experience design. Notable work includes the groundbreaking film title sequence for *Se7en,* the Emmy-winning title sequence to *Mad Men*, commercials for Pepsi, Microsoft, and Scion among others, multimedia entertainment experiences at the Wynn Resort in Las Vegas, and an installation for the Museum of Modern Art in New York City dubbed "New City."

MAD MEN OPENING TITLE SEQUENCE

Creative and Production Process Our creative challenge was to connect a 1960s period TV series with today's audience. We created an elegant and abstract cityscape of vintage ads from the late 1950s/early 1960s. The juxtaposition of vintage ads with contemporary design connects the past with the present. We were inspired by advertisements from the time period and followed a very specific brief by the series' creator, Matthew Weiner.

We approached the *Mad Men* opening title sequence like a live action film title instead of a purely animated piece. The disciplined use of camera angles combined with sophisticated graphics achieves an insight into the main character's subconscious and the precarious duality of his boys club career and perfect nuclear family. The action of falling past endless skyscraper walls creates a claustrophobia and helplessness that is abruptly cut short by his composed reclining pose now synonymous with the show.

Tools Power PC G5 Mac OS 10.4 (Quad + Dual processors), Photoshop CS, Illustrator CS, After Effects 6.5 Professional, Xeon Intel Windows XP, Softimage XSI 5, Final Cut Pro HD 5.04, DVD Studio Pro 4, Quicktime Pro 7

Credits
Directors: Mark Gardner, Steve Fuller, Alan Taylor
Executive Producer: Maribeth Phillips
Producer: Cara McKenney
Coordinator: Michele Watkins
Designers: Jeremy Cox, Fabian Tejada, Joey Salim
Animators: Fabian Tejada, Jason Goodman, Jeremy Cox, Jordan Sariego
Editor: Caleb Woods

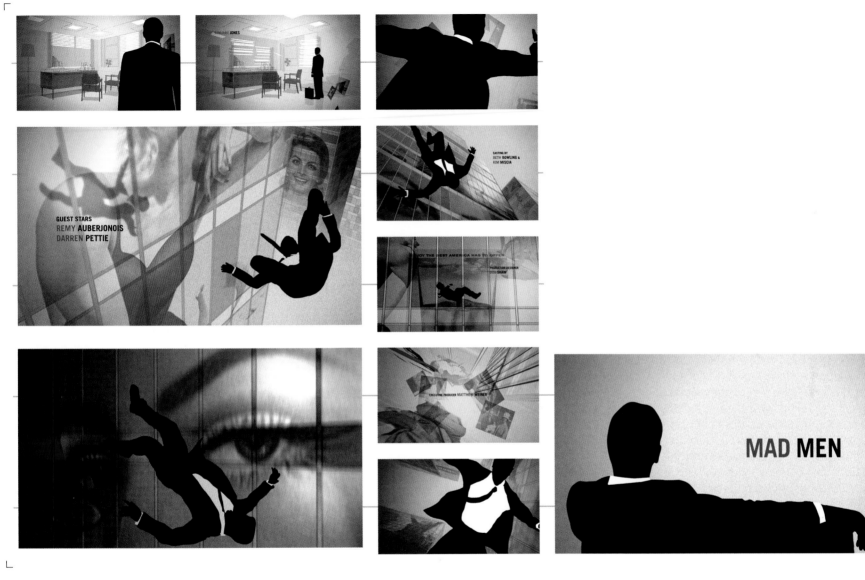

STUDIO PHILOSOPHY

Established in 1997 as a home for the very latest high-end photo-real visual effects technologies and the industry's most innovative and talented graphic design artists, visual effects company a52 creates award-winning imagery for the world's most visually ambitious commercial and television projects. Having relocated to Santa Monica in 2007, the company's work has earned AICP Show recognition for 11 consecutive years along with recent "Outstanding Commercial" Emmy, Andy, BDA, Belding, Clio, British Design and Art Direction, International Monitor, International Automotive Advertising, London International Advertising, One Show, and PROMAX awards.

ACURA: "MOTION"

Creative and Production Process For Acura "Motion," a52's effects team, under the guidance of VFX supervisor and lead artist Patrick Murphy, worked with the creatives from RPA and Director Lance Acord to formulate a unique project workflow. Acord wanted to let the grace of motion of the human body draw the viewer in, with the contrasting reality of a true impact—presented in the end copy—providing the drama to the spot, along with the image of each person being "jerked out" of his or her daily routine.

The result is powerful scenes showing individuals in everyday situations suddenly experiencing the type of violent inertia that occurs inside a vehicle during a collision. To capture live action footage of the actors (each of whom was a trained stunt performer) violently thrown into odd directions, Acord and his colleagues from Park Pictures, along with Murphy and a52 producer Pete King, captured high-speed footage of the actors as they were pulled by wires up to 25 feet from where they began, over the time span of a second or two. With that footage slowed down to stretch the one-second scenes out to five seconds or more, editor Kirk Baxter of Rock Paper Scissors conformed a rough edit, and in the selected footage, a52's artists used Autodesk Inferno and Flame to composite the performers into background plates to make them appear at home, in

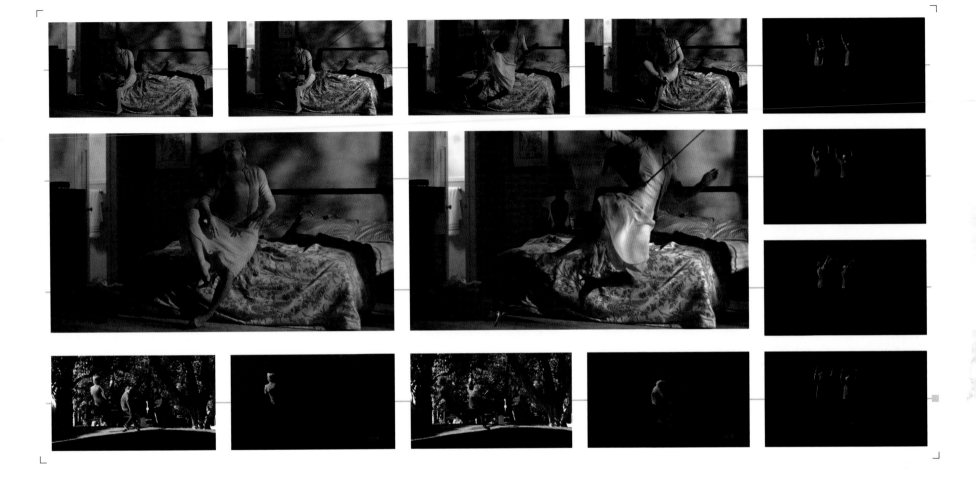

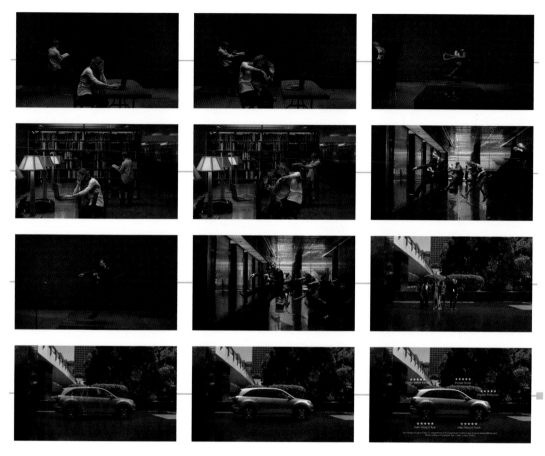

a park, awaiting an elevator in an office building, etc. Effects artists also performed rig removal on the wires and handled other effects, like clothing repair and replacement, to finesse the seamless finished look of the performers within their respective scenes. At the end of the spot, a52's artists created titles around the Acura MDX, and artfully layered in a car forming around a family. Rock Paper Scissors Lead Editor Angus Wall did a final color correction in Apple Color.

Tools Autodesk Inferno, Flame, Apple Color

Credits
VFX Supervisor: Patrick Murphy
2D VFX Artists: Stephan Gaillot, Mike Bliss,
 George Cuddy, Billy Higgins, Carlos Morales
VFX Executive Producer: Ron Cosentino
VFX Producer: Pete King

LEXUS: "POP-UP"

Creative and Production Process Like other spots in ad agency Team One's sensational Actively Safe campaign for the Lexus RX350, "Pop-Up" was conceived as a stylish, uniquely memorable approach to relating the vehicle's many Actively Safe features. Through the course of preproduction, it became clear to Director Stylewar, the agency's creative team, and a52's lead team of VFX Supervisor Andy Hall and Producer Sarah Haynes that building a 30-foot-tall pop-up book to accommodate a full-sized Lexus was not practical. As a workaround, production built a giant, full-sized book frame for greenscreen, with tabs and wheels that could be manipulated by actual stagehands, and the actual pop-up book with moving parts was a mere 6 feet high. To capture their live action elements in anticipation of performing a great deal of artistic compositing on the part of a52's team, Stylewar and Director of Photography Toby Irwin filmed the background actors operating the 30-foot book frame on a greenscreen. Next, they shot each page of the miniature pop-up book opening and closing, as well as the animated movements within the pages. Using the movements of the actors for timing, a52's Lead Flame Artist Raul Ortego re-timed the live action of each page to match each other's and the actors' movements. Autodesk Flame and Smoke were used to rotoscope out the different pop-up pieces, which were then composited together in Flame. For the city scene, a52's CGI artists recreated every visual element in Maya—using high-resolution stills from the shoot as textures—and tracked them to the live action for final compositing in Flame. For every action of the book, a52's artists either re-created or re-timed them to ensure a seamless feel to the storytelling. Live action passes taken of the hero Lexus to capture reflections and shadows were also combined in Flame, and virtual holes were created for the pop-up book's pages—also in Maya—where the Lexus appears. Additional touches by a52's artists include Maya-created tabs and wheels for the book, the book's shadow, the page edges and thickness, and the entire cover page and binding. Final Flame flourishes include reflecting the book in the floor, as well as color grading and addition of logo and titles. Smoke was used to assemble the final versions for lay-off.

Tools Autodesk Flame/Inferno, Maya, Smoke

Credits
VFX Supervisor: Andrew Hall
2D VFX Lead Artist: Raul Ortego
2D VFX Artists: Mike Bliss, Tim Bird,
 Kirk Balden, Brandon Jolley
3D Lead: Dan Gutierrez
3D FX Artists: Chris Janney, Kirk Shintani,
 Kevin Clarke
VFX Executive Producer: Mark Tobin
VFX Producer: Sarah Haynes

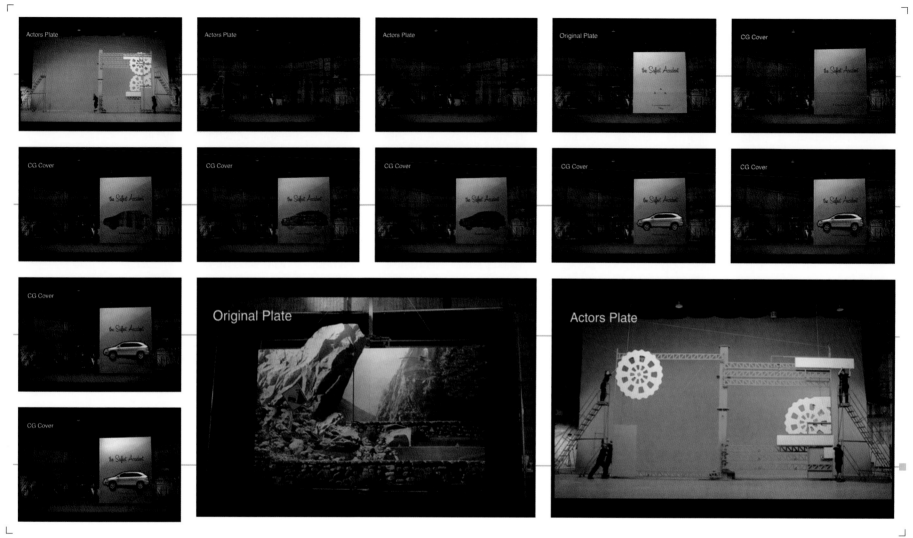

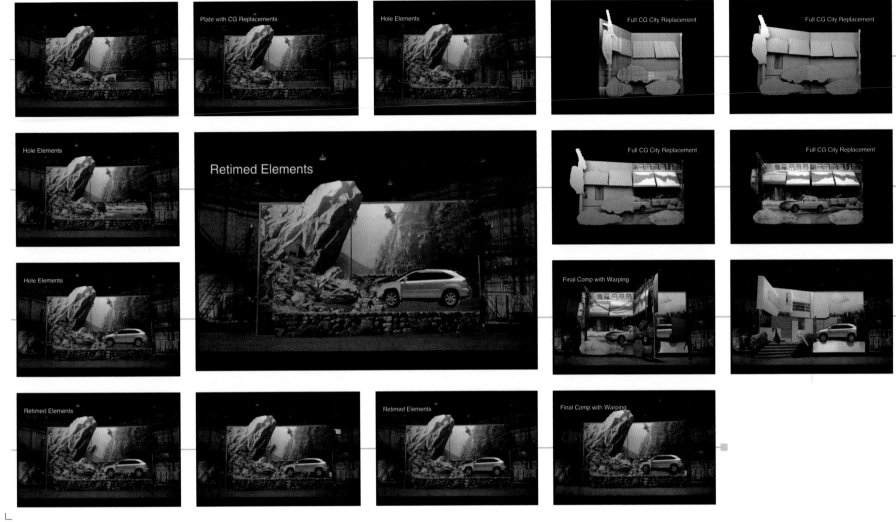

STUDIO PHILOSOPHY

Method is an artist-driven visual effects company, created 10 years ago by Co-Founder/Visual Effects Supervisor Alex Frisch. Method provides artists and directors with the best creative environment in order to create high-end visual effects. Over the past decade, Method has been consistently at the top of its field, creating award-winning visual effects for commercials, music videos, and feature films. A talent-centered studio, Method is organized around an exceptional team of artists, who are in direct contact with clients: directors and ad agency creatives. Method's unique approach of combining traditional filmmaking techniques with the most sophisticated digital solutions in 2D compositing and 3D animation has helped to build the company's stellar reputation over the past 10 years. Recent credits for Method include commercial projects for Bridgestone, Miller Lite, Audi, Washington Mutual, and Gatorade.

PEPSI

Creative and Production Process The election of President Obama was historical on two fronts. Alongside the significant decision to elect our first black president, we also saw the youth of our nation mobilize and energize with a spirit unmatched in previous campaigns. Pepsi commemorated this momentous inauguration with a retrospective of defining moments in history to advocate change from the present generation. Director Dante Ariola and TBWA\Chiat\Day relied on Method's finishing team led by Compositors Claus Hansen and Alex Frisch to create this narrative.

Believability was crucial to the success of this piece, so both Dante's production designers and Method's artists researched historical evidence to depict exact details of each time period. 3D Artist Andy Boyd and Matte Painter Helen Maier brought viewers back to World War II with a recreation of V-Day in Times Square. Alluding to Alfred Eisenstadt's famous photo of a soldier kissing a nurse, the artists produced full CG buildings from 1940s Times Square with authentic advertisements from that time. Crowds were shot in camera in five different places and then rotoscoped together with supplementary crowd replication. Even the computer-generated confetti was analyzed, with the determination that it must appear to be long cuts of typing paper thrown from the skyscrapers, as was done back then for New York parades.

Further manipulations crafted to create a realistic picture included removing graffiti alongside the Los Angeles River to bring back purity to the 1950s drag race and adding graffiti to the surroundings of the 1980s breakdancers.

Another important aspect of this spot was the seamless transition from generation to generation. Integrating the hippie peace and love rally with the '70s disco scene, Claus took thorough

steps to add flare action and match greenscreen shots of the siren in both scenes. Another organic flow massaged in Flame is the jump from a crumbling Berlin Wall into a present-day live concert by compositing in the view from each side of the hole.

Pepsi has always been true to its current ad branding of change since its inception in the 1890s by a pharmacist in North Carolina. From recognizing the economic crisis in its pricing during the Depression to being one of the first products to portray African Americans in a positive light via an all-black ad team, Pepsi is once again defining itself as the beverage of our generation.

Tools Flame

Credits
Director: Dante Ariola
Compositors: Claus Hansen, Alex Frisch
3D Artist: Andy Boyd
Matte Painter: Helen Maier

STUDIO PHILOSOPHY

Panoptic is a director's collaborative started in 1997 by Gary Breslin. A pioneer in motion graphics, Panoptic's early work centered around site-specific installations and information graphics. Over time this spread to music videos and TV commercials, in addition to the art and short films they created. During the process of integrating live action with design elements, narrative became a central focus. As each project now has its own distinct look and style, it is this narrative sensibility and personality behind the work that sets Panoptic apart.

LINCOLN MKZ: "TOUCH"

Creative and Production Process Joseph Kosinski directed this campaign for Lincoln MKZ. Originally Panoptic was hired to do the end tag along with some graphic flourishes throughout the pieces. As the process evolved in post with this "Touch" spot, we had the opportunity to reconceptualize the piece with a series of impossible camera moves, pushing the boundaries of what had already been shot. Working primarily with a digitally generated car and environment, we stitched together pieces of the footage with a sense for the dynamic rhythm inspired by the track used, "Technologic" by Daft Punk.

The primary process was to pre-vis the CG with as finished a look as possible so the clients would have a feel for how it would look in its final form. The animation was created in Lightwave and then composited in After Effects. Once this was approved, we sent our files over to Digital Domain, who had already been working on Joe's other two spots. They took our camera moves, replaced with their version of the car, and rendered as photo real as possible. We then took the elements to Absolute Post here in NYC to reproduce our composited look on the Flame.

Tools Lightwave, After Effects, Flame

Credits
Director: Joseph Kosinski

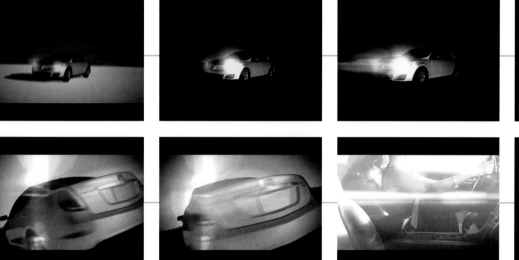

COLE HAAN

Creative and Production Process This project took the form of two videos, one for women's shoes and one for the men's. Originally conceived for in-store HD displays, it made its way to print and billboard versions as well. All Cole Haan shoes have Nike Air pads inside them, so our brief was to highlight that fact and the challenge was to show this hi-tech feature while at the same time keeping them fashion-y.

We shot the shoes at super high speeds using the Phantom HD camera. For the women's shoes, we simply tossed the shoes in the air in front of the camera, 1 second of hang time equaling about 60 seconds of seemingly zero-gravity floating. We

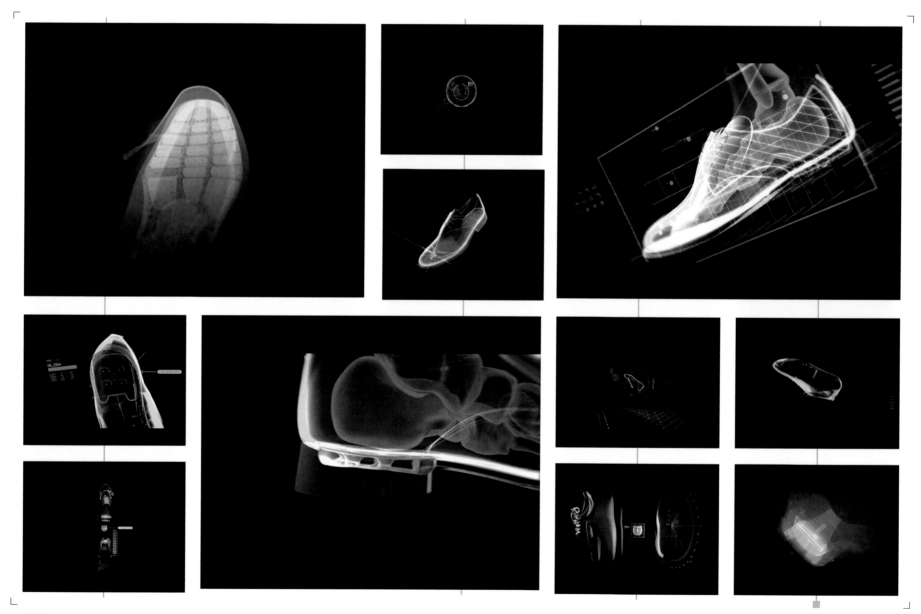

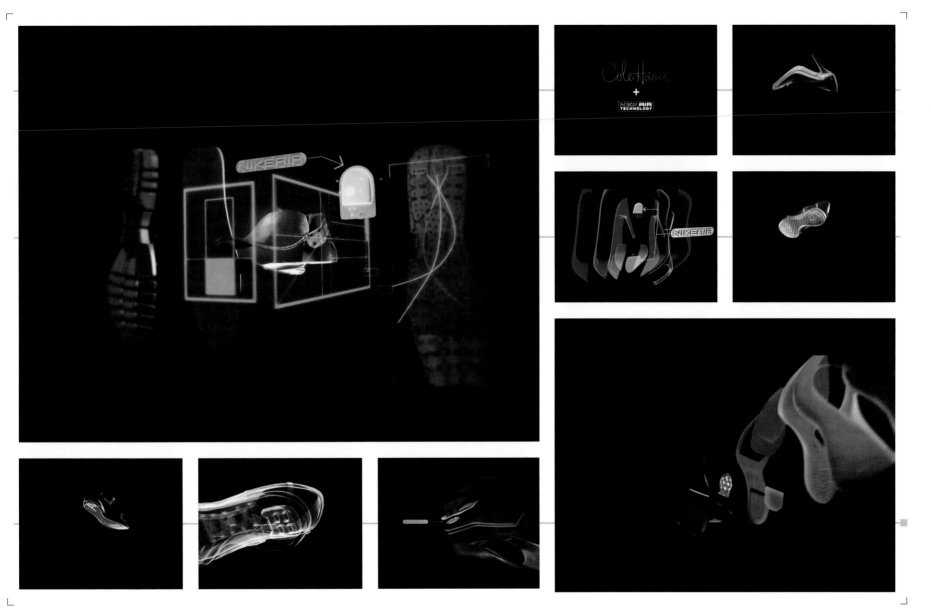

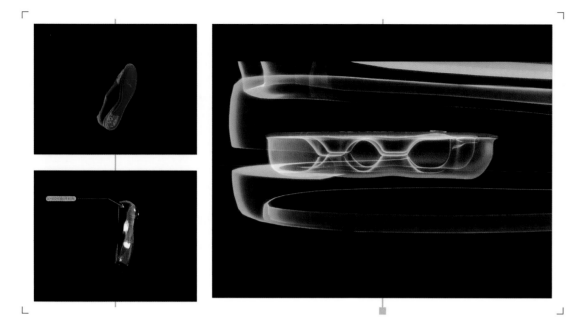

also modeled in CG each shoe's interior and exterior. In order to get the X-ray look we were going for, we cut the real shoes in half to see all the guts that would appear beneath the surface.

Tools Final Cut, 3D Studio Max, Maya, Lightwave, After Effects

DR DOG

Creative and Production Process Panoptic teamed up with Adam Kurland to make this music video for Philadelphia-based rock band Dr Dog, inspired by the colorized versions of old movies like *King Kong*. Using projections of miniatures for sets, we set out to make something equally analog and artificial-looking. Before shooting the band we built a tabletop diorama for the forest scene, creating a different version for each season. We then shot all our footage on 16mm, with most of the environmental effects practical. We transferred the footage and had it projected behind the band as they performed. A lot of effort was put into set design to integrate the projection screen into

the larger environment. The headless shots we accomplished by having Tobey, the lead singer, sitting on a skateboard with a greenscreen suit, while the old man walked on a treadmill.

Tools Maya, After Effects

Credits
Director: Adam Kurland

STUDIO PHILOSOPHY

Prologue is a Venice-based design company specializing in film and broadcast. Founded in 2003 by Kyle Cooper, the company has grown to a diverse team of 35 that includes designers, animators, editors, directors, and producers. With this expanding group, Cooper continues to build on a body of work that includes over 150 film title sequences, numerous advertising campaigns, various projects in branding (broadcast, interactive, environmental), entertainment marketing, and video game design. At Prologue, we listen to and respect our clients, many of whom are filmmakers and artists themselves. We strive to support them creatively and help them tell their stories. We are proud of our accomplishments but not content. We are constantly sharpening each other in the hope that we will create work that will communicate and inspire.

Cooper, also the co-founder of Imaginary Forces, earned an M.F.A. in graphic design from the Yale University School of Art and holds the honorary title of Royal Designer for Industry from the Royal Society of Arts in London.

ACROSS THE UNIVERSE

Creative and Production Process For this project, Prologue Films designed and created main and end titles as well as six special effects sequences for Julie Taymor's 2007 feature film, *Across the Universe*. The movie tells the story of a love affair between Jude, a British artist living illegally in New York, and Lucy, a girl from New Jersey. The turbulence of the 1960s provides the backdrop, and 33 Beatles songs drive the narrative. The sequences designed by Prologue reflect the turmoil of the setting and evoke the emotional upheaval experienced by the film's characters, fluctuating from the whimsical to the tragic.

In the *Mr. Kite* sequence, Eddie Izzard as well as a large group of dancers in costumes were shot on film as live action elements and then inserted into a 2D collaged environment. The aesthetic was designed in the spirit of 1960s experimentation and creativity. It was intended to veer away from a highly refined, visual effects treatment and fall more to the childlike, simple, handmade, and playful. Each live action element was shot separately then animated together to create the final sequence. Much of the filming of the song by Eddie Izzard was improvised and spontaneous, and that same feeling was carried over into the design of the environment.

The *I Want You* sequence depicts the character of Max being processed through the military induction center. The animation is designed to reveal the dehumanizing nature of the experience Max is being put through as he is prepped for military service. Second unit photography of Max being poked and prodded was shot against blue screen by Julie Taymor and second unit director Kyle Cooper.

By placing Max in various boxes, which were always referred to as the cornell boxes, by isolating body parts and bodily functions, by quantifying and measuring and cropping and cutting, a visual metaphor is created that allows us to experience the feelings of the character as he is put through a frightening rite of passage into the unknown. As the sequence progresses, we see Max's identity being pulled away from him until at last he is prepared and finally spit out into this domineering martial machine.

The movie as a whole is gritty, whimsical, and highly theatrical, so these are the qualities reflected in the visual effects sequences. Photoshop, Illustrator, Final Cut Pro, Shake, and Maya were all used to produce the final effects. The images used are both stylized and surreal, giving the music a fresh look, while simultaneously echoing back to the old animated classic *The Yellow Submarine* and to the history of stop motion animation.

Although the look of these effects retains a childlike quality, the design was anything but simple. In fact, the choreography in many of the effects is both unique and extremely complex. The VFX walk a fine line between reflecting the chaos

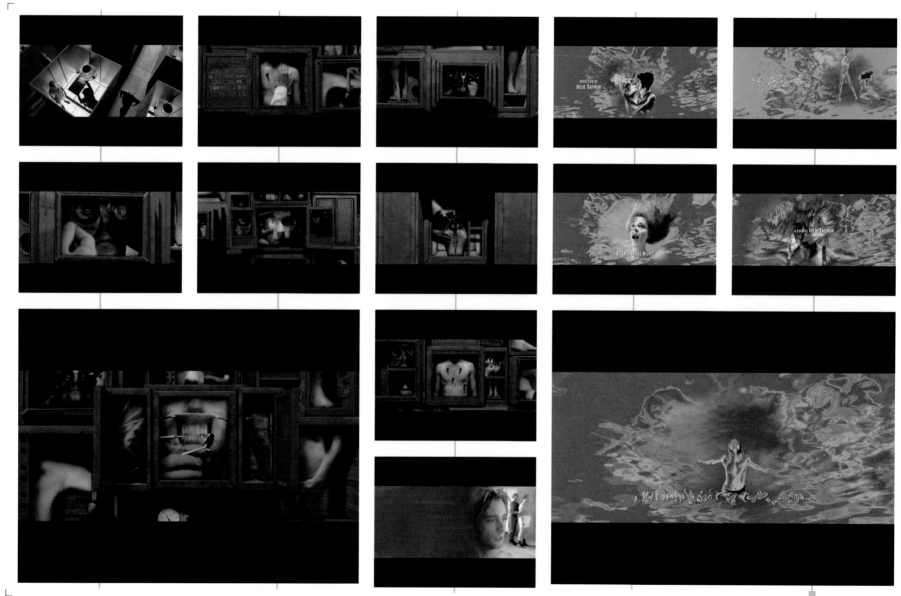

and whimsy of the '60s and reflecting the turmoil of the anti-war movement, incorporating a highly refined sense of color, choreography, emotion, and design.

The resulting images are filled with as many contradictions as the era they reflect. In addition, the use of 2D collage in many of the sequences, including *Strawberry Fields* and *Helter Skelter*, allows for a great deal of freedom and helps reflect the diversity of the time. In the end, each sequence is at once simple and complex, chaotic and refined, beautiful and distorted. In *Helter Skelter*, wave after wave comes crashing down on footage

of riots, with soldiers in gas masks fighting the crowd and dragging people away. The white-wash transforms into newspapers, and words bleed through the water as the waves relentlessly pound.

Strawberry Fields is another segment that dovetails into the film's narrative, using 2D collage and live action projections to create the scenes. Before any principal photography was shot, Julie Taymor met with Kyle Cooper and asked him to design the sequence. It begins with Jude, lost inside his paintings, melting into a psychedelic reverie while Lucy looks on, fearing for her brother

on the fields of Vietnam. Her brother is revealed to her in flowing news footage of the war, and Lucy is lost between her fear and her boyfriend, whose art and whose purpose seem inconsequential in light of the danger that her brother faces. Lucy has already lost one boyfriend to the war, and she is frightened for her brother's life. Jude, on the other hand, is passionately creating his art, pinning up huge grids of strawberries to newspaper articles and canvas, dipping the berries in paint and hurling them at the wall, then watching as the berries explode and paint drips down like blood. Strawberries melt, transforming

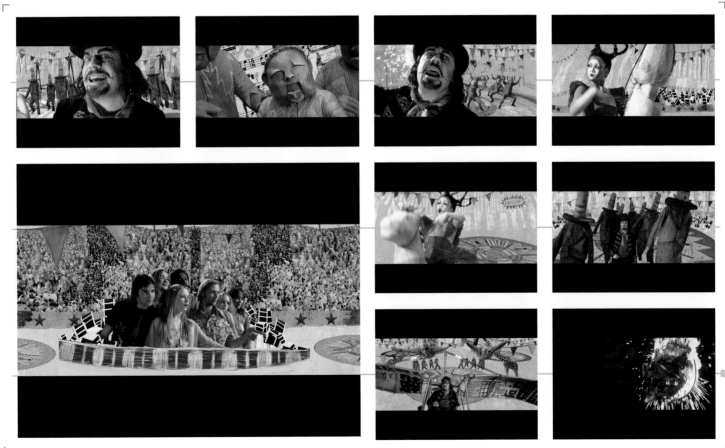

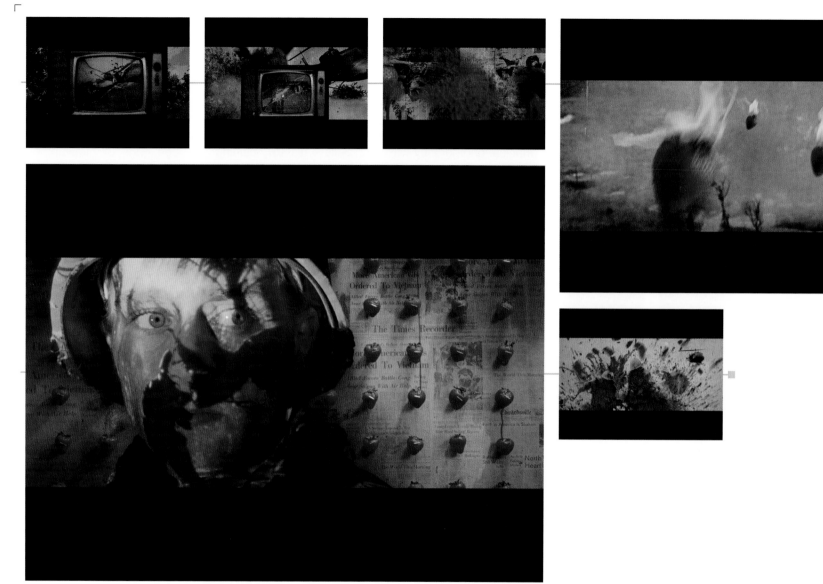

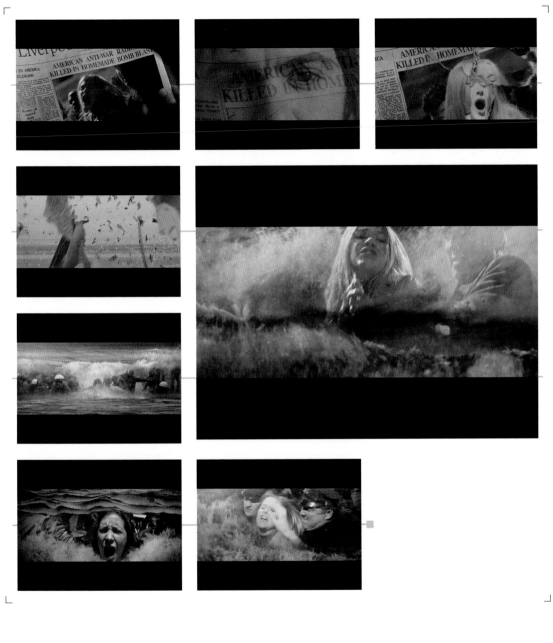

into bombs and bursting into flame. Newsreel footage melts into art, and art melts into life as Jude becomes lost in the violence of his work, Lucy's boyfriend becomes lost in the violence of the war, and the strawberry fields finally become the blood-soaked fields of Vietnam.

Tools Photoshop, Illustrator, Final Cut Pro, Shake, Maya

Credits
Director: Julie Taymor
Second Unit Director: Kyle Cooper

IRON MAN

Creative and Production Process Our task was to supplement the film with graphic interfaces driven by the in-home computer system of Tony Stark's Malibu residence (Jarvis). Jarvis is the workhorse behind all research and development on a very personal level—the system functions like a butler that is voice activated and is intelligent enough to speak back to and interact with Mr. Stark. Jarvis is his home system as well, providing all digital appliance and entertainment technology. The interfaces exist all over the house—in the workshop, living spaces, and bedroom. Our task was to work with very specific moments of dialogue between Tony Stark and this system.

We were originally contracted to provide editorial and animation for main titles and a conference video shown in the Apogee Awards scene. When the director saw what we were doing for the main titles, he decided to use the same visual language of computer-driven vector wireframes for the interfaces shown throughout the film. This gave us a tremendous opportunity to take what we have learned as a motion design shop and apply it to visual effects sequences for film.

Most of the animation and design was made using Adobe's Creative Suite software: Illustrator, Photoshop, and After Effects. 2d3d Boujou was used to matchmove scenes and create camera and locator data, and all 3D components were made using Autodesk Maya. Final composites and film output were completed in Apple's Shake.

All scenes required very specific interfaces that assisted Tony Stark. They needed to respond on cue very quickly and intuitively and carry out each task with supercomputer speed and efficiency.

Using Illustrator and After Effects, we designed and animated screen interfaces timed very precisely to each interaction. To do this, we placed the film edits in After Effects and imported Illustrator files as layered comps. Using that import method, the files appear in the After Effects comp as individual layers, ready to be animated. Most of the animation was done manually with keyframes, but for certain elements like a sphere that analyzes voice waveforms we used the "audio react" feature in the plug-in Form, made by Trapcode. This gave us a nice 3D shape that animated well and gave the illusion of a particle object.

For 3D elements, like a wireframe satellite and exploding 3D views of Iron Man's suit, we used Maya and rendered the geometry using Mental Ray's contour rendering features. All of these were rendered as 24 fps 16-bit .SGI sequences at 2k resolution.

One of the main challenges was matchmoving. Boujou does a tremendous job, but there is always cleanup involved because there are so many imperfections in film that confuse the software—objects that are out of focus and film grain are major problems for the software. There are techniques that can make the analysis cleaner, but nothing can compare to shooting everything as crisply as possible. Also, with matchmoving software you have to use create masking that will isolate the parts of the scene that are still. Any moving elements will confuse what needs to be identified as a part of a static space for the computer to recognize. The other side of matchmoving is 3D tracking, which is what was done on Tony Stark's arm when we simulated a prototype of the mechanical arm he was building over his own. In that scene he calls the element up as a 3D hologram and then inserts his arm into it. For the interfaces in the monitors four-point cornerpinning was used in Shake to composite the animation plates into the bluescreen monitors. Once the composites were done we rendered everything from Shake as 2k .DPX sequences and sent the film on hard drives for color correction in DI and final print of the film.

Tools After Effects, Illustrator, Maya, Mental Ray, Photoshop, Shake, 2d3d Boujou

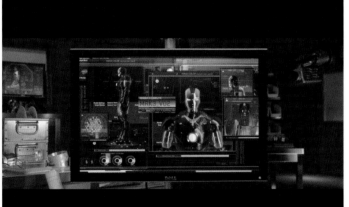
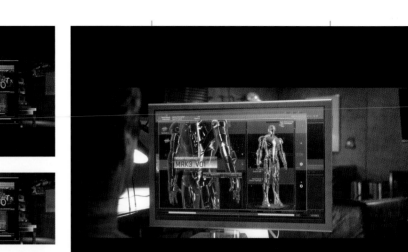
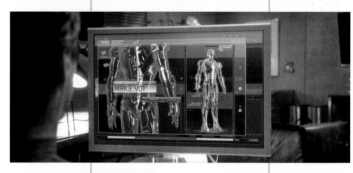
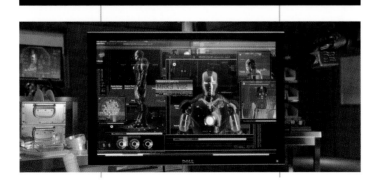
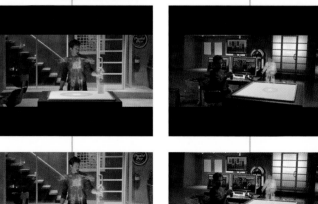

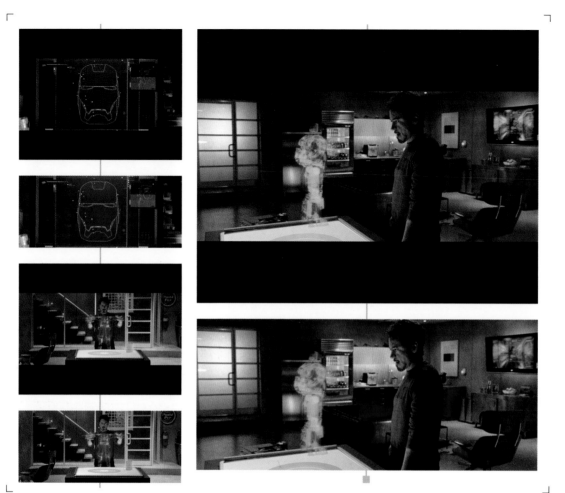

STUDIO PHILOSOPHY

Pixeltrick is a television motion-graphic design company based in Manchester, England, and has been providing television production companies with GFX since 2004. The company specializes in broadcast-standard CG animation, special effects, and color correcting for video and film.

Recent projects have included motion-graphic design on Peter Kay's *Britain's Got the Pop Factor* (Mcintyre/Lion Eyes), *Raider of the Pop Charts* (Mcintyre/Lion Eyes), and SFX compositing work on *The Street* (Jimmy McGovern/Granada Television), *Instinct* (Tightrope Entertainment), and *Coronation Street* (Granada Television).

INSTINCT

Creative and Production Process I was contacted by Granada Television to digitally remove some unwanted objects from a shot from a new UK drama by director Terry McDonough called Instinct (Tightrope Pictures, 2007). Terry wanted to remove a lamppost and street sign from the scene so as not to detract from the grand industrial mill in the background and the contrasting car

rushing past in the foreground. It would have been too expensive and time consuming to reshoot the scene and therefore the objects had to be removed from the sequence frame by frame.

To start the process I imported the film plate into Shake as a digitized tiff sequence, and before I carried out any removal I steadied the shot using the stabilize motion node within the software. It was actually a locked off shot; however, there were a few very small movements that can make further tracking or frame interpolated painting trickier. Once the shot was stabilized, I exported one of the frames of the sequence into Adobe Photoshop and painted out the signpost (circled center of image) and lamppost (circled right) using the clone stamp tool. This file was then imported back into Shake and used as a patch to place over the underlying existing layer using the "over" node. In the case of the street sign, it was fairly straightforward. I created a mask around the painted-out signpost patch so that when the car, situated on the below layer, passed in front of it, I could shape the mask around the car so as not to obscure it. Shake has a nice feature on its

shape tools that lets one blur the individual edges of the mask independently. This is very handy when a fast-moving object has motion blur.

The lamppost was a little more difficult due to the moving sky behind it. I couldn't rely on the patch alone; otherwise, a particular part of the sky behind it would remain static and would easily be detected as an irregularity by the eye. So in this case I had to use the clone brush tool to paint the sky back in frame by frame. Fortunately, Shake has the ability to interpolate painted frames over the entire sequence, which allowed me to paint every tenth frame. Because we can pick out even the smallest of movements between frames, this interpolation avoids any undesirable bubbling or jerky effects.

Finally, to make the whole composition look like it was filmed from the same camera, I added specific film grain back to the patch layer to make it blend back into the film layer beneath it.

Tools Shake, Adobe Photoshop

Credits
Executive Producer: Steve Clarkson

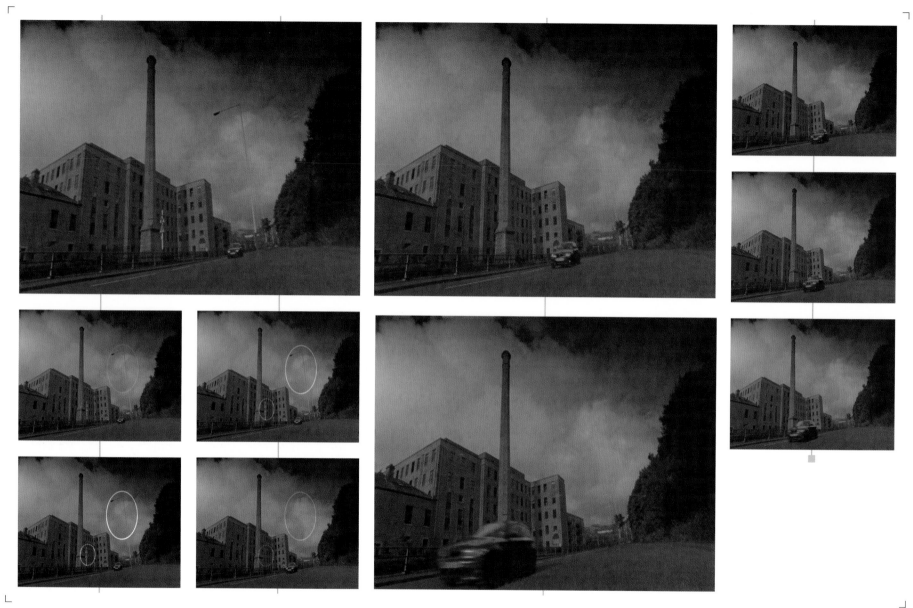

STUDIO PHILOSOPHY

Founded in 1998 by Spot Welders, Sea Level VFX is a boutique postproduction company providing high-end finishing and effects for commercials, music videos, and content for the web. In November 1998, Jim Bohn and Ben Gibbs were brought on as minority partners in order to bring the quality of service and artist involvement that they had always found lacking in the large facility environment. Its roster of CG supervisors, Flame and Inferno visual effects artists, motion graphics designers, and VFX producers has contributed to award-winning national and international spots for Adidas, Levi's, Honda, Nike, Toyota, Miller Light, MGD, Ikea, Target, and Guitar Hero, among many others. Sea Level VFX works with the industry's most groundbreaking directors, including Spike Jonze, Mike Mills, Fredrik Bond, Patrick Daughters, Jonas Akerlund, Mark Romanek, Tarsem and many others. Gibbs and Bohn left the company in 2007. Currently Sea Level is headed up by Christopher Noellert, who joined the company from Stockholm Sweden as the new Lead VFX Supervisor. The company is based in Venice, California.

TOYOTA PRIUS: "UNLITTER"

Creative and Production Process Unlike many shops, Sea Level's approach to digital visual effects has been primarily a 2D or 2.5D solution with 3D additions. While other shops would immediately reach for the 3D switch to flick, Sea Level's visual effects supervisors have been renowned for their ability to construct solutions to commonplace visual effects problems using in-camera techniques combined with compositing brute force and know-how. Much of the best visual effects work completed at Sea Level will be shots you were never meant to notice.

Toyota's "Unlitter," by contrast, wears its effects "on its sleeve," making extensive use of grading and rotoscoping techniques. A saturated and vibrant Prius would drive through a dark, drab world, undoing the damage being done to the surroundings and highlighting the Prius's positive effect on the environment. Also by contrast to Diet Coke, the Toyota spot was shot using digital acquisition on the Red one, making it a completely digital production from start to finish.

As color was to play such a large role in the production, the decision was made quite early on to grade all of the material in the Flame rather than performing a grade in a DaVinci or Pandora, especially given the complexity of the masking and roto that would be required. Also during preproduction, it was decided that rather than using motion control, the camera would be a series of locked-off highly overcranked shots in order to further highlight the moment as it unfolded.

The postproduction process consisted of two steps. First was compositing the forward-moving Prius over a plate of reversed motion using mainly rotoscoping and keying techniques. Second, the Prius was isolated completely from the background and graded such that it was saturated and bright. The isolated background was in turn graded down, removing significant amounts of saturation and pushing the contrast into a faux bleach bypass. This two-pronged approach held for almost the duration of the spot with a few small deviations, like adding more smoke here and there or simple sky replacements to enhance the overall feeling of doom and gloom.

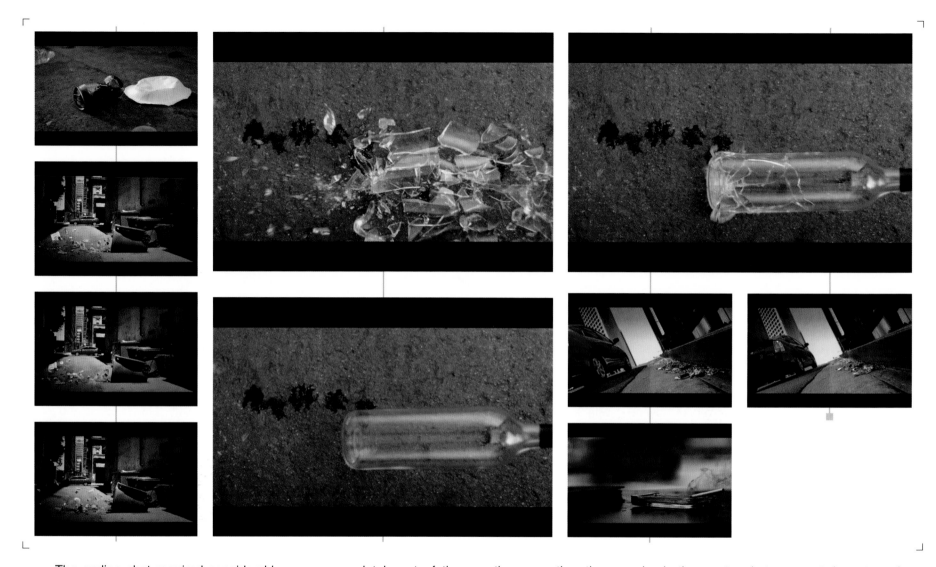

The ending shot required considerably more attention. The idea was that at the end of the commercial the skies would open up, the sun would shine, and the world would be a better place—conceptually, a difficult message to convey visually in under 4 seconds. On location, there were issues as well. During the location scouting, the production team found a fantastic overpass and down ramp with a scenic view of the city. Unfortunately, closing the overpass for the shoot was completely out of the question, so rather than sacrifice the location, production shot a take of the main action on the car, and then just let the camera roll in order to have enough material to remove the other "unwanted" traffic and bystanders that were present in the master take.

In post, the pieces of the extra material were composited over the master take, so that the Prius essentially drives down an empty on-ramp onto an empty highway. Skyscrapers and lamp poles in the master shot were cut down to make room for more visible sky. As the whole shoot had taken place on an intentionally cloudy and overcast day, a vibrant blue sky was rendered in 3D and a series of feathered and animated rotosplines, atmospherics, and flares were created to reveal the beautiful sky under cloudy sky. Lastly, animated shadows were created to further enhance the feeling of the sun "turning on."

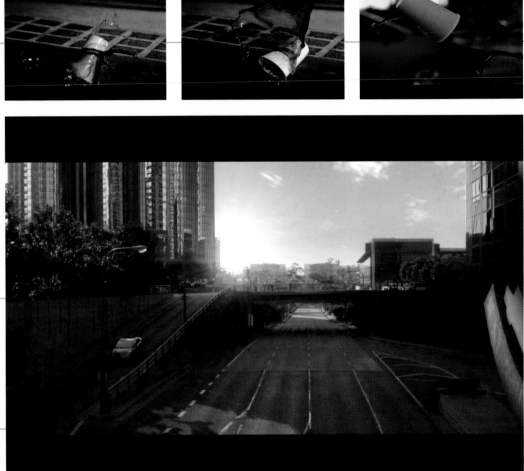

Tools Flame

THE COCA-COLA COMPANY: "HEIDI KLUM RED DRESS"

Creative and Production Process The Diet Coke "Red Dress" campaign spot was never intended to be a visual effects spot, and on the surface it's nothing more than a long master shot through a series of different set and wardrobe changes exemplifying Heidi Klum's frantic lifestyle pace. The spot was initially intended to be a single continuous take, shot in-camera; however, on set it became painfully obvious that this approach was not going to work. The interconnected timing of so many events and talent made it too large of a gamble, so the decision was made to break the single shot into three shorter shots in order to reduce the possibility of error. In order to facilitate this new direction, as motion control was never in the scope of the production, each of the three sections started and ended with an element that could be used either to wipe away or reveal the previous or incoming element, respectively.

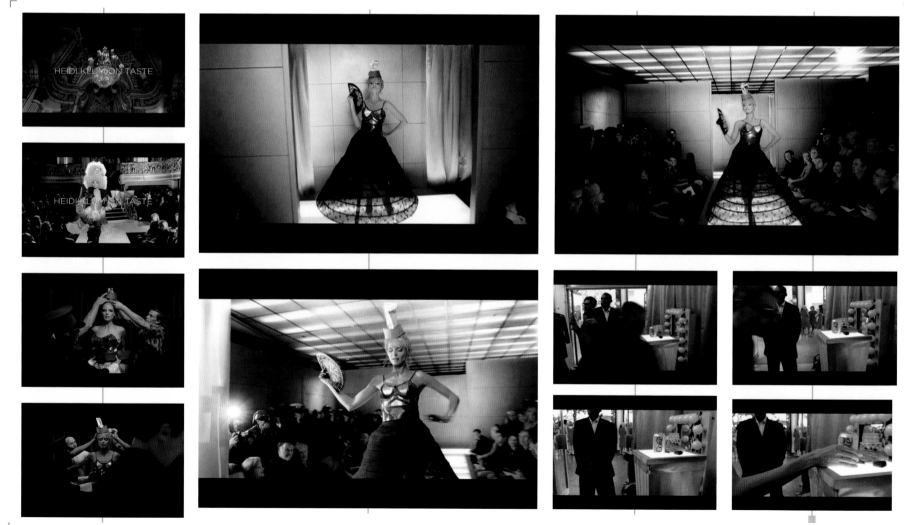

During editorial the challenge became twofold. There were certain sections of the various takes that the end client and the agency wanted to dwell on for a beat or two longer than was shot. This basically meant that the images would all need to be treated not only in spatial terms, to ensure that the different takes would move seamlessly in and out of each another, but also temporally, adjusting the timing of certain key moments, like dwelling longer on the moment when Heidi Klum reaches out and takes the Diet Coke can.

The postproduction process was a two-pronged approach as well. First, the various takes were lined up and blocked out spatially so that there was some semblance of continuity. This was easier said than done. Each of the takes was camera tracked and stabilized in 3D, negating as much of the perspective shift as possible from the incoming and outgoing takes. Next, a new camera move was created that blended the incoming shot into the outgoing shot, essentially by dissolving one camera data set into the other and then massaging the result so that there were no occlusion issues from objects not present in one take that were missing from the other or improperly timed (as talent rarely can perform the exact same action more than once). The new camera move was then applied to the outgoing and incoming 3D stabilized sources, creating a single continuous shot. Next, occluded and missing objects were added back to the new continuous shot using the camera tracking data and a good deal of roto-scoping, resulting in a final master sequence.

The next issue was the timing of the action from the various takes, now combined into the single master shot. This proved easier than expected, using a combination of rotoscoping, wipes, and motion-estimation-based time remapping.

Credits
VFX Artist and Title Lead Flame: Chris Noellert

STUDIO PHILOSOPHY

Digital Domain is an Academy Award-winning digital production studio focused on visual effects for feature film and advertising production. The company has built a legacy of achievement, listing *Titanic, The Day After Tomorrow,* and *The Curious Case of Benjamin Button* among its 75+ film credits. A creative giant in advertising, Digital Domain has created some of the world's most memorable spots. The studio works with top directors, including David Fincher, Michael Bay, and Clint Eastwood, and is recognized for its pioneering work in photo-real digital humans and productions that bring movies, games, advertising, and the web closer together.

HALO: "STARRY NIGHT"

Creative and Production Process This 60-second television spot was part of Microsoft's multi-pronged marketing campaign to promote the hugely popular Halo video game franchise. It premiered during ESPN's Monday Night Football on December 4, 2006, to 7.9 million viewers and was watched 3.5 million times on YouTube by September of the following year.

We worked with Director Joseph Kosinski to create an experience of the Halo universe that appealed to gamers and lay audiences alike by making it look and feel like a cinematic story rather than show actual game footage. Except for the children who open the spot, everything else is a photorealistic digital representation of the game's environments, weapons, and the main character: Master Chief.

Master Chief was a combination of motion capture and keyframe animation. His design was based on actual game elements provided by the game developer, Bungie. We took these low-resolution character references along with the original character sketches to keep his look consistent, then fleshed them out, adding the detail necessary to hold up in the spot's close-up camera angles. Detailed texturing work including scratches, rust, dirt, and scars was done during the modeling process. Actors were shot wearing motion capture suits, and we used that motion as a base for animation, which was created using Maya.

We created a new lighting pipeline, using radiosity renders through v-Ray. This approach imbues CG lighting with a photo-real look by adding more bounce and surface attributions than traditional three-point lighting setups provide.

The complex detonator and Buckminster Fuller-inspired dome shield we created for this spot were used in the actual game. The goal was to generate the shield in an interesting way and enable audiences to see the character inside. We developed it entirely in Houdini, adding reflections and refractions.

The sand bomb explosions were created using a sophisticated $2\frac{1}{2}$D setup that we had developed for the feature film *Flags of Our Fathers*. For Halo we took the actual Houdini elements, brought them in, and re-rendered them to the Halo camera setup, amplifying them using 3dsMax. Missiles were also created in Houdini. Clouds were created by animating matte paintings.

The opening scene has live action children in a real set. We extended the grass using a Lightwave hair shader and created the mountains, craters, and sky digitally. The helmet lying in the

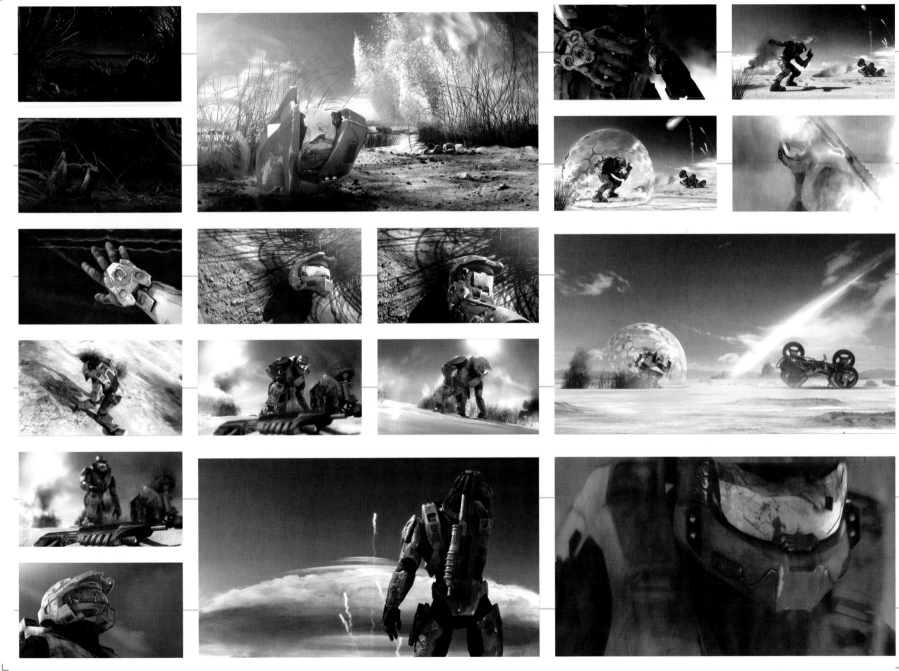

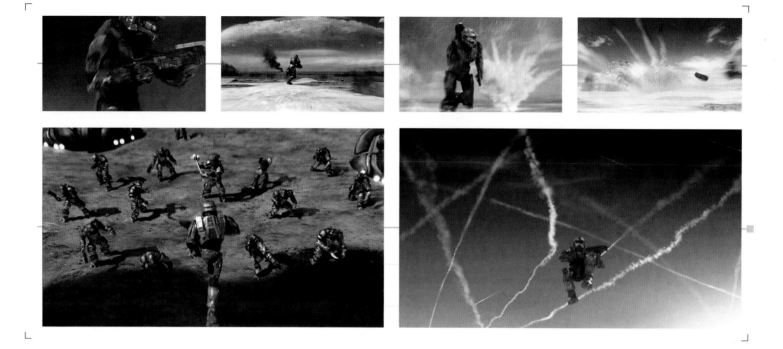

grass is a 2½D matte painting projected onto a card that was integrated into 3D grass.

Tools Maya, v-Ray, Houdini, 3dsMax, Lightwave

Credits
Executive Producer: Lisa Beroud
CG Supervisor: Vernon Wilbert
Visual Effects Producer: Michael Crapser
Visual Effects Coordinator: Chris House

ADIDAS: "MECHANICAL LEGS"

Creative and Production Process Director David Fincher conceived this 60-second spot, imagining a frenetic pair of mechanical legs clad in Adidas shoes testing the footwear by running, jumping, and spinning, and demonstrating their superiority over a shoeless pair of robot legs. The action takes place on an omnidirectional, moving basketball-court-esque platform that appears to try to outsmart the legs, which always stay one step ahead.

The groundbreaking spot is 100% CG. Combining 3D modeling, animation, global illumination, texturing, and compositing, it set new standards of photo-realistic lighting and animation. "Mechanical Legs" received a number of industry honors, including a Gold Clio Award for Animation, AICP Awards for Animation and Visual Effects, a London International Advertising Award for Special Effects, and the award for Best Effects Art Direction in a Commercial from the Visual Effects Society.

The industrial environment was created using photogrammetry. We conducted a two-day shoot in a retired aerospace hangar, where we lit an entire wall and photographed the room, taking high dynamic range image (HDRI) spheres of lighting and a set survey of actual geometry. We stitched together those photos and color graded them to re-project back onto the surveyed geometry.

One practical light box was made and we shot it for reference and to create the HDRIs. Using the HDRI data we gathered, a lighting rig was then developed to light all the hero foreground geometry. This was a combination of traditional art-directed CG lighting utilizing some proprietary lighting tools we developed and global illumination. The result was a highly photorealistic render.

We developed a Maya-to-Lightwave pipeline to maximize each package. All camera pre-visualization, texturing, lighting, and rendering was done in Lightwave, but character setup, animation, and motion capture management was done in Maya, to take advantage of our animation team's talent. Modeling was split between Lightwave and Maya. All compositing was done in Nuke.

The mechanical legs, shoes, and the platform, along with the other sets of robotic legs and wires, were pre-visualized using Maya and modeled in Lightwave.

We developed the look of the legs, then shot athletes playing basketball in motion capture suits. After editing the motion capture sessions, we moved forward into full pre-visualization. David Fincher blocked out the camera moves based on the locked animation that was being fed to him by the animation team. This also included the animated table.

We developed a rigging system using Maya and applied the motion capture data to it, then applied keyframe animation on t reverse-engineered the motion and that the legs always stayed centered form. We also designed, rigged, and anim platform so that it could bank and pitch, mathematically and automatically anticipate wh the feet were coming from and going to. To creat the CG shoes, we scanned an actual pair of shoes, pre-visualized them using Maya, and modeled them in Lightwave using high-resolution geometry. Then we remodeled them at a lower, sub-D resolution, textured them using Lightwave and Photoshop, and rendered them with a Lightwave global illumination and CG hybrid solution.

Tools Maya, Lightwave, Nuke, Adobe Photoshop

Credits
Executive Producer: Gabby Gourrier
Visual Effects Supervisor: Eric Barba
Visual Effects Producer: Baptiste Andrieux
Conceptual Designer: Jeff Julian
Compositing Supervisor: Feli di Giorgio
Compositor: Greg Teegarden
Animation Supervisor: Bernd Angerer

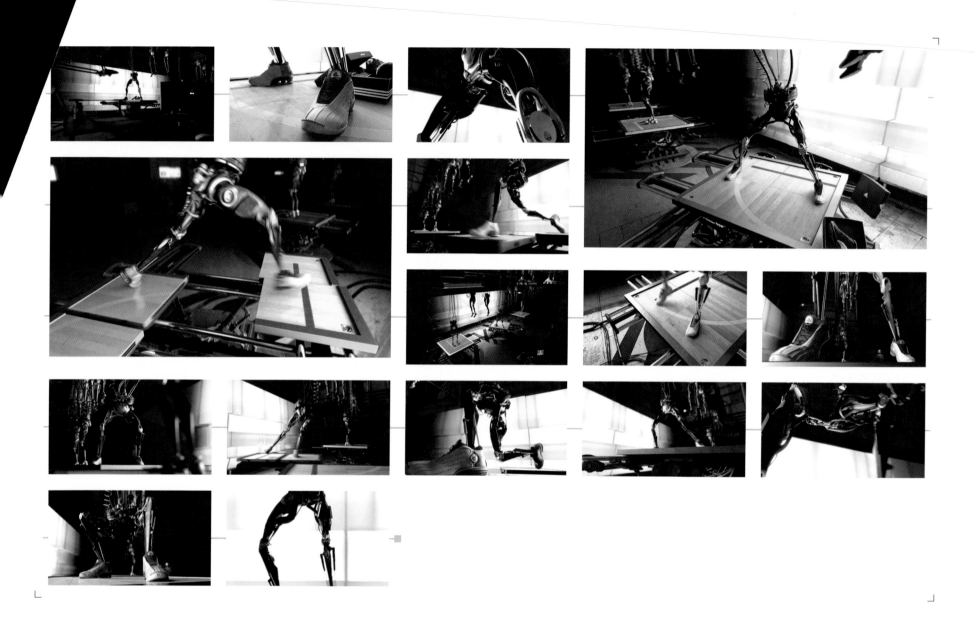

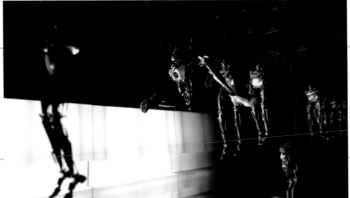

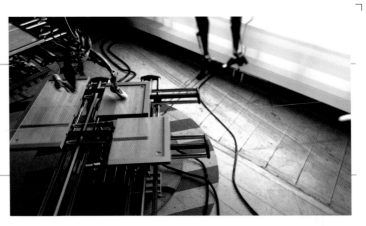
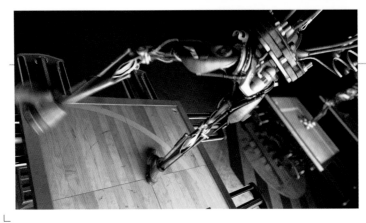

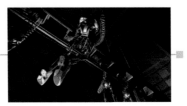

STUDIO PHILOSOPHY

PMcD Design is a New York–based, full-service design company. PMcD specializes in all aspects of broadcast and print design as well as production for the entertainment industry. Clients include ABC, NBC, ESPN, NGC, Starz, Encore, PBS, MSG, Disney, TLC, FRC, and WNET. For the moving image, their specialties include 2D/3D design, animation and composite, film and HD live action, editorial, and digital output. For print, PMcD handles corporate image and identity, collateral, signage, press and sales materials, and outdoor and trade advertising.

STARZ NETWORK: *CRASH* PROMO

Creative and Production Process In 2009 the Starz Network entered the original programming market with a series based on the Academy Award-winning film *Crash*. This was a huge endeavor for the network, and they knew that one of the keys to success for the show would be its branding and marketing to its audience. They came to us to design and produce a comprehensive promotional package that included IDs, end pages, long-form title sequence, and a comprehensive toolkit that their producers and editors could use to create tease, launch, and episodic campaigns for the life of the series.

Our idea was to illustrate the uneasy and volatile quality of the relationships seen in the show. We used high-speed photography of breaking glass and crushing metal to visually suggest the random destruction of lives. We also wanted to capture the character of Los Angeles and give it a sensual quality. For that we used time-lapse photography to capture the feeling of chaos and the energy of life in general.

To begin the process, designer/director Suzanne Kiley created storyboards in Adobe Photoshop to offer a general look and feel. This helped the PMcD team and Starz collaborate on a style and set the overall creative direction for the shoot. Once the look was finalized, the boards became the blueprint for the director/DP to hone in on setups and camera angles.

Because the look required a camera with an exceptionally high frame rate ability and enormous detail, the Phantom digital camera was chosen to shoot all live action elements, with speeds up to 1000 fps. These images included full glass plates breaking into shards, metal crumpling and twisting, water spraying and splashing through space and on the metal surfaces, and typography projected on these surfaces. Time-lapse footage of the Los Angeles skyline in two locations was captured using a still camera. Prior to the actual shoot day, numerous tests were completed with the Phantom to study various impacts on several types of glass and metal sheets, as well as a myriad of camera angle explorations. These angles were crucial in capturing the essence of a crash.

From there we digitized the film footage, paying close attention during the color-correct process to give the footage some dynamic color contrasts. We also incorporated the technique of verispeeding, in which we can slow and speed up the film at certain times to create a sense of drama and intensity.

Once all the footage was digitized we then began the intricate job of compositing some 80 layers of elements, all of which was done primarily

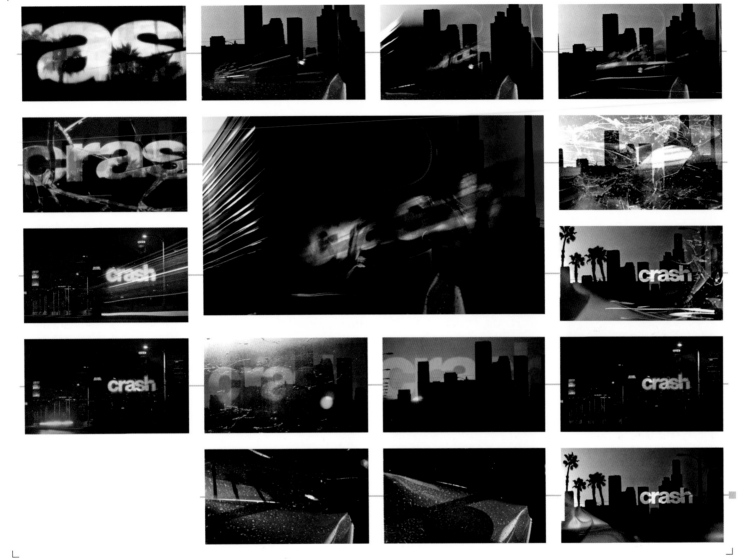

using Adobe After Effects. In any scene, it was common to have scores of layers containing not only live action super slow motion footage, but also matte sequences, light sources and effects, typography, time-lapse photography, and the Starz logo and various filters and mock camera lens effects—to enhance the camera's angles—along with 2D and 3D animation.

Tools Adobe Photoshop, Adobe After Effects, Gen Arts Sapphire plug-ins for After Effects, Final Cut Pro

Credits
Creative Director: Patrick McDonough
Executive Producer: Dana Bonomo
Designer: Suzanne Kiley

Producer: Alison Cole
Live Action Producer: Alessandra Pasquino
Director/DP: Andrew Turman
Lead Animator: Alex Gasowski
Animation/Editor: Genevieve Manion
Media Artist: Josh Lynne